Artists' Letters

Artists' Letters

Leonardo da Vinci to David Hockney

Michael Bird

WHITE LION
PUBLISHING

Contents

006 Introduction

1 'I saw the new giraffe'
Family & Friends

014 **Salvador Dalí** to Paul Éluard
016 **Francisco Lucientes y Goya** to Martín Zapater
018 **Lucian Freud** to Stephen Spender
020 **Vanessa Bell** to Duncan Grant
022 **Michelangelo Buonarroti** to Lionardo di Buonarroto Simoni
024 **Philip Guston** to Elise Asher
026 **Beatrix Potter** to Noel Moore
028 **Piet Mondrian** to Kurt Seligmann
030 **Gustav Klimt** to Josef Lewinsky
032 **Jasper Johns** to Rosamund Felsen
034 **Edward Burne-Jones** to Daphne Gaskell
036 **William Blake** to William Hayley
038 **Alexander Calder** to Agnes Rindge Claflin
040 **Zhu Da** to Fang Shiguan
042 **Camille Pissarro** to Julie Pissarro
044 **Marcel Duchamp** to Suzanne Duchamp
046 **Dorothea Tanning** to Joseph Cornell

2 'Like a sleepwalker'
Artist to Artist

050 **Paul Gauguin** to Vincent van Gogh
052 **Vincent van Gogh** to Paul Gauguin
054 **Sebastiano del Piombo** to Michelangelo Buonarroti
056 **Paul Signac** to Claude Monet
058 **David Alfaro Siqueiros** to Jackson Pollock, Sande Pollock and Harold Lehman
060 **Pablo Picasso** to Jean Cocteau
062 **Mark Rothko** to Lee Krasner
064 **Édouard Manet** to Eugène Maus

066 **David Hockney** to Kenneth E. Tyler
068 **Francis Picabia** to Alfred Stieglitz
070 **Robert Smithson** to Enno Develing
072 **Claude Monet** to Berthe Morisot
074 **Ulay and Marina Abramović** to Mike Parr
076 **Mike Parr** to Marina Abramović and Ulay
078 **Benvenuto Cellini** to Michelangelo
080 **John Constable** to John Thomas Smith

3 'Your book on witchcraft'
Gifts & Greetings

084 **Cindy Sherman** to Arthur C. Danto
086 **Joseph Cornell** to Marcel Duchamp
088 **Leonora Carrington** to Kurt Seligmann
090 **Wang Zhideng** to a friend
092 **Yayoi Kusama** to Donald Judd
094 **George Grosz** to Erich S. Herrmann
096 **Yoko Ono and John Lennon** to Joseph Cornell
098 **Joan Miró** to Marcel Breuer

4 'The best I have painted'
Patrons & Supporters

102 **Guercino and Paolo Antonio Barbieri** to unknown recipient
104 **Nancy Spero** to Lucy Lippard
106 **Pierre-Auguste Renoir** to Georges Charpentier
108 **Roy Lichtenstein** to Ellen H. Johnson
110 **Peter Paul Rubens** to Balthasar Gerbier
112 **Cy Twombly** to Leo Castelli
114 **Winslow Homer** to Thomas B. Clarke
116 **Eva Hesse** to Helene Papanek
118 **Mary Cassatt** to John Wesley Beatty
120 **Jackson Pollock** to Louis Bunce
122 **Leonardo da Vinci** to Ludovico Sforza

124 **Egon Schiele** to Hermann Engel
126 **William Hogarth** to T.H.
128 **Joseph Beuys** to Otto Mauer
130 **Agnes Martin** to Samuel J. Wagstaff
132 **Judy Chicago** to Lucy Lippard

5 'Hey beautiful'
 Love

136 **Frida Kahlo** to Diego Rivera
138 **Joan Mitchell** to Michael Goldberg
140 **Jean-Auguste-Dominique Ingres** to
 Marie-Anne-Julie Forestier
142 **Paul Nash** to Margaret Odeh
144 **Ad Reinhardt** to Selina Trieff
146 **Jules Olitski** to Joan Olitski
148 **Jean Cocteau** to unknown recipient
150 **Alfred Stieglitz** to Georgia O'Keeffe
152 **Georgia O'Keeffe** to Alfred Stieglitz
154 **Auguste Rodin** to Camille Claudel
156 **Camille Claudel** to Auguste Rodin
158 **Ben Nicholson** to Barbara Hepworth
160 **Eileen Agar** to Joseph Bard

6 'My 1244 guilders'
 Professional Matters

164 **Nicolas Poussin** to Paul Scarron
166 **Henry Fuseli** to unknown recipient
168 **Henry Moore** to John Rothenstein
170 **James McNeill Whistler** to Frederick
 H. Allen
172 **Joshua Reynolds** to Philip Yorke
174 **Anni Albers** to Gloria Finn
176 **Naum Gabo** to Marcel Breuer
178 **Rembrandt van Rijn** to Constantijn
 Huygens
180 **Gustave Courbet** to Philippe de
 Chennevières
182 **Aubrey Beardsley** to Frederick Evans

184 **Kazimir Malevich** to Anatoly
 Lunacharksy
186 **John Linnell** to James Muirhead
188 **Andy Warhol** to Russell Lynes

7 'I hope to get to Venice'
 Travel

192 **Edward Lear** to Hallam Tennyson
194 **Berenice Abbott** to John Henry
 Bradley Storrs
196 **Georges and Marcelle Braque** to
 Paul Dermée and Carolina Goldstein
198 **John Ruskin** to unknown recipient
200 **Helen Frankenthaler and Robert
 Motherwell** to Maria and Hans
 Hofmann
202 **Albrecht Dürer** to Willibald
 Pirckheimer
204 **Carl Andre** to Eva Hesse
206 **Francis Bacon** to Erica Brausen
208 **Ana Mendieta** to Judith Wilson
210 **Lee Krasner** to Jackson Pollock

8 'I see better'
 Signing Off

214 **Thomas Gainsborough** to
 Thomas Harvey
216 **Paul Cézanne** to Émile Bernard

218 Timeline
220 Index
222 Picture Credits

Introduction

'Your letter comes, speaking as you'
W.H. Auden

In Venice, in the small hours of a February night in 1506, Albrecht Dürer signs and seals a letter to his closest friend, Willibald Pirckheimer, an eminent lawyer and humanist scholar in his home town of Nuremberg. Dürer arrived here a few weeks earlier, after a journey of four hundred miles across the Alps, much of it probably on foot. Financed by his wealthy friend, he will spend a year in Venice, studying proportion, perspective and other skills and secrets of Italian artists, and proving that he, Dürer, a German-speaking painter from the uncouth north, can beat them at their own game. His letter will travel back the same way, along claggy winter roads and mountain passes, reaching Pirckheimer, with luck, by the end of the month. Dürer explains that his mother has been nagging him to write, afraid that her son has offended his useful friend. He has been unable to paint because of a skin rash (better now, thankfully). He gently teases Pirckheimer about his love life. In between – casually reporting, complaining, boasting – he gives him, and us, one of the earliest first-hand descriptions of what we would now call the art world.

By writing his letter – as he may be well aware – Dürer shows himself to be an inhabitant of this 'world', in which artists converse on equal terms with writers, thinkers, lawyers, the upper echelons of a still largely illiterate society. He is proud to report that 'men of sense and knowledge, good lute-players and pipers, judges of painting, men of much noble sentiment and honest virtue' want to be friends with him, and that the Venetian painter he most admires, Giovanni Bellini, has taken an interest in his work. Dürer's father was a leading goldsmith – an artist in his way – but he would never have kept this sort of company, in which books and music, connoisseurship and foreign travel, and writing long letters about your thoughts and impressions were part of a relatively new mode of European artistic life (much newer in northern Europe than in Italy). Similarly, though it deals with such domestic matters as a gift of cheese and choosing a wife, Michelangelo's letter of December 1550 to his nephew Lionardo is written in the beautifully clear handwriting developed by humanist scholars to share their ideas, the script of a free intellectual, not a jobbing craftsman. Benvenuto Cellini's 1559 letter to the octogenarian Michelangelo coincides with a further hike in artistic self-esteem. Cellini addresses Michelangelo as if he were a prince, while (though he doesn't mention this) he himself is at work on an autobiography in which he plays the role of creator-hero, a man who takes orders from no one.

This selection of ninety or so letters from as many artists covers almost the entire history of the artist-as-letter-writer (in the Western world, at any rate – it was a different situation in China and elsewhere), between the curriculum vitae Leonardo da Vinci sent to the Milanese despot Ludovico Sforza around 1482 and Cindy Sherman's 1995 thank you

postcard to the art writer Arthur C. Danto. Letters, that is, in the sense of physical documents, inscribed by hand, whacked by typewriter keys or (in one case) scrolled out by a fax machine. Letters as objects, handled and stared at, folded, unfolded, crumpled up and smoothed flat, slipped into envelopes and jacket pockets, used as bookmarks, ringed with coffee, nibbled by mice, forgotten in shoeboxes. 'Handwritten letters', as Mary Savig observes, 'are performances on paper ... intertwining language and art'.[1] From the mid-1990s onwards, we have had, and increasingly preferred, digital alternatives to 'performances on paper'. A selection of artists' letters from 1995 to 2495 will – if anyone is still around to read it – be a much thinner (in several senses) publication.

The things friends and lovers tell each other in letters have not changed much in five hundred years. 'How I wish you were here,' says Dürer to Pirckheimer. In 1931 Ben Nicholson scribbles a note to Barbara Hepworth – 'suddenly I missed you' – while his wife, Winifred, is 'painting happily' nearby. 'I miss you & wish you were sharing this with me,' writes Lee Krasner in 1956 to Jackson Pollock, the troublesome husband she is meant to be taking a break from in Paris. Letters like these are poignant in a way that eludes electronic media: what the reader holds in his or her hands is a token of presence that simultaneously speaks of absence and distance. Like dinosaur bones or fragments of ancient pottery, almost any letter retrieved from the past (including our own earlier life) is laced with clues to the much larger picture that surrounds the circumstances of its making – physical clues like the style of handwriting or type of paper, as well as the many signs and pathways that can be tracked through its content (where, when and to whom it was written; allusions and references that connect to other histories; the always revealing choice of word and phrase). In this sense, the pleasures of imaginatively recovering the moment when the letter writer sat down to write are no different in artists' letters than with any other collection of correspondence.

What *is* different is the variety and the slight yet consistent unexpectedness of the insights they provide into the history of art beyond the personal. You could read Krasner's letter to Pollock purely as a scene from a marriage: wife of alcoholic Great White Male feels warmly towards him again, once she is the other side of the Atlantic. He sends deep red roses to her hotel. One part of her wants to kiss and make up; the other, as if through a conditioned reflex, cannot help querying his actions and state of mind ('How are you Jackson?'). Looked at another way, if you follow up every single thread, every place and person Krasner mentions on one side of a sheet of airmail paper,

[1] Mary Savig, *Pen to Paper: Artists' Handwritten Letters from the Smithsonian's Archives of American Art* (Princeton Architectural Press, New York, 2016), p.9.

and the connections between them, you can unpack entire episodes in the story of postwar American and European painting – enough for a book. In each of the short commentaries that accompany the transcripts, I have drawn out a few such threads. Letters may not be meant to be interpreted this way. Traditionally they are sealed or packaged like gifts, so that only the person for whom they are intended is licensed to snap the seal or slit the envelope. But a strange fact about reading all these lines that were not addressed to us is that, to the eye of history, there is no such thing as privacy.

The most intimate correspondence in this book, which is also one that relates most clearly to art's Big History, is between the nineteenth-century French sculptors Camille Claudel and Auguste Rodin. It is a well-known story that begins when a famous middle-aged genius falls in love with a beautiful and talented young assistant, who resists his advances for far longer than he is accustomed to. In a letter to Claudel, Rodin, who is not a natural wordsmith, ties himself in knots trying verbally to get her into bed. He describes himself kneeling adoringly in front of her, like the male figure in *The Eternal Idol*, a sculpture on which he may already have been working. Claudel's letter to Rodin dates from the later, honeymoon phase of their relationship, when they were spending as much time as possible together, out of public view, in a bijou château on the Loire. Where Rodin's letter is all about him, as if he were besieged by his own feelings but unable to fathom hers, Claudel's reveals, subtly and rather movingly, how well she understands Rodin. She wants to swim in the river, she says, instead of going to the public baths. Can he buy her a bathing costume in Paris – a dark blue one with white trimming? Since Rodin has to touch things in order to understand them, shopping for a bathing costume ('medium size') will make him – absent with important work to do, or perhaps with his long-term mistress, Rose Beuret – physically conscious of Claudel. She ends by describing what she knows he is already imagining and what will bring him back: 'I sleep completely naked, so that I can pretend you're there.' Claudel and Rodin's summer of love was not a prelude to a happy ending: their relationship eventually broke her. It is easy, knowing what was to come, to import a tragic irony into her happy, youthfully confident, frankly erotic letter. But maybe the clues were already there, in a certain tone – self-pitying, attitude-striking – that creeps into Rodin's earlier letter of attempted seduction, and in Claudel's postscript: 'Above all, don't deceive me any more.' Here the reader – you or I – is almost awkwardly conscious of being the third person in the room.

Whether it is based on love, money, professional comradeship or rivalry, or simply feeling obliged to reply to an enquiry out of the blue, the relationship between writer and recipient forms the matrix for every letter. Since they were the people who kept and

preserved the letters, sometimes because they realised their potential historical interest, and whose possessions ended up in museums and archives, it is not surprising that many of the recipients' names also feature in the annals of art. Some are well-known historical figures in their own right, like the seventeenth-century poet, composer, diplomat and princely art-adviser Constantijn Huygens or Anatoly Lunacharsky, People's Commissar for Education in revolutionary Russia. Others, like Renoir's patron Georges Charpentier, the New York dealer Leo Castelli or the critic and curator Lucy Lippard, helped to shape the cultural economy of their times, collecting, organising exhibitions, interpreting, selling, in one way or another changing the weather around art.

Artists' reasons for writing letters have to do as often with this support system as with the work itself. Rembrandt's correspondence with Huygens is an object lesson in how to inject a note of deferential restraint into a message of righteous impatience – a common theme in artists' letters from the sixteenth century to the present day – 'Where's my money?' Courbet's brusque, guarded letter to the Marquis de Chennevières comes from an artist who owes much of his worldly success to people he can't help but despise. Judy Chicago writes to Lucy Lippard as to a fellow activist and ideological comrade in the women's art movement of the 1970s. The role of artists' advocate is a vocation in itself: Otto Mauer, John Rothenstein, Sam Wagstaff and Erica Brausen are nowhere near as well known as the artists they supported (Joseph Beuys, Henry Moore, Agnes Martin and Francis Bacon). But in these letters, at least, we see the two-way relationship at work.

The letters in which the writers seem most able to speak their minds or paint word pictures are often, as you would expect, between artist and artist. Hoping that his *compare* (best mate) Michelangelo can use his contacts to ensure that he gets paid, Sebastiano del Piombo admits 'to tell you the truth, I am in in the red'. 'Sometimes,' muses Dorothea Tanning in a letter to Joseph Cornell, 'I think that the only true and satisfactory means of contact with those we love is by writing rather than talking … our letters are far more the real barometer of our feelings than when we speak for a few overcharged moments in New York.' Replying to Ulay and Marina Abramović, whom he met at a recent festival of performance art in Europe and who have asked him to send them ten boomerangs, the Australian artist Mike Parr recounts a surreal journey to Queensland, '1000kms in a typically crazy australian train' through 'spaces that crawl to the edge of the horizon line that make you feel in a dream'. And occasionally the process of writing a letter, 'intertwining language and art', becomes a way of thinking about the work. Describing a now-famous picture of his bedroom in Arles, Van Gogh explains his choice of colours to Gauguin: 'the walls pale lilac, the floor in a broken and faded red, the chairs and bed chrome yellow … the window green', and how he had 'wished to

express utter repose with all these very different tones'. In Marcel Duchamp's letter from New York to his artist sister Suzanne in Paris during the First World War, the phrase *une sculpture toute faite* ('a sculpture already made') becomes on the next page 'Readymade' – his first recorded use of a term that would define his formative contribution to conceptual art.

Running through the art gossip and the insights into personal preoccupations ('it seems to me that I make slow progress,' confides an elderly Cézanne at the height of his powers) is the constant pulse of the everyday – the real world without which the art world is just a talent show. Claudel's shopping suggestions for Rodin, which include the Grands Magasins du Louvre and Le Bon Marché, open a momentary window onto a cultural phenomenon of the belle époque – the democratised chic of the new Parisian department stores. We hear about Vanessa Bell's plans for home improvements ('I should probably white or colour wash the walls'), Michelangelo's thoughts about what to do with all the cheese his nephew has sent him, Mondrian's problems with his teeth and Zhu Da's constipation, Pissarro's tips on homeopathy, Hockney's new fax machine, George Grosz's birthday party, Eva Hesse's medication and Jules Olitski's shortage of cling-film. Francis Bacon admires the 'starched shorts and highly polished leggings' of Rhodesian policemen ('too sexy for words'). John Constable explains to his mentor John Thomas Smith that he has asked the village shoemaker to deliver his letter, a man who was 'perhaps never twenty miles from home before'.

Some of the artists in this book were writers too. Michelangelo and William Blake were poets, Dürer and Joshua Reynolds theoreticians. For Chinese artists like Zhu Da and Wang Zhideng, painting, poetry and calligraphy – the 'three perfections' – were equal and integral aspects of the artists' vocation. John Ruskin and Edward Lear are better known for their books than their art. Yet, collectively and overwhelmingly, these letters breathe a visual sensibility, which often moves between words and pictures. In the self-portrait he sketches for his childhood friend Martín Zapater, Goya slips into the caricature mode that he'll develop and deepen in his phantasmagoric print series *Los Caprichos*. Illustrating her letter to a sick child with pictures that she hopes will cheer him up, Beatrix Potter begins to assemble the cast of animal characters who will star in her famous children's books. Paul Signac heads his letter to Monet with a beautiful miniature painting of the old port at La Rochelle, to prove that self-medicating with 'watercolour therapy' has been much better for his health than a spell in a thermal spa.

Maybe 'letter therapy' will become – or already is – a standard form of digital detox. But physical documents have their shortcomings too. They demand time, travel and the need to be in a particular place at a specific moment. I could not have put this selection

together without access to high-quality scans of letters in digitised archives that can be searched online. Institutions that have invested in the labour-intensive process of digitising and documenting their paper archives are making it possible for physical letters, which are often fragile objects, to have a long afterlife in the digital age (the Beinecke Library, British Museum, Courtauld Gallery, Metropolitan Museum of Art, Morgan Library & Museum, Tate and Smithsonian deserve special mention here). Even on screen, however (captured, saved), letters retain their wonderfully ephemeral integrity, populated by passing thoughts and chance observations, which we pin down at our peril. This selection concludes with two letters written by artists very near the end of their lives – the letter from Cézanne to Émile Bernard that I have already cited and one from Thomas Gainsborough to a collector, Thomas Harvey. Gainsborough is dying of cancer, and almost knows it. He is experiencing 'a great mixture of bodily Pain'. It is odd, he says, 'how all the Childish passions hang about one in sickness, I feel such a fondness for my first imitations of little Dutch Landskips that I can't keep from working an hour or two of a Day … I am so childish that I could make a kite, catch Gold Finches, or build little ships.' It reads as if the act of writing this letter, of communicating his thoughts, had brought him a brief release. He thinks of copying Dutch landscape paintings when he was a boy, of making kites and toy ships, and holding a goldfinch in his hands. Looking, painting, pulling the different bits together, the feel of colour – his entire life as an artist.

A note on the text

Each letter is presented in the form of a reproduction with a commentary and transcript or translation on the facing page. Some of the original letters are several pages long; not every page of every letter is reproduced, and the transcripts are often edited versions of the complete text, with omissions marked by ellipses in square brackets. In most cases I have preserved misspellings and unconventional or absent punctuation, with minimal editorial additions in square brackets. Where it seemed helpful or interesting, I have included handwritten or printed letterheads in the transcripts. Published sources for existing translations and translator credits for new translations can be found on pages 222–3. I have grouped the letters into eight thematic sections, within which they are not arranged chronologically. There is a timeline of letters on pages 218–19.

Chapter 1

'I saw the new giraffe'

Family & Friends

Salvador Dalí (1904–89) to Paul Éluard
September 1939

In September 1939 Salvador and Gala Dalí rented the villa La Salesse in the seaside town of Arcachon in south-west France. They had been on the move since 1936, when civil war broke out in Dalí's native Spain, staying at various times in London, Paris and at the fashion designer Coco Chanel's house on the Côte d'Azur. In the spring of 1939 Dalí had been a bad-boy star of the New York art scene. Between February and May, his erotically suggestive dream images and objects had scandalised and excited visitors to his exhibition at Julien Levy's gallery, his window display at Bonwit Teller department store (now the site of Trump Tower) and his Dream of Venus pavilion in the Amusement Zone of the New York World's Fair. This consisted of a small building resembling a bleached coral cave, within which seventeen 'Liquid Living Ladies' took turns in a long glass tank filled with water.

With the outbreak of war in Europe, Dalí chose Arcachon as a refuge because he thought it would be the last place in France that German forces would reach and, perhaps more importantly, because of its gastronomic reputation, particularly for oysters. Writing in rather broken French to his friend and fellow surrealist, the poet Paul Éluard, he exhorts him to visit with his wife Nusch ('Ninis') – an offer that Éluard is unlikely to be able to accept, since he is called up for military service that same month. The Latinate wordplay at the end of Dalí's letter, 'Leonoris Finis est', suggests that the beautiful, exhibitionistic Argentine surrealist Leonor Fini has already joined them at La Salesse. In August 1940 the Dalís left France for New York, where they would spend the rest of the war.

. .

Dearest Paul: We have just rented quite a large villa, of a kind that if you come with Ninis to enjoy what's on offer I am sure you'll be like the 'fish in water', come, come! We have so many questions to work through together (in conversation). We are going to America next autumn, now I have to 'push on to the finish', which begins for the first time to become really good, what realism [is] more original than the one I am in the process of inventing –

I send my love and demand the promise that you come to see us at Arcachon, their is a very good fish, voysters – Leonors Finis est – Friendly hello, Your little Dalis

No puede ser 1800: Bayeu m.º 1795.

5ª 2

Londres 2 d Agºᵗᵒ d 1800

S.mᵒ B.

Por Justo Juicio d Dios, te
molestaran mis bobadas, y aunq.
Silberrys, las puedes echar con las
tuyas, y echarias ā morder, todas
como ganan. con mucho, las mias
muy tengo la banidad d q. se pin-
taran solas en el mundo.

Mas te balia benir me ā ayudar
a pintar a la d Alba, q. ayer se me
metio en el estudio a q.e la pintase
la cara, y se salio con ello; por cier-
to q. me gusta mas q.e pintar en lienzo
q. tanbien la he d retratar d cuerpo en-
tero

y bendra aquñas acabe yo, un
borron q. estoy aciendo d el Duque
d la Alcudia ā caballo q.e me
embio a decir me abisaria y dis-
pondria mi alojam.to en el sitio
pues me estraña mas tiempo d q.
yo pensaba: te aseguro q. es
un asunto d lo mas dific q se le
puede ofrec.r a un Pin.r

Bayeu lo debia aber echo pero
ā huido el cuerpo, y se a echo muchas
becs instancia; pero amigo el Rey no
quiere q trabaje tanto y dijo el q se
biviria p. 2 meses a Zarag. y dijo el Rey
ningu sean th. Ay lo tienes consejalo
y ayudale a biben.te

Tanbien tienes esa carta

te empeño p.ª q. ayas lo q.
debes, acer y siento d aya muer-
to si es alguno d los dos q. yo cono-
es ay ā Dios y si quieres saber
mas pregunta a Clemente

asi estoy.

Francisco Lucientes y Goya (1746–1828) to Martín Zapater
July 1794

Francisco Goya and Martín Zapater first met as schoolboys in Saragossa in the 1750s and maintained a close friendship until Zapater's death in 1803. After Goya left for Madrid in 1775, they corresponded regularly, exchanging news, salacious gossip and offbeat humour (like the false date of 1800 in this letter heading). Zapater stayed in Saragossa, becoming a successful businessman and administering the funds that Goya, who was soon achieving parallel success as an artist, sent home to support his relatives.

In 1786 Goya was appointed Painter to the King, then, with the accession of King Charles IV in 1789, Senior Court Painter. He was kept busy with portraits of the new king and queen, the extended royal family and inner-circle aristocrats like the Duchess of Alba. Goya also had to continue producing designs for the Royal Tapestry Factory, which he had been doing since his early years in Madrid. This work may have exposed him to toxic chemicals, contributing to a serious illness in the winter of 1792–3, which left him deaf. His letter to Zapater hints at the pressures of being a royal artist: his court colleague, brother-in-law and fellow Saragossan Francisco Bayeu has landed him with the arduous task of painting an equestrian portrait of the vain and demanding royal favourite, Manuel Godoy, Duke of Alcudia. The self-caricature Goya adds to the letter anticipates the intimate satirical sketches he made while staying on the Duchess of Alba's estate two years later, which became source material for his phantasmagoric print series *Los Caprichos*.

..

God's truth! my scribblings must annoy you, but although they may be rough, just put them next to yours and compare them and you will find that mine win easily, for I can boast that mine are the only ones in the world that are drawn.

It would have been worth your while to have come and helped me paint La Alba, who barged into my studio yesterday to have her face painted, and now it's done. I definitely prefer this to painting on the canvas, and now I also have to do her in full-length once I have finished a sketch I am making of the Duke of Alcudia on horseback, who sent to tell me that he was having accommodation arranged for me at the Palace [El Escorial], for I shall be there for longer than I thought. I tell you it is one of the most difficult subjects for a painter.

Bayeu was to have done it but he got out of it. He was asked a number of times, but the King did not want him to take on so much work and told him he should take leave and go to Saragossa for two months, or maybe four. You will have him there, so look after him and help him enjoy his stay.

Also, you will have that document which guarantees a loan I made and which you are dealing with, but I have a feeling that he will have died if he is one of the two I knew there.

Adios, and if you need to know any more, ask Clemente [Aranaz, Zapater's secretary].
This is me.

Spethen,

Dearest Stephen, Thanks terribly for your letter. It crossed one of Mine I think? Suffolk
Life for me is no longer the monotony of waking up in a old room to find
myself with Clap, D.Ts, Syph, or perhaps a poisoned foot or ear!
No Schuster, those happy and carefree days are gone the phrase
"Freud and Schuster" no longer calls to the mind such happy scenes
such as two old hebrews hand in hand in a wood or a bath-
room in Atheneum Court or Pension-day in the freud-Schuster buil.
building but now the people think of freud and Schuster in
bathchairs, freuds ear being amputated in a private nursing
homes, and puss running out of his horn. Schuster in an epilep-
tic fit with artifcial funnybones. When I look at all my
minor and major complaints and deseases I feel the
disgust which I experience when I come across intimate
passages in letters not written to me.

Benton End
Hadleigh

Cedric has painted a portrait
of me which is absolutely amazing.
it is exactly like my face is green
it is a marvellous picture I have
painted a portrait and also a picture
of a cat after it has been skinned
Do come down here if you can! What about

Mrs. p.s at Haulfrynny in march?
John Jameson has been down here
for some days and also a man who
was a great friend of the strange
enlishmen who threw fits
to whom tibbles
was employed in Italy.

Here is our Telephone
call. Do you realise that if you
shaved your nose every days you would soo
grow a reasonable beard on it? The firm ought to
realise these little things in case of a buissiness drops.

Lucian Freud (1922–2011) to Stephen Spender
1940

As refugees from Nazi Germany, Lucian Freud's family had settled in England in 1933. In 1938, after a patchy secondary education, Freud enrolled in the East Anglian School of Painting and Drawing run by Cedric Morris and Arthur Lett-Haines. 'Cedric taught me to paint,' Freud recalled, 'and more important to keep at it.' In 1939 he spent two months in north Wales, where the poet Stephen Spender briefly joined him. They collaborated on an album of surreal scenarios and sketches, which they called the 'Freud–Schuster Book' (Schuster was Spender's mother's maiden name), fondly evoked here by Freud. Morris's 'absolutely amazing' green-faced portrait of the eighteen-year-old Freud, visually pastiched in this letter, is now in the Tate collection.

Benton End
Hadleigh
Suffolk

Dearest Spethen, Stephen,

Thanks terribly for your letter. It crossed one of mine I think? Life for me is no longer the monotony of waking up in a cold room to find myself with Clap, D.Ts, Syph, or perhaps a poisoned foot or ear! No Schuster, those happy and carefree days are gone the phrase 'Freud and Schuster' calls to the mind happy scenes such as two old hebrews hand in hand in a wood or a bath-room in Aheneum Court or Pension-day in the freud-Schuster building but now people think of freud and Schuster in bathchairs, freuds ear being amputated in a private nursing home, and puss running out of his horn. Schuster in an epileptic fit with artifcial funnybones. When I look at all my minor and major complaints and deseases I feel the disgust which I experience when I come across intimate passages in letters not written to me. Cedric has painted a portrait of me which is absolutely amazing. It is exactly like my face is green it is a marvellous picture. I have painted a portrait and also a picture of a cat after it has been skinned. Do come down here if you can! What about Mrs P's at Haulfrnny in march? John Jameson has been down here for some days and also a man who was a great friend of the strange englishmen who threw fits to whom tibbles was employed in Italy. Here is our Telephone call. Do you realise that if you shaved your nose every day you would soo grow a reasonable beard on it? The firm ought to realise these little things incase of a business drops [...]

out-houses - lots of room for
hens - a hen-house. almost
too much room in fact - I
wondered if we could ever
do with one servant. However
I just see why we need use
many of the rooms at first.
Unfortunately nearly all the
rooms were papered with
rather horrid but quite new
papers. So Mr S. wouldn't
do them again naturally.
The paint too was quite
good, but harmless colours -
mostly white or green - I said
I should probably white or
colour wash many of the
walls & he said he didn't
mind what I did - but of
course he'll only pay for what

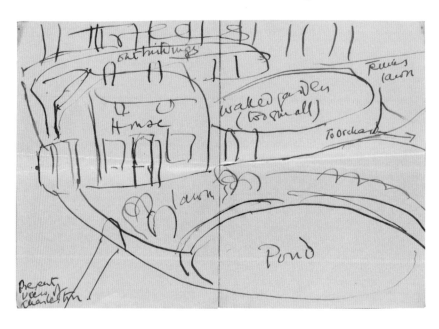

Vanessa Bell (1879–1961) to Duncan Grant
c. September 1916

During the First World War, Bell, Duncan Grant, Roger Fry, Lytton Strachey, John Maynard Keynes and other members of the intellectual-artistic coterie known as the Bloomsbury Group shuttled between London and various country retreats. In 1916 Bell was looking for a place where she and Grant, just returned from a spell in Suffolk with his lover, Edward Garnett, and on the cusp of a long-term relationship with her, could set up home together. Charleston farmhouse in Sussex, first described and illustrated in Bell's enthusiastic letter, became one of Bloomsbury's main centres. Bell's reference to the 'depressing' arrival of her period suggests that she and Grant may already have been hoping to conceive a child. Their daughter, Angelica, was born at Charleston in 1918.

46 Gordon Sq.
Wednesday

My darling Bear,

I seem always to write to you when I'm in the thick of every sort of confusion. I have just returned from Charleston, which I have taken – all but the signing of the lease. I found your letter waiting, thank goodness. It was so nice to hear from you – only I'm disturbed at your sore throat. Mine is better. You'd tell me if you got bad wouldn't you & I'd come back at once and make you possets. Please, my old creature, do this. Anyhow I shall come on Friday.

I must tell you my doings since I last wrote. I dined with Roger [Fry] & had a rather melancholy evening but I won't go into that. I suppose it was my fault, because I was feeling rather exhausted after working here all day at clearings out & the journey the day before & this morning (isn't it depressing, but I didn't expect anything else this time) my monthlies began.

Well, this morning I went off by the 9 o'clock train, the only one that connected well with Glynde. When I got there no sign of Mr Stacey, but presently he drove up in a small motor for 2 & whisked me off to Charleston. I see that I'm the most hopeless person at describing a place – this time to my great surprise I saw something quite different. A large lake, an orchard, trees all round the back of the house & farm buildings [...] The rooms (according to today's impression) are very large & light & numerous. There are huge cupboards, innumerable larders – a dairy – cellars – all sorts of out-houses – lots of room for hens – a hen-house – almost too much room in fact. I wondered if we could ever do with one servant [...]

Unfortunately nearly all the rooms were papered with rather lurid but quite new papers. So Mr S. wouldn't do them again naturally. The paint too was quite good, but harmless colours – mostly white or green. I said I should probably white or colour wash many of the walls [...] I think the house could be made quite lovely [...] Lytton dines here tonight, also Maynard & probably Sheppard [...]

Your loving
Rodent

Lionardo io ebbi e marzolini cioè dodici caci sono molto begli ne
farò parte agli amici e parte p casa e come altre volte vo scri
tto non mi madate più cosa nessuna se io non ve ne chieggo e ma
ssimo di quelle che vi costano danari // Circa il tuo torre donna come
e necessario io non so che dirti se non che tu non guardi a dota
p che ece più roba che vo mini solo ai aver lo chio a la mobi
lita a la sanita e più alla bota che a altro Circa la belleza
nō sēdo tu pero el più bel giovane di fireze nō te nai da
curar troppo pur che non sia storpiata ne schifa altro non
ma chiade Circa questo // ebbi veri una lettera da messer
giovan francesco che mi domanda se io o cosa nessuna della
marchesa di pescara vorrei che tu gli dicessi che io cerche
ro e rispoderogli sabato che viene bē che io non credo aver
niete p che quando stetti amalato fuor di casa mi fu tolto
di molte cose // Arei caro quado tu sapessi qualche stre
ma miseria di qualche cittadino nobile e massimo di quegli
che anno fā ciute i casa che tu m'avisassi p che gli farrei qual
che bene p l'anima mia

 A dì veti di dicēbre 1550.

 Michelagnolo buonarroti
 Thomas

Michelangelo Buonarroti (1475–1564) to Lionardo di Buonarroto Simoni

20 December 1550

Lionardo di Buonarroto was Michelangelo's nephew and heir to the childless artist's estate. This situation led to serious fallings-out between the two men. In the winter of 1545–6, after Michelangelo was mistakenly reported in Florence to be dying or dead, Lionardo had rushed to Rome to secure his inheritance rights but failed to call on his uncle. His professed affection was nothing but 'Cupboard love!', Michelangelo raged.

Things had calmed down by 1550, when Michelangelo's letters to Lionardo are busy with avuncular advice about property and marriage (Lionardo was now thirty-one). 'Everyone tells me that I ought to present you with a wife,' he writes in August, 'as if I had a thousand of them in my pocket.' Money comes up again in this letter in the form of dowry commitments (the bridegroom's family was expected to provide security for the bride's dowry, in case of the groom's premature death) and Michelangelo's desire to perform good deeds by contributing towards dowries for the daughters of cash-strapped gentry. The Marchesa di Pescara was Michelangelo's beloved friend Vittoria Colonna, who had died in 1547 and whose manuscript poems were among the things Michelangelo believes were stolen while he was ill.

Lionardo – I got the *marzolini*, that is to say, twelve cheeses. They are excellent. I shall give some of them to friends and keep the rest for the household, but as I've written and told you on other occasions – do not send me anything else unless I ask for it, particularly not things that cost you money.

About your taking a wife – which is necessary – I've nothing to say to you, except that you should not be particular as to the dowry, because possessions are of less value than people. All you need have an eye to is birth, good health and, above all, a nice disposition. As regards beauty, not being, after all, the most handsome youth in Florence yourself, you need not bother overmuch, provided she is neither deformed nor ill-favoured. I think that's all on this point.

I had a letter yesterday from Messer Giovan Francesco asking me whether I had anything of the Marchesa di Pescara's. Would you tell him that I'll have a look and will answer him this coming Saturday, although I don't think I have anything; because when I was away ill, many things were stolen from me.

I should be glad if you would let me know if you were to hear of any citizen of noble birth in dire need, particularly someone who has daughters in the family, because I would do them a kindness for the welfare of my soul.

On the 20th day of December 1550.
Michelangelo Buonarroti in Rome

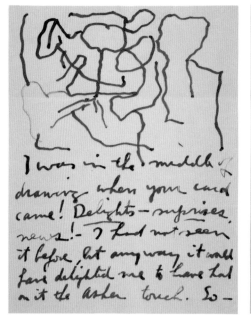

I was in the middle of
drawing when your card
came! Delights — surprises,
news! — I had not seen
it before, but anyway it would
have delighted me to have had
in it the Asher touch. So —

this is to let you know
we are happy, miserable
inspired, dull — lots of
work — bad and good.
It would be so ⚘ to be
together —

But everything just
𝆏𝆏 ? smacks from
us to —
Philip

MUSA

Philip Guston (1913–80) to Elise Asher
17 August 1964

Philip Guston was working on paintings destined for his 1966 exhibition at New York's Jewish Museum when he wrote this note to the poet and artist Elise Asher. Today Guston is mainly associated with his later, figurative works in a deliberately awkward, cartoonish idiom, but in the mid-1960s he was an established abstract expressionist painter. After a retrospective at the Solomon R. Guggenheim Museum in 1962, he started to reduce the amount of colour in his work, eventually using only black and white paint. He explained, 'white pigment is used to erase the black I don't want and becomes grey. Working with these restricted means as I do now, other things open up which are unpredictable, such as atmosphere, light, illusion.'

In Guston's large painting *Prospects* (1964; National Gallery of Australia, Canberra), the interweaving vertical and horizontal brushstrokes create a mesh of varying greys. In its essentials, the balance of open (or maybe solid) shapes and the matrix of intersecting lines is not so far from the drawing with which he heads this note. He may be thanking Asher in kind for a drawing of her own on the card she has just sent him. Married to the poet Stanley Kunitz, she incorporated lines from his poems into her own near-monochrome, abstract paintings in which the brushmarks – as in Guston's work – are conspicuously 'drawn'. After his exhibition at the Jewish Museum, Guston would stop painting and spend two years producing hundreds of drawings – both abstract and representational. He saw this as 'a very significant interlude … before going into the objective work of '68–'70'.

Guston includes his wife, Musa McKim – also an artist – in his sign-off. They had met at Otis Art Institute in the 1930s and collaborated during the Second World War on public mural projects. By the 1960s they were living in Woodstock, New Jersey, from where Guston writes to Asher at her and Kunitz' beachside summer home at Provincetown, on the northern tip of Cape Cod.

..

I was in the middle of drawing when your card came! Delights – surprises, news! I have not seen it before, but any way it would have delighted me to have had on it the Asher touch. So – this is to let you know we are happy, miserable – inspired, dull – lots of work – bad and good. It would be so [drawing of flower] to be together –

Isn't everything just [drawing of happy face]?

xxx
smacks from us too –
Philip
and
Musa

March 5th 95.

2, BOLTON GARDENS,
LONDON, S.W.

My dear Noel,

I am so sorry to hear through your Aunt Rosie that you are ill, you must be like this little mouse, and this is the doctor

Mr Mole, and Nurse Mouse with a tea-cup.

Beatrix Potter (1866–1943) to Noel Moore
8 March 1895

The seven-year-old Noel Moore received this get-well letter from Beatrix Potter while he was ill in bed. Potter knew the kinds of details that would cheer him up – she had herself been a poorly, lonely child, who had found solace in drawing and the natural world. Noel's mother, Annie, had once been her governess. The fantasy she spins for Noel, involving Mr Mole the doctor and Nurse Mouse, adds to a cast of animal characters that had started life in an illustrated letter to him in 1893, featuring Peter Rabbit.

At that time, Potter was a serious amateur mycologist, producing beautifully observed watercolours of fungi (in 1897 she presented a paper to the Linnaean Society of London, 'On the Germination of the Spores of *Agaricineae*'). It was the pictures and stories in her letters to Noel, however, that led to her first illustrated children's book, *The Tale of Peter Rabbit*, which she self-published in 1901 after multiple rejections. A book deal with Frederick Warne & Co. in 1902 led to more than twenty further titles, including stories of Tom Kitten, Jemima Puddleduck, the hedgehog Mrs Tiggy-Winkle and frog Jeremy Fisher, which became world-wide children's classics and earned Potter a fortune. The debonair lady mouse in this letter would reappear in 1917 in one of the last of the series, *Appley Dapply's Nursery Rhymes*.

2, Bolton Gardens,
London, S.W.

My dear Noel,

I am so sorry to hear through your Aunt Rosie that you are ill, you must be like this little mouse, and this is the doctor Mr Mole, and Nurse Mouse with a tea-cup.

I hope the little mouse will soon be able to sit up in a chair by the fire.

I went to the zoo on Wednesday & saw the new giraffe. It is a young one, very pretty, and the keeper says it will grow a good deal taller.

I saw the box that it came in, the keeper says it had quite a stiff neck because the box was not large enough. They brought it by train from Southampton and they could not have a larger box because of getting through the tunnels. I also saw a new monky, called Jenny, it had black hair & a face like a very ugly old woman. A man gave it a pair of gloves which it put on, and it took a bunch of keys & tried to unlock its cage door.

I gave the elephant a lot of buns out of a bag but I did not give any to the ostriches because people are not allowed to feed them, since a naughty boy gave them old gloves & made them ill. I saw a black bear rolling on its back. I did not know that the old wolf was so good tempered.

I remain yrs aff
Beatrix Potter

353 East 56 St. N.Y.C.

Dear Seligman,

Thank you for the address, but I am sorry I did not explain you the situation with the Teeth. The absces is on a tooth which keeps already an appareil and is not very strong. This makes that the operatition in any case has to be done, one time or the other. So it is superfluous to inquire and I caused you trouble for nothing.

But perhaps your dentists address can be uspull to me later.

Very much thanks again and hoping to see you again, with greeting to your both, your

Mondrian

I should have written you direct, but I didn't know your address.

Piet Mondrian (1872–1944) to Kurt Seligmann
early 1940s

In September 1938 Piet Mondrian left the studio in Paris where he had worked for the best part of twenty-six years and moved to London. Anticipating the outbreak of war in Europe, Mondrian always intended to travel on to the United States. News of the invasion of his native Netherlands and France by German forces in summer 1940, followed by the London Blitz in September, left Mondrian unable to paint. By October he was in New York.

He was welcomed by Harry Holtzman, an American abstract artist and former student of Hans Hofmann, who had visited Mondrian in Paris and now set him up with a studio on the corner of 56th Street and 6th Avenue. For Mondrian, the discovery of American jazz, the New York streetscape and new materials like coloured sticky tape sparked a new phase of work. In *Broadway Boogie Woogie* (1942–3; Museum of Modern Art, New York) – almost the last painting he would complete before his death in February 1944 – he replaced his familiar black grid with yellow lines punctuated by squares of bright red and blue.

During the 1930s Mondrian's studio in rue du Départ had been a place of creative pilgrimage for American artists and curators. In New York he was revered as a modern master by members of the American Abstract Artists group and met up with many refugee European artist friends. In March 1942 he exhibited in *Artists in Exile* at the Pierre Matisse Gallery, alongside Marc Chagall, Max Ernst, Fernand Léger and others including Kurt Seligmann (see also page 89). The well-connected Seligmann seems to have offered to introduce Mondrian to his dentist so that he can have a tooth abscess treated – an offer Mondrian courteously declines, explaining that he cannot avoid an operation on the troublesome tooth, which is already held in place by some kind of device (he uses the French term *appareil*).

..

<div align="right">353 East 56 St. N.Y.C.</div>

Dear Seligman,

Thank you for the address, but I am sorry I did not explain you the situation with the tooth. The absess is on a tooth which keeps already an appareil and is not very strong. This makes that the operatition in any case has to be done, one time or the other. So it is superfluous to inquire and I caused you trouble for nothing.

But perhaps your dentist's address can be useful to me later.

Very much thanks again and hoping to see you again, with greetings to your both, yours

Mondrian

I should have written you directly but I did't know your address.

Gustav Klimt (1862–1918) to Josef Lewinsky
19 May 1894

After studying at the Kunstgewerbeschule in Vienna, Gustav Klimt worked in partnership with his brother, Ernst, and another fellow student, Franz von Matsch, on a series of paintings commissioned for public buildings. In 1886 they began work on a cycle of ten frescoes for the grand staircases of the new Vienna Burgtheater. Klimt's four frescoes, based on classical and Shakespearean themes, won him the Golden Cross of Honour, a career-launching Imperial award. Before the Old Burgtheater was demolished, Klimt and Matsch were further commissioned to paint a watercolour of the auditorium, complete with accurate miniature portraits of some 200 audience members, drawn from Viennese high society.

The project about which Klimt is writing to the veteran actor Josef Lewinsky is yet another commission intended to celebrate the Old Burgtheater's legacy. Lewinsky is a perennial star of the Viennese stage, one of the great character actors of his time. Klimt, who has by now had plenty of practice dealing with the sensibilities of eminent people, approaches him with studied deference (the salutation 'Euer Hochwohlgeboren!', literally 'Your High Well-born!', is correct form for addressing nobility). It works.

Klimt's portrait of Lewinsky, completed in 1895, shows the actor as Don Carlos in Goethe's tragedy *Clavigo* (Österreichische Galerie Belvedere, Vienna). Lewinsky had first played the role in 1858, the year of his debut at the Old Burgtheater, and was still reprising it – still to great acclaim – in 1894. Klimt poses Lewinsky in Romantic manner, his face set in an expression of passionate determination. Within a few years Klimt would leave behind the robustly academic style of painting that had brought him such success for a symbolic, patterned, hieratically erotic idiom that perplexed and scandalised well-born Viennese but for which he is now famous.

..

Honoured Sir!

The Society of Reproductive (print) Arts is publishing a large work about the Viennese theatre, and primarily about the Old Burgtheater and I believe that you will, Honoured Sir, through His Excellency Freiherr von Wieser, already be in receipt of a communication about this matter.

I have been given the commission to paint one of the artists of the Old Burgtheater, specifically in a role, which will preferably alter the appearance of the artist concerned very little.

I have taken the liberty of choosing your portrait, Honoured Sir, and beg to ask you kindly to inform me where and when I may have the privilege of talking with your distinguished self.

Awaiting your early reply, I am signing faithfully
Honoured Sir
always yours
Gustav Klimt

VIII. Josefstätterstrasse 21

I January 1970

Dear Rosamund:

I thought to begin the new year properly by writing
to you, even though I can't find your last letters.
I just returned last night from IO days in St. Martens,
a much needed and, I thought, deserved vacation in the
sunshine. The island was beautiful and has about eight
beaches, each with a character that differs from the
others.

One no sooner sets foot on New York than one feels the
muscles and nerves tighten up and start to jerk. It is
almost as though one hasn't been away at all. Maybe it
is good that that is the way it is. I have to dye
costumes and shrink sweaters for Merce C. who opens his
season on the 5th and finish a couple of drawings and see
that everything is framed and hung for my show at Leo's
on the IOth. I hope that it will all get done and I
think it will. It often does.

Thank you for offering to send more of the Baby's Tears
but don't do it just now. There are two cats here now
who insist upon sitting in the flower pots in spite of
my efforts to keep them out. And I think there isn't
enough sunshine to help the plants recover from this
sort of treatment. A bit of the first batch is still
holding on.

The news about your job at the museum is great. I hope
you are enjoying it and that you like being an expert.

I wish us all a happy new year.

Love,

Jasper Johns (b.1930) to Rosamund Felsen
1 January 1970

Jasper Johns writes to the young curator and future gallerist Rosamund Felsen on return to New York from a winter-sun break on the Caribbean island of St Martin. He is preparing for an exhibition of drawings at Leo Castelli's gallery, due to open on 10 January. It is fifteen years since Johns made the first of the series of American-flag paintings for which he became famous. Along with his series of targets and alphabets, and sculptures cast from commercial objects like beer cans, they were early versions of the fusion of fine art and American mass culture that soon became the wider phenomenon of Pop. Johns continued to revisit these graphic motifs. 'I like to repeat an image in another medium,' he said, 'to observe the play between the two: the image and the medium.'

Johns mentions the costumes he has designed for a new dance production, *Second Hand*, by the choreographer Merce Cunningham, with music by John Cage. Johns' idea is to have each of the ten dancers wearing a single colour. There will be no other décor, so the visual effect will be created by the interaction of colour as the dancers move. *Second Hand*'s première is at Brooklyn Academy of Music in exactly one week's time, and he still has to dye the costumes. 'I hope it will all get done,' he tells Felsen. 'It often does.' He politely declines her offer of posting baby's tear plants (*Soleirolia soleirolii*) from Los Angeles for his apartment.

...

Dear Rosamund:

I thought to begin the new year properly by writing to you, even though I can't find your last letters. I just returned last night from 10 days in St. Martens, a much needed and, I thought, deserved vacation in the sunshine. The island was beautiful and has about eight beaches, each with a character that differs from the others.

One no sooner sets foot on New York than one feels the muscles and nerves tighten up and start to jerk. It is almost as though one hasn't been away at all. Maybe it is good that this is the way it is. I have to dye costumes and shrink sweaters for Merce C. who opens his season on the 5th and finish a couple of drawings and see that everything is framed and hung for my show at Leo's on the 10th. I hope that it will all get done and I think it will. It often does.

Thank you for offering to send more of the Baby's Tears but don't do it just now. There are two cats here now who insist upon sitting in the flower pots in spite of my efforts to keep them out. And I think there isn't enough sunshine to help the plants recover from this sort of treatment. A bit of the first batch is still holding on.

The news about your job at the museum is great. I hope you are enjoying it and that you like being an expert.

I wish us all a happy new year.

Love,

Jasper

I can draw much better now
this is a bird

it is a owl it was the favorit
berd of Menenvia
i can draw your dea mama
croming the sea

the captin

i can draw lots of things now
but not quit as well as Phil
he had lenons at a regular
school. how is draw
lein will you give her my
kind regards, this is me
painting a pickture

it is a lanskip and
is spoken very well of

Edward Burne-Jones (1833–98) to Daphne Gaskell
c.1897–8

The Pre-Raphaelite painter Edward Burne-Jones was an eminent artist in his sixties
when he wrote this letter to Daphne Gaskell, daughter of his close friend Helen Mary
(May) Gaskell, an unhappily married society hostess. After Burne-Jones and May first
met in 1892, they kept up an intimate, copious correspondence, exchanging letters up to
five times a day, though their passion apparently remained platonic. He also wrote
regularly to Daphne, adopting a childlike persona, spelling and drawing style.

Daphne was about five when Burne-Jones appeared on the scene and eleven at the
time of his death in 1898. Some of his undated letters to her evoke a nursery world in
which 'there is nobody to kerrect my spellink because they have gon out … we had rowly
Powly for dinner and chess cakes'. With its references to a German governess ('frau
lein'), the London social season, which ran from Christmas to early summer (Burne-
Jones mentions gingham 'umberellas' or parasols), and changing fashions, this letter
seems to be addressed to an older girl. There are signs, too, that the game of writing
childishly to a child is becoming less appropriate as Daphne grows up, or that Burne-
Jones is weary. He slips into correct spelling more often than he once did ('quit' becomes
'quite') and fails to have fun with 'fashion' and 'gingham'. Yet he signs off with his usual
friendly mangling of 'affectionate'.

Chewsday

My der dafny

i called to see you to play with you, but you had not come back, write & tell me the minit you
come back [...]
 I have had drawing lessons while you have been away
 I can draw much better now this is a berd
 it is a owl it was the favrit berd or Menervia
 i can draw your der mama crossing the sea
 the captain
 i can draw lots of things now but not quit as well as Phil he had lessons at a regular school.
how is frau lein will you give her my kind regards, this is me painting a pickture
 It is a landskip and is spoken very well of
 in the papers.
 i wanted your papa to buy it but he says not if he knows it.
 i am quite well, Angela is quite well the seson is nealy over and lilac trimmings are come into
fashion and alpacca cloaks and galoshes and gingham umberellas but corderoys have quite
gone out though i wear them still because i haven't worn them out

i am your very effectnitate friend

edward burne-jones

Dear Sir

I begin with the latter end of your letter & grieve more for Miss Pooles ill health than for my failure in sending proofs tho I am very sorry that I cannot send before Saturdays Coach. Engraving is Eternal work. the two Plates are almost finished. You will receive proofs of them for Lady Hesketh.. whose copy of Cowpers letters ought to be printed in Letters of Gold & ornamented with Jewels of Heaven Havilah Eden & all the countries where Jewels abound I curse & bless Engraving alternately because it takes so much time & is so intractable. tho capable of such beauty & perfection

My Wife desires with me to Express her Love to you Prayers for Miss Polly. perfect recovery & we both remain

March 12 Your Affectionate
 1804 Will Blake

William Blake (1757–1827) to William Hayley
12 March 1804

In September 1800 the poet and biographer William Hayley persuaded William Blake to move out of London into a cottage at Felpham in Sussex, near his own newly constructed 'hermitage'. Now known as a visionary poet and artist, Blake was by trade an engraver, whom Hayley commissioned to produce the illustrations for his projected biography of the poet William Cowper. Cowper, who had recently died, was one of several talented friends that Hayley – a man of substantial means as well as the author of odes, epitaphs and unsuccessful plays – enjoyed nurturing. The individualistic Blake found Hayley's controlling habits hard to take, but he stayed three years at Felpham.

Writing in March 1804, after his return to London, Blake admits that the engravings are unfinished. The missed deadline isn't entirely his fault, he suggests, since 'Engraving is Eternal work.' His prints were duly published that year in the *Life of Cowper*, a hugely successful project that eventually earned Hayley £11,000 (about £485,000 today). Blake had noted that Lady Harriett Hesketh, a relative of Cowper's, was hard to please, since she 'almost adored her Cousin the poet & thought him all perfection'. Lady Hesketh privately complained that Blake's head of Cowper, engraved from a portrait by George Romney (another of Hayley's creative friends), resembled 'some unhappy man, who, with eyes starting from his head, was escaping from his keepers!'

Dear Sir,

I begin with the latter end of your letter & grieve more for Miss Poole's ill-health than for my failure in sending proofs, tho' I am very sorry that I cannot send before Saturday's Coach. Engraving is Eternal work; the two plates are almost finish'd. You will receive proofs of them for Lady Hesketh, whose copy of Cowper's letters ought to be printed in letters of Gold & ornamented with Jewels of Heaven, Havilah, Eden & all the countries where Jewels abound. I curse & bless Engraving alternately, because it takes so much time & is so untractable, tho' capable of such beauty & perfection.

My wife desires me to Express her Love to you, Praying for Miss Poole's perfect recovery, & we both remain,

Your Affectionate,
Will Blake
March 12
1804

June 6/36

CALDER
PAINTER HILL ROAD
R. F. D. ROXBURY,
CONN., U.S.A.

TEL. & TEL. WOODBURY 122-2

Dear Agnes
From
your list of colours
you must be a
parcheesi hound.
But its purple, not blue

I too, am very fond
of the parcheesi

2/ colour scheme
i.e. the size, +
(area)
intensity of each
colour (I guess you got it)
Please do send
the things back to
New York +
You can have the
one from Hartford
for 100 —
But if you make
me work in pastel
shades its 125 —
(I hope this wont
create a dilemma)
And your credit
can be quite long
drawn out and gentle

3/ I'm too much of
a truck driver already
to come over
— you must excuse
me! — But there
seems to be so much
time spent concentrat^g
on keeping out of
the gutter that at
times I hate the car.

If you go to
Middletown via Hartford
you certainly circum—
navigate us with
a vengeance!
Next time
go thru New milford
and follow my map

4

CONN., U.S.A.
TEL. & TEL. WOODBURY 122-2

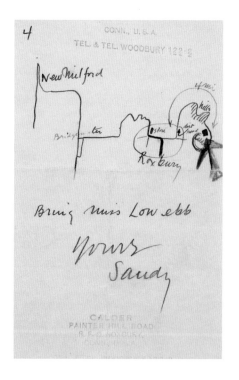

Bring miss Low ebb

Yours
Sandy

CALDER
PAINTER HILL ROAD
R. F. D. ROXBURY,
CONN.

Alexander Calder (1898–1976) to Agnes Rindge Claflin
6 June 1936

After his first trip to Europe in 1926, Alexander Calder moved regularly between France and the United States. Performances of his *Cirque Calder*, a collection of miniature circus acts fashioned from bent wire and oddments of textiles, rubber, cork and other materials, made him something of a celebrity in the Parisian avant-garde between the wars. A visit to Piet Mondrian's studio in October 1930 led Calder to experiment with abstract paintings, then with mechanised abstract sculptures, for which Marcel Duchamp suggested the term 'mobiles'.

In July 1933 Calder and his wife, Louisa, left Paris for New York. They bought a run-down colonial-era farmhouse in Roxbury, Connecticut, where Calder set up his studio. A steady stream of guests passed through the Roxbury farmhouse, including Agnes Rindge Claflin, a young art history professor from Vassar College in Poughkeepsie. Their friendship seems to have dated from her interest, in summer 1936, in commissioning a mobile or stabile (a standing rather than hanging mobile). Calder relates her preferred colour scheme to the game parcheesi, played on a board composed of coloured rectangles and subdivided circles. In 1944, when Claflin complained to Calder that she had 'nothing to wear' to a party, he made her a 'Fire Proof Veil' – a modernist tiara of metal letters dangling from curved wires (Calder Foundation, New York).

. .

<div align="right">

Calder
Painter Hill Road
R.F.D. Roxbury,
Conn., U.S.A.
Tel. & Tel. Woodbury 122-2

</div>

Dear Agnes

From your list of colours you must be a parcheesi hound. But its purple, not blue
 I too, am very fond of the parche(e)si colour scheme i.e. the size (area) & intensity of each colour (I guess you get it!)
 [Please do send the things back to New York
 You can have the one from Hartford for 100 –
 But if you make me work in pastel shades its 125 –
 (I hope this wont create a dilemma)
 And your credit can be quite long drawn out and gentle
 Im too much of a truck driver already to come over – you *must* excuse me. – But there seems to be so much time spent concentrating on keeping out of the gutter that at times I hate the car.
 If you go to Middletown via Hartford you certainly circumnavigate us with a vengeance!
 Next time go thru New Milford and follow my map
 Bring Miss Low ebb

Yours
Sandy

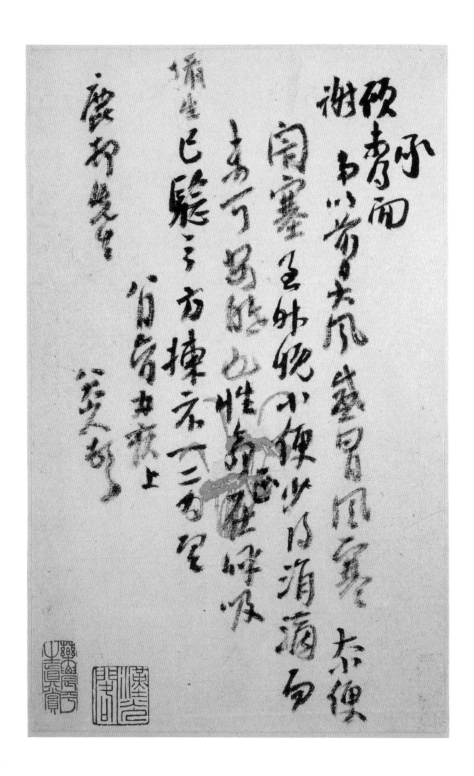

Zhu Da (also known as Bada Shanren)
(1626–1705) to Fang Shiguan
c.1688–1705

Zhu Da was born into the House of Zhu, the imperial family of the Chinese Ming dynasty. In 1644, at the age of eighteen, he was forced to flee his native Nanchang when, after years of conflict, Manchurian forces took Beijing and overthrew the Ming dynasty. Zhu Da became a Buddhist priest, a poet and a painter. In 1680, frustrated by his failure to gain any kind of official position because of his connections to the previous regime, he reportedly suffered a breakdown, tearing off and burning his Buddhist robes. After this, 'crazy monk' Zhu Da became a travelling artist, famed for his expressive, calligraphic manner of painting birds, animals and landscapes. As his circumstances and feelings changed, he adopted different names. Between 1681 and 1684 he signed his paintings and calligraphies Bada Shanren, which translates as 'Mountain man of eight greatnesses', the name he uses on this letter to his close friend Fang Shiguan.

Fang preserved numerous letters written by Zhu Da in his sixties and seventies, when landscape became the main focus of his work. He used spare, dry brushwork, like a kind of notation, as if trying to create entire landscapes – trees, headlands, open sky, ships at sea – with the most minimal, unforced means. The letters of artists and calligraphers such as Zhu Da were highly valued. However prosaic their content (in this letter Zhu Da complains of constipation and urinary retention), they were seen as a particularly natural, personal medium of artistic expression.

..

I haven't been able to thank you in person for your kindness. I caught a cold from the strong wind the other day, and could not urinate or defecate. By last night I only managed to excrete a few drops and could not sleep well. I am barely hanging on to life. Could you get me a few prescriptions whose efficacy has been proved? To Mr Lucun. Bada Shanren bows in multiple illnesses on the sixth of the eighth lunar month.

qui est plus sûr que Renò. qu'il
pensait qu'il n'était pas néces=
=saire de quitter l'angleterre
qu'à Bornemouth ou l'Ile
de White ce serait-Très bien,
Ce n'est en somme qu'une
opinion, ces gas ont-cru que
l'on voulait-les empêcher
d'aller en Espagne. Cela m'est
égal l'Espagne. Si cela convient,
En somme le vrai mal est
enrayé et-tu as dû voir par
la lettre de S. Simon qu'il
n'en paraissait-pas inquiet,
Je n'ai pas assez d'argent
pour payer 80 £ à S. Simon
ce sera à mon retour.
Tu as dû recevoir 500 de
Durand.
Le Dr de Londres dit-que
dans une quinzaine les gas
pourront partir, car tu sais
qu'il ne faut-pas prendre froid
quand on est sous l'influence
de Merc. Sol ou Bella.

Voilà la lettre Lucien.
je vous embrasse tous
ton mari aff.
C. Pissarro

Peux tu m'envoyer mon shall
ou couverture. pour partir
il commence à faire froid.

Camille Pissarro (1830–1903) to Julie Pissarro
25 October 1896

Camille Pissarro was a young French-Jewish painter, born on the Caribbean island of St Thomas, and Julie Vellay a vine-grower's daughter from Burgundy, employed as a cook by Pissarro's parents, when the two met in 1860. Pissarro, who had until now been largely self-taught, was studying at the Académie Suisse in Paris, with Claude Monet and Paul Cézanne, and had just started to show at the Salon. Over the next twenty-four years, Julie and Camille would have eight children. They eventually married in 1871, while in temporary exile in London during the Franco-Prussian War. Writing to Julie in 1896 from the Hôtel d'Angleterre in Rouen, Pissarro discusses the health of their son Georges, the seaside cure he is seeking in England, and a letter from his doctor. He also encloses a letter from another grown-up son, Lucien. Mentored by his father, Lucien too had become an artist and had moved permanently to England in 1890.

Sometimes called the 'father of Impressionism', Pissarro was the only painter to show in all eight Impressionist exhibitions between 1874 and 1886. In the mid-1880s, after meeting Paul Signac (see page 57) and Georges Seurat, he adopted the pointillist method of painting with tiny dots of unmixed colour. By 1896 he had returned to the broader brushstrokes and atmospheric colouring of Impressionism, as in *Morning: An Overcast Day, Rouen*, a view of Boieldieu Bridge painted from the window of his room in the Hôtel d'Angleterre.

Pissarro grumbles to Julie that a bad cold is preventing him from working and that he's run short of cash. He assumes that she will have received payment from his dealers, the Durand-Ruels. He sounds knowledgeable about homeopathic medicine. Georges is apparently taking Mercurius solubilis and Belladonna (deadly nightshade), typically prescribed for ear infections and sore throats.

[The doctor] thought that it wasn't necessary to leave England, since it would be fine at Bournemouth or the Isle of Wight. In the end, it's only an opinion, these lads thought that they could be stopped from going to Spain. It's all the same to me Spain if that's what's best. In short, the real health problem has been addressed and you must have realised from L. Simon's letter that he didn't seem concerned.

I don't have enough money to pay L. Simon 80 francs that will have to wait until I get back. You should have received 900 from Durand.

The doctor from London says that the lads can leave in a fortnight, as you know that one mustn't catch cold when one is under the influence of Merc. sol. or Bella.

Here is Lucien's letter.

my love to all of you
your aff[ectionate] husband
C. Pissarro
Could you send shawl[?] or blanket. for going away it's started to get cold.

15 Janvier environ.

mon cher Suzanne

Merci beaucoup pour t'occuper de toutes mes affaires - mais pourquoi n'aurais tu pas pris cette mon atelier pour habiter. J'y pense juste maintenant Mais je pense que peut être ça ne t'irait pas.

En tout cas, le bail finit 15 Juillet et si tu reprenais, ne le fais qu'en proposant à mon proprio. de louer 3 mois par 3 mois, comme cela se passe ordinairement; il acceptera sûrement. Peut être père ne serait pas mécontent de regagner ta terre si c'est possible que tu quittes La Condamine pour 15 avril. —— But I don't know anything about your intentions and je ne veux que te suggérer quelquechose. ——— chez moi.

Maintenant si tu es montée tu as vu dans l'atelier une roue de bicyclette et un porte bouteilles. - J'avais acheté cela comme une sculpture toute faite. Et j'ai une intention à propos de cedit porte bouteille: Ecoute.

Ici, à N.Y., j'ai acheté des objets dans le même goût et je les traite comme des "readymade", tu sais assez d'anglais pour comprendre le sens de "tout fait" que je donne à ces objets — Je les signe et je leur donne une inscription en anglais. Je te donne qques exemples:

J'ai par exemple une grande pelle à neige sur laquelle j'ai inscrit en bas: In advance of the broken arm. traduction française: En avance du bras cassé — Ne t'exprime pas trop à comprendre dans le sens romantique ou impressionniste ou cubiste — Cela n'a aucun rapport avec;

une autre "readymade" s'appelle: Emergency in favor of twice. traduction française possible: Danger (crise) en faveur de 2 fois.

Tout ce préambule pour te dire:

Prends pour toi ce porte bouteilles. J'en fais un "Readymade" à distance. Tu inscriras en bas et à l'intérieur du cercle du bas en petites lettres peintes avec un pinceau à l'huile en couleur blanc d'argent, la phrase inscription que je vais te donner ci-après. et tu signeras de la même écriture comme suit:

[d'après] marcel Duchamp.

Marcel Duchamp (1887–1968) to Suzanne Duchamp
mid-January 1916

Of the six Duchamp children (four of whom became artists), Marcel was closest to his younger sister Suzanne, who would often ask his advice on her paintings. After the First World War broke out, Duchamp, rejected for army service, sailed for New York, where he'd already had some success with his work. Suzanne remained in Paris, serving as a nurse. Duchamp writes to Suzanne as to a fellow artist who will at least try to understand the strange conceptual turn his work has taken. He has decided to designate ordinary objects, like a bicycle wheel, bottle rack and snow shovel, as sculptures. They are, he says, 'toute faite', a phrase he translates into English as 'readymade' – the first use of a term that will resonate through twentieth-century art practice and critical theory. Duchamp thanks Suzanne for keeping an eye on his old studio in Paris and proposes that she could collaborate with him in making a '"Readymade" from a distance' by signing the bottle rack according to his instructions. Duchamp will not discover until years later that Suzanne has already thrown the bottle rack out with the rubbish.

..

My dear Suzanne,

Thanks a lot for taking care of all my stuff – but why couldn't you have taken my studio to live in? It occurred to me just now, but I suppose that probably won't do for you. In any case the lease expires on July 15th and if you were to take it, do so only if you offer my landlord to rent it three months at a time as it's usually done; he will surely agree. Father probably wouldn't mind recovering a month's rent if it's possible for you to leave [rue] la Condamine by April 15th. – But I don't know anything about your intentions and I just wanted to suggest something to you –

Now, if you went up to my place you saw in my studio a bicycle wheel and a *bottle rack*. I had purchased this as a sculpture already made. And I have an idea concerning this said bottle rack: Listen.

Here, in N.Y., I bought some objects in the same vein and I treat them as 'readymade'. You know English well enough to understand the sense of 'readymade' that I give these objects. I sign them and give them an English inscription. I'll give you some examples:

I have for example a large snow shovel upon which I wrote at the bottom: *In advance of the broken arm*, translation into French: *En avance du bras cassé*. Don't try too hard to understand it in the Romantic or Impressionist or Cubist sense – that does not have any connection with it.

Another 'readymade' is called: *Emergency in favour of twice*, possible translation in French: *Danger (Crise) en faveur de 2 fois*. This whole preamble in order to actually say:

You take yourself this bottle rack. I will make it a 'Readymade' from a distance. You will have to write at the base and on the inside of the bottom ring in small letters painted with an oil-painting brush, in silver white colour, the inscription that I will give you after this, and you will sign it in the same hand as follows:

[after] Marcel Duchamp

Letter to D.
about 9ᶜ 1944
C. P. late aft.

Dear
Joseph:

Sometimes
I think that the only true
and satisfactory means of contact with those
we love is by writing rather than talking.
So it seems to me that our letters are far
more the real barometer of our feelings
than when we speak for a few over-
charged moments in New York. Certainly
you will agree that the atmosphere there,
in most cases, is electric and artificial.
And yet, warring and
struggling as I am nearly all of my
waking moments, with the problems of au-
thenticity and value, it is not always
that I am fit to write a letter of any
kind. I want the letters I write to you
to have a real clarity which I feel I
am ill-equipped to give them. My dreams,

Dorothea Tanning (1910–2012) to Joseph Cornell
3 March 1948

Dorothea Tanning met Joseph Cornell (see also pages 87 and 97) at the Julien Levy Gallery, New York, around the time of her first solo exhibition there in 1944. Cornell had been showing his collages, then his distinctive wooden box assemblages at the gallery since the landmark *Surrealism* exhibition of 1932. 'Gaunt, pearl-pale, and surprised, he usually sat just a little apart,' Tanning recalled. Cornell enjoyed the dream imagery in Tanning's work, about which he told her 'chaste, cobwebby things'. After Tanning married Max Ernst in 1946 and moved to Arizona, she and Cornell corresponded regularly. Her reported dream of a silk-clad prince, hawk and room 'where anything could happen' echoes her 1942 self-portrait *Birthday* (Museum of Art, Philadelphia).

Dear Joseph:

Sometimes
I think that the only true and satisfactory means of contact with those we love is by writing rather than talking. So it seems to me that our letters are far more the real barometer of our feelings than when we speak for a few overcharged moments in New York. Certainly you will agree that the atmosphere there, in most cases, is electric and artificial.

And yet, wavering and struggling as I am nearly all of my waking moments, with the problems of authenticity and value, it is not always that I am fit to write a letter of any kind. I want the letters I write to you to have a real clarity which I feel I am ill-equipped to give them. My dreams, my illusory impressions and my waking life are all so mixed and confusing that I sometimes wonder if there is any reality at all. One can be so easily depressed and then again, so easily exalted. And where is the measure? It may sound foolish but it is my belief that there is only poetry and revulsion. I'd like to let the poetry in and keep the revulsion out. That is something that you, of all the people I know, have somehow managed to do [...]

Last night I dreamed of the little prince that I saw in a movie when I was a child. He was about twelve years old, wore a doublet and long silk stockings and little satin slippers [...] I dreamed that he had a pet hawk. The hawk was occupying a large dark room where anything could happen and when the little prince emerged carrying him the hawk spoke. He simply said: 'They defy you' ... and then somehow *I* was the prince, I carried the hawk on *my* shoulder and he whispered into my ear, rather unintelligibly, I'm afraid, for I don't remember what he said. Dreams almost always stop this way, just at the magic moment.

Thank you *so* much for the photo of the doll that you know I love deeply. Thank you for all the lovely birds in the snow. Let me hear from you soon again, do please, Joseph.

Max sends his warmest wishes.
Love
Dorothea.

Capricorn Hill
Sedona, Arizona

Chapter 2

'Like a sleepwalker'

nly offer to supply 3 guards t
been able to regain my stren
all team off to the big match
evelopment. The show is not c
terrific for deaf people. I see
ying to say that, particularly in
time since I last wrote, it's sin
Paris for **Artist to Artist** a day
on the days when the Mistra
it could well happen that th
ith the problems of form in a
teful for I'm exceedingly than
er patients at this thermal sp
estival in honour of the musici
the honour of agreeing to b
who are systematically ripped
because it's expensive takin
especially now that I realize

Mon cher Vincent

Nous avons accompli votre désir, d'une autre façon il est vrai mais qu'importe puisque le résultat est le même. Nos 2 portraits. n'ayant pas de blanc d'argent j'ai employé de la céruse et il pourrait bien se faire que la couleur descende et s'alourdisse. Du reste ce n'est pas fait au point de vue de la couleur exclusivement. Je me sens le besoin d'expliquer ce que j'ai voulu faire non pas que vous ne soyez apte à le deviner tout seul mais parceque je ne crois pas y être parvenu dans mon oeuvre. Le masque de bandit mal vêtu et puissant comme Jean Valjean qui a sa noblesse et sa douceur intérieure. Le sang en rut inonde le visage et les tons de forge en feu qui enveloppent les yeux

indiquent la lave de feu qui embrase notre âme de peintre. Le dessin des yeux et du nez semblables aux fleurs dans les tapis persans résume un art abstrait et symbolique. Ce petit fond de jeune fille avec ses fleurs enfantines est là pour attester notre virginité artistique. Et ce Jean Valjean que la société opprime mis hors la loi, avec son amour sa force, ne m'est-il pas l'image aussi d'un impressioniste aujourd'hui Et en le faisant sous mes traits vous avez mon image personnelle ainsi que notre portrait à tous pauvres victimes de la société nous en vengeant en faisant le bien. Ah! mon cher Vincent vous auriez de quoi vous divertir

à voir tous ces peintres d'ici confits dans leur médiocrité comme les cornichons dans le vinaigre. Et ils ont beau être gros longs ou tordus à verrues c'est toujours et ce sera toujours des cornichons. Eugène, viens voir! Eugène c'est Habert, Habert c'est celui qui a tué Dupuis vous savez ... Et sa jolie femme et sa vieille mère tout le bordel, quoi! Et Eugène peint, écrit dans les journaux, voyage gratis en Première Monsieur. Il y a de quoi rire ici à en pleurer. En dehors de son art quelle sale existence et est-ce vraiment la peine que Jésus soit mort pour tous ces sales peintres. En tant qu'artiste oui

en tant que réformateur je ne crois pas. Le copain Bernard travaille et tire des plans pour vous aussi à Arles. Laval que vous ne connaissez pas mais qui vous connaît par vos lettres et nos racontars se joint à nous pour vous serrer la main

à vous

Paul Gauguin

Soleil ardent qui passe ... arrête ta course scabreux ... je veux sans ... peindre ta face chrome doux! —

Paul Gauguin (1848–1903) to Vincent van Gogh
1 October 1888

Like Van Gogh, Paul Gauguin was a late starter as an artist. After serving in the French navy and a spell as a stockbroker, he began exhibiting in the mid-1870s and by 1879 was showing with the Impressionists. His work caught the eye of Van Gogh's art dealer brother, Theo, who in June 1888 offered Gauguin an allowance in exchange for one painting a month. Another condition was that he should accept Vincent's invitation to join him in Arles in the south of France, where he could keep an eye on the increasingly unstable Van Gogh. Gauguin, however, was involved in the art colony of Pont-Aven, at the opposite end of the country. 'I love Brittany,' he wrote. 'When my clogs resonate on this granite ground I hear the muffled and powerful thud that I'm looking for in painting.' He and the young artist Émile Bernard sent portraits of each other to Van Gogh (Van Gogh Museum, Amsterdam). Gauguin subtitled his 'les misérables', after Victor Hugo's novel featuring the hero-thief Jean Valjean. We artists are like Valjean, says Gauguin, knowing how this will appeal to Van Gogh, 'victims of society, taking our revenge on it by doing good'. In the Yellow House in Arles, Van Gogh was soon preparing – excitedly and a bit anxiously – for Gauguin's arrival three weeks later (see page 53).

My dear Vincent

We've satisfied your desire; in a different way, it's true, but what does it matter, since the result is the same? Our 2 portraits. Having no silver white, I used lead white, and it could well happen that the colour becomes darker and heavier. And besides, it's not done exclusively from the point of view of colour. I feel the need to explain what I was trying to do, not that you're not capable of guessing by yourself, but because I don't believe that I've achieved it in my work. The mask of a thief, badly dressed and powerful like Jean Valjean, who has his nobility and inner gentleness. The rutting blood floods the face, and the tones of a fiery smithy, which surround the eyes, suggest the red-hot lava that sets our painters' souls ablaze. The drawing of the eyes and the nose, like the flowers in Persian carpets, epitomizes an abstract and symbolic art. That girlish little background, with its childish flowers, is there to testify to our artistic virginity. And that Jean Valjean, whom society oppresses, outlawed; with his love, his strength, isn't he too the image of an Impressionist today? By doing him with my features, you have my individual image, as well as a portrait of us all, poor victims of society, taking our revenge on it by doing good — ah! my dear Vincent, you would have plenty to amuse you, seeing all these painters here, pickled in their mediocrity like gherkins in vinegar. Makes no difference whether they're fat, long or twisted and warty, they're still, and will always be, nitwit gherkins [...]

Yours,
Paul Gauguin

[...]

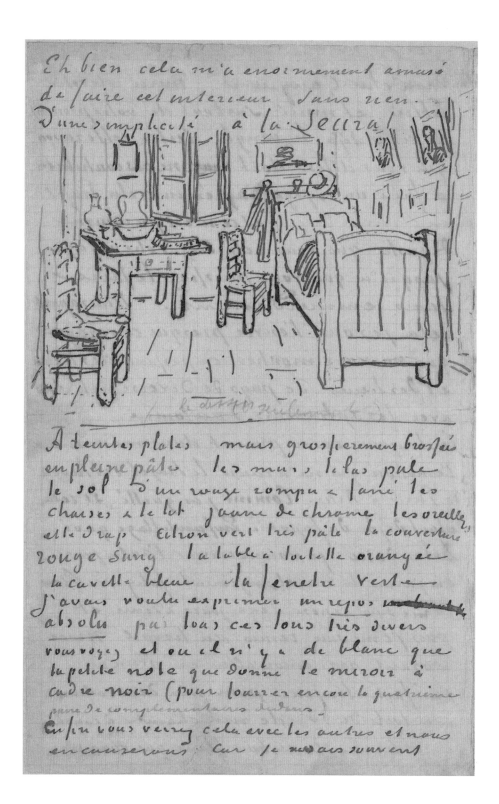

Eh bien cela m'a énormément amusé
de faire cet intérieur sans rien.
D'une simplicité à la Seurat.

À teintes plates mais grossièrement brossés
en pleine pâte les murs lilas pâle
le sol d'un rouge rompu et fané les
chaises et le lit jaune de chrome les oreilles
et le drap citron vert très pâle la couverture
rouge sang la table à toilette orangée
la cuvette bleue la fenêtre verte
j'avais voulu exprimer un repos
absolu par tous ces tons très divers
vous voyez et où il n'y a de blanc que
la petite note que donne le miroir à
cadre noir (pour fourrer encore la quatrième
paire de complémentaires dedans)
Enfin vous verrez cela avec les autres et nous
en causerons car je ne sais souvent

Vincent van Gogh (1853–90) to Paul Gauguin
17 October 1888

Enthralled by the Japanese woodblock prints he'd seen in Paris but unable to afford the fare to Japan, Van Gogh set off for the south of France in February 1888, hoping to find a Japanese-style landscape closer to home. He rented the 'Yellow House' in Arles and encouraged Paul Gauguin (see page 51) to join him. Van Gogh believed that a painter could orchestrate colour to evoke very specific emotions – in the case of *The Bedroom* (Van Gogh Museum, Amsterdam), a feeling of 'utter repose'. When Gauguin did arrive, however, life in the Yellow House was anything but peaceful. After an optimistic start, relations between the two artists broke down. One particularly bitter dispute resulted in the mutilation of Van Gogh's ear.

My dear Gauguin,

Thanks for your letter, and thanks most of all for your promise to come as early as the twentieth. Agreed, this reason that you give won't help to make a pleasure trip of the train journey, and it's only right that you should put off your journey until you can do it without it being a bloody nuisance. But that apart, I almost envy you this trip, which will show you, in passing, miles and miles of countryside of different kinds with autumn splendours.

I still have in my memory the feelings that the journey from Paris to Arles gave me this past winter. How I watched out to see 'if it was like Japan yet'! Childish, isn't it? Look here, I wrote to you the other day that my vision was strangely tired. Well, I rested for two and a half days, and then I got back to work. But not yet daring to go outside, I did, for my decoration once again, a no. 30 canvas of my bedroom with the whitewood furniture that you know. Ah, well, it amused me enormously doing this bare interior. With a simplicity à la Seurat. In flat tints, but coarsely brushed in full impasto, the walls pale lilac, the floor in a broken and faded red, the chairs and the bed chrome yellow, the pillows and the sheet very pale lemon green, the bedspread blood red, the dressing table orange, the washbasin blue, the window green. I had wished to express utter repose with all these very different tones, you see, among which the only white is the little note given by the mirror with a black frame (to cram in the fourth pair of complementaries as well).

Anyway, you'll see it with the others, and we'll talk about it. Because I often don't know what I'm doing, working almost like a sleepwalker.

It's beginning to get cold, especially on the days when the mistral blows.

I've had gas put in the studio, so that we'll have good light in winter.

Perhaps you'll be disillusioned with Arles if you come at a time when the mistral's blowing, but wait . . . It's in the long term that the poetry down here soaks in.

You won't find the house as comfortable yet as we'll gradually try to make it. There are so many expenses, and it can't be done in one go. Anyway, I believe that once here, like me, you'll be seized with a fury to paint the autumn effects, in between spells of the mistral. And that you will understand that I've insisted that you come now that there are some very beautiful days. Au revoir, then.

Ever yours,
Vincent

Sebastiano del Piombo (1485–1547) to Michelangelo Buonarroti
29 December 1519

In the early sixteenth century, many leading Italian artists and architects were headhunted to work on prestige projects in Rome, including both Michelangelo and the Venetian painter Sebastiano Luciani (known as 'del Piombo' after his later appointment as Keeper of the Papal Seals). The two artists became *compare* (mates) and collaborators – an unusually close creative relationship for the notoriously difficult Michelangelo. In 1516 Cardinal Giulio de' Medici commissioned Sebastiano to paint the *Raising of Lazarus* (National Gallery, London), on the understanding that Michelangelo would first draw the figures. This was effectively a talent contest, pitting the two artists against Raphael, whose *Transfiguration* (Vatican Museums, Rome) Giulio had also commissioned.

By the time the painting was finished, Michelangelo was back in Florence. Knowing that his *compare* may be overwhelmed by his workload, Sebastiano tries to impress on him how urgently he needs to be paid, for which the cardinal requires Michelangelo's sign-off.

..

My dearest *compare*, it is many days since I received your most welcome letter, and I am extremely grateful that you did me the honour of agreeing to be my son's godfather. As for those women's rituals, they are not the custom in our house; it is enough for me that you are my *compare*. I'll send you the [baptismal] water with the next letter.

I had the baby baptised some days ago and called him Luciano, which is my father's name. [...]

Apart from this, I am writing to let you know that I have finished the painting and delivered it to the Palace. Everyone seemed to like it rather than dislike it, apart from the curial officials who don't know what to say. It is enough for me that the most reverend Monsignor [Cardinal Giulio de' Medici] told me that I had given him more satisfaction than he was expecting. I believe my painting is better designed than those tapestries that have arrived from Flanders.

Now, since for my part I did what I owed, I tried to sort out my final payment. The most reverend Monsignor told me that he wants you to assess the work, as long as messer Domenico agrees to this. So as to resolve the question quickly I tried to put the matter to His reverend monsignor [Pope Leo X], but he did not want to have anything to do with it. I showed him the bill for the whole job, and he wanted me to send it to you so that you can see it all. So here it is. And I pray you, if you would do me this favour, to do it without casting any doubts on the matter, because the most reverend Monsignor and I are willingly putting our trust in you. It is enough that you saw the work at the beginning and it now has forty figures in total, excluding those in the landscape. Included in this job and as part of the bill, there is the painting for Cardinal Rangone, which Messer Domenico saw and therefore knows how big it is. I will say no more. My *compare*, I beg you, send the letter soon, before the most reverend Monsignor leaves Rome, because, to tell you the truth, I am in the red. May Christ keep you in good health. Recommend me to messer Domenico and I recommend myself to you infinite times.

On the 29th day of December 1519
Your most faithful *compare* Sebastiano, painter in Rome
To the lord Michelangelo, sculptor in Florence

cher Monsieur Monet, mes très
respectueuses et si cordiales amitiés.

Paul Signac

Un bon souvenir aux Butler. Je
vous prie, s'ils sont auprès de vous.

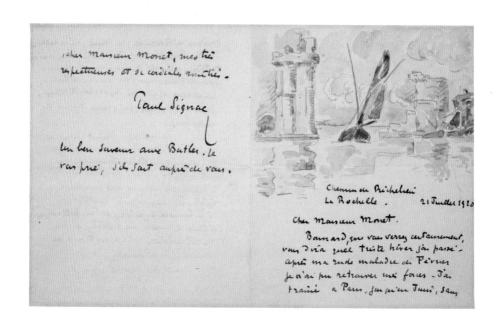

Chemin de Richelieu
La Rochelle . 21 Juillet 1920

Cher Monsieur Monet.

Bonnard, que vous verrez certainement,
vous dira quel triste hiver j'ai passé
après ma rude maladie de Février
je n'ai pu retrouver mes forces - J'ai
trainé a Paris, jusqu'en Juin, sans

pouvoir ni travailler, ni causé, ni marcher.
Je n'ai donc pu profiter de votre bonne invi-
tation. C'eut été pour moi une si grande
joie de passer une belle journée à Giverny
près de vous, et de voir vos grands travaux.
Veuillez m'excuser ; j'ai grand chagrin de
ce déboire.

Les médecins m'ont envoyé au
Mont-Dore ! Mais a l'idée de la table
d'hôte de cette station thermale, j'ai
fui . Et j'ai préféré faire une cure
d'aquarelles dans ce port aux voiles
bizarrées, aux coques multicolores,
à la lumière argentée, et si pittoresques
à faire écumer un cubiste ou un
néo-Davidien . Elle me trouve bien
bien de ce traitement = les forces
reviennent et le travail reprend.

Je vous adresse,

Paul Signac (1863–1935) to Claude Monet
21 July 1920

The elderly Claude Monet (see page 73) was a generous host, regularly inviting artists, writers, collectors and politicians to lunch at his studio-home and garden at Giverny. When Paul Signac writes to express regret at not having been able to accept Monet's invitation, he means it. It was Signac's first encounter with Monet's paintings, at the age of seventeen in Paris in 1880, that made him determined to train as an artist. Forty years later, Monet is working on his monumental series of 'Water Lily' canvases, the *Grande Décoration* that France's most famous living artist plans to leave as his lasting legacy to the French state. Signac, too, has had a successful career. With Georges Seurat, he pioneered the divisionist, or pointillist, technique of painting, applying unmixed colours in tiny dots and dabs so that the blending effect is created in the viewer's eye. Both Camille Pissarro and Vincent van Gogh (see pages 43 and 53) admired and adopted Signac's method.

Signac feels sure that his and Monet's mutual friend, Pierre Bonnard, will have explained what a rough time he has been having with illness. He has been prescribed treatment at the thermal springs of Mont-Dore in the Auvergne (now a ski resort), but cannot face sanatorium society. A holiday at La Rochelle turns out to be working wonders – the old port is so lovely that even a cubist or a 'neo-Davidian' (a reference to the classical revival after the First World War) would want to paint it. With a yachtsman's interest in boat types and rigs, Signac heads his letter with a watercolour sketch of a sailing ship in port, showing the long, curved yardarms used for fishing. His 'watercolour therapy' also results in *Fishing Boats in La Rochelle* (Minneapolis Institute of Arts), a side view of the same kind of boat in open sea, with the larger of La Rochelle's distinctive medieval towers visible in the distance.

Dear Monsieur Monet,

Bonnard, whom you'll certainly be seeing soon, will tell you what a wretched winter I've had. After my awful illness in February, I haven't been able to regain my strength. I stayed on in Paris until June, without being able to work, write or go out for a walk. I was unable to take up your kind invitation. It would have been such a joy for me to spend a fine day with you at Giverny and to see your great project. Please forgive me: I'm so sorry about these setbacks.

The doctors sent me to Mont-Dore! But the prospect of shared meals with other patients at this thermal spa made me take flight. Instead, I've opted for watercolour therapy in this port with its motley sails, its hulls of every colour and its sparkling light, so picturesque it would make even a cubist or a neo-Davidian drool! And I'm doing well on this course of treatment – my strength is returning and I'm getting back to work.

dear Monsieur Monet, my respectful and cordial greetings,

Paul Signac
Please give my best wishes to the Butlers, if they are still with you.

December 1936.

Comrades: *Pollack, Sandy, Lehman;*

Since I realize that there exists a misunderstanding on the part of some of you as to the provisional closing of the workshop and my present activities for my next exhibition, I believe that it is necessary to write this letter by way of explanation.

I would like you to remember our last meeting at 5 West 14th St. when we unanimously agreed to close our workshop as a place for daily xxpxixtxxpxxxxxxxxtxxxxxx production so as to give me time to prepare my personal exhibition, believing this exhibition could help our initial movement to further the understanding of the people about our technique. To further this plan we agreed that a small number of comrades who could devote most of their time would help me in the realization of my work.

I believe I explained everything very clearly at this meeting - that to realize my plan it would be necessary for me to seclude myself for some time. And now I want to say that I am working in accordance with this plan, and at this time I am at more unrest with the problems of form in art than ever. I have not yet crossed the bridge of experimentation that will put me on the road to production, and for this reason I have not yet asked you all to come to my place and carry on a collective discussion of our realizations. However, the time is near, and I sincerely ask you to be patient with the assurance that before I leave the United States our workshop will open again under very different conditions from the lamentable misunderstandings which disrupted our work in the past.

Always your comrade,

Siqueiros

David Alfaro Siqueiros (1896–1974) to Jackson Pollock, Sande Pollock and Harold Lehman
December 1936

In the 1920s the Mexican painter David Alfaro Siqueiros was closely involved in the post-revolutionary movement to create a new, socialist narrative of Mexico's history through large-scale public mural projects. In 1925 he gave up painting to work full-time for the Mexican Communist Party. This later led to his imprisonment and, in 1932, exile to the United States. In Los Angeles he established a 'Bloc of Painters' to create political murals; its members included Harold Lehman, Philip Guston (see page 25) and Sanford (Sande) Pollock, Jackson Pollock's older brother.

In 1936 Siqueiros moved to New York. In April, at his loft in West 14th Street, he set up his Laboratory of Modern Techniques in Art, where he encouraged young artists to experiment with synthetic paints and non-traditional techniques. Like other participants in Siqueiros' workshop, Sande and Jackson Pollock (see page 121) had been involved in the Federal Arts Project – a Depression-era scheme that employed artists on public projects. They collaborated with him to produce a large float for New York's May Day parade.

Siqueiros writes to the Pollocks and Lehman to explain why the workshop has been temporarily closed. He has had to 'seclude' himself to focus on new work, and perhaps to escape unspecified 'lamentable misunderstandings'. The following year Siqueiros would leave for Spain, where he joined the Republican army in the Civil War.

..

Comrades: Pollock, Sandy, Lehman;

Since I realise that there exists a misunderstanding on the part of some of you as to the provisional closing of the workshop and my present activities for my next exhibition, I believe that it is necessary to write this letter by way of explanation.

I would like you to remember our last meeting at 5 West 14th St when we unanimously agreed to close our workshop for a place of daily production so as to give me time to prepare my personal exhibition, believing this exhibition could help our initial movement to further the understanding of the people about our technique. To further this plan we agreed that a small number of comrades who could devote most of their time would help me in the realization of my work.

I believe I explained everything very clearly at this meeting – that to realize my plan it would be necessary to seclude myself for some time. And now I want to say that I am working in accordance with this plan, and at this time I am at more unrest with the problems of form in art than ever. I have not yet crossed the bridge of experimentation that will put me on the road to production, and for this reason I have not yet asked you all to come to my place and carry on a collective discussion of our realizations. However, the time is near, and I sincerely ask you to be patient – with the assurance that before I leave the United States our workshop will open again under very different conditions from the lamentable misunderstandings which disrupted our work in the past.

Always your comrade,
D.A. Siqueros

Pablo Picasso (1881–1973) to Jean Cocteau
16–19 November 1916

Pablo Picasso first met Jean Cocteau (see page 149) in June 1915. The cubist circle in Paris had been broken up by the First World War, with Georges Braque and other artists now serving in the army. With Cocteau's encouragement, Picasso gravitated towards a new avant-garde circle centred on the impresario Sergei Diaghilev and his Ballets Russes. For his part, Cocteau fell under Picasso's spell.

After publishing his first volumes of poetry in his early twenties, Cocteau had met Diaghilev, his dancers and artistic collaborators. To audiences in Europe at that time, Diaghilev's productions were the embodiment of modernity – sensational, shocking, unprecedented in their fusion of music, movement and visual art. Cocteau began by designing posters for the Ballets Russes, then in 1912 wrote the libretto for *Le Dieu bleu* (The Blue God), starring the great Russian dancer Nijinsky.

Cocteau was already mulling over the scenario for his ballet *Parade* when Picasso arrived on the scene. He wanted his new ballet to be a 'total' artwork; if Picasso could be persuaded to design the costumes and sets, *Parade* would astonish everyone by bringing cubism – that strangest and most revolutionary of contemporary developments in art – to the stage. In May 1916 he took Diaghilev to visit Picasso in his studio. In August Picasso agreed to be part of the team, which would include the composer Erik Satie and choreographer Léonide Massine. When he wrote this get-well-soon note to Cocteau from his new studio in Montrouge in November, work had yet to begin in earnest on their 'theatre story' (that would happen when the collaborators got together in Rome in February 1917). Picasso – always interested to adapt and explore a new visual influence – decorated the margins with watercolour designs that look much more like Ballets Russes fabric patterns than cubist riffs.

Parade premièred at the Théâtre du Châtelet in Paris on 18 May 1917. It featured several characters wearing large cubist constructions and a drop curtain – the largest painting Picasso ever made – on which a motley crowd of performers shares the stage with a winged horse on whose back a fairy is daintily balanced. The mixed audience of modern art aficionados and soldiers on leave from the Western Front reacted with the expected (even hoped-for) outrage.

Montrouge (Seine)
22 Rue Victor Hugo

My dear Cocteau

I am very sad to hear that you are ill. I hope you will get well soon and that I will see you.
 At Montparnasse next Wednesday festival in honour of *the musician*
 I look forward to seeing you. I've got good ideas for our theatre story – we'll talk about it

All the best
Picasso

Vermont
Thursday Aug 16

Dear Lee - I wish I could find some way
to tell you how I feel about Jackson. I do
remember my last conversation with you,
and that, then, I made some effort to tell you.
Unfortunately I had never found the occasion
nor really knew a way in which to
sufficiently indicate to him. Whatever
it may have meant to him, it would have
meant a lot to me to say so; especially
now that I realize I can never do it.

What I am trying to say that,
particularly in recent months, and
in addition to his stature as a great
artist, his specific life and struggle
had become poignant and important
in meaning to me, and came a great
deal in my thoughts; and that the
great loss that I feel in not an
abstract thing at all,

Mark Rothko (1903–70) to Lee Krasner
16 August 1956

In summer 1956 Lee Krasner left Jackson Pollock at their home in Springs, Long Island, to travel to Europe. Their marriage was under strain, and the trip was meant to give them both some breathing space. Writing from Paris in late July, Krasner told him 'I miss you & wish you were sharing this with me' (see page 211). Then, on 11 August, shortly before she was due home, Pollock died in a car crash, drunk at the wheel. She returned to organise his funeral.

Dated the day after the funeral, Mark Rothko's letter of condolence expresses regret that he never told Pollock face-to-face that he considered him 'a great artist'. This isn't the kind of compliment that often passes between artists in the midst of their working lives. It hints that, by 1956, American abstract expressionism – the post-war movement in which Rothko and Pollock were leading figures – was already taking its place in history. Their work was very different: Rothko's paintings of the early 1950s were based on large, rectangular blocks of luminous, thinly brushed colour, Pollock's on calligraphic trails and constellations of spattered paint. But they had both been represented by the same New York gallery and shared many art-world friends and associates (Rothko mentions Barnett Newman).

Krasner was also an artist, but she had devoted much of her energy to supporting Pollock. Rothko wants to reassure her that these efforts were not wasted, especially in view of the fact that Pollock had produced nothing for the past eighteen months, feeling burnt out and directionless. Echoing Pollock's creative 'struggle', Rothko repeatedly pushes against the limits of what can be said in words: he never 'knew a way' to 'indicate' his admiration. In case the phrase 'great loss' sounds formulaic, he needs Krasner to know that his sense of bereavement 'is not an abstract thing at all'.

Vermont

Dear Lee –

I wish I could find some way to tell you how I feel about Jackson. I do remember my last conversation with you, and that, then, I made some effort to tell you. Unfortunately I had never found the occasion nor really knew a way in which to sufficiently indicate to him. Whatever it may have meant to him, it would have meant a lot to me to say so; especially now that I realize I can never do it.

What I am trying to say that, particularly in recent months, and in addition to his stature as a great artist, his specific life and struggle had become poignant and important in meaning to me, and came a great deal in my thoughts; and that the great loss that I feel is not an abstract thing at all.

I had talked to Tony, and I knew that both he and Barney were going to be with you on Wednesday. I wish I had been there, too, for my own sake.

Please see us soon, and our deepest love to you.

Mark

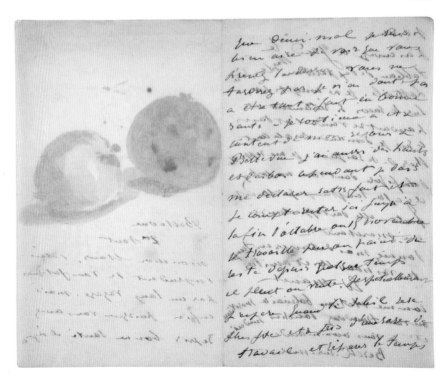

Bellevue
2e Aout

Mon cher Blanc, j'était
imprudent de vous fatiguer
par un long bavardage. mais
enfin puisque vous avez
repris bonne santé il n'y a

[handwritten letter text, partially legible]

...donnez moi de vos nouvelles en temps
de vos nouvelles et amitiés
 Ed. Manet

[signature and address: Berck sur mer]

Édouard Manet (1832–83) to Eugène Maus
2 August 1880

From his forties onwards (he died aged fifty-one), Manet suffered acute joint pain caused by syphilis. The summer of 1880, spent with his wife, Suzanne, in a small rented house in Bellevue on the rural outskirts of Paris, was meant to be both working holiday and rest cure. Since its first appearance at the Paris Salon in 1859, Manet's work had had a very mixed reception. In the 1860s there had been notable scandals surrounding *Déjeneur sur l'herbe* and *Olympia*, with their fusion of Old Master references and frank, contemporary sexuality. As his colours became brighter, his brushwork lighter in the 1870s, Manet's name was linked with the younger Impressionist artists, though he never exhibited with them.

Writing to the Belgian artist Eugène Maus, he mentions a painting he finished the previous year, *Chez Père Lathuile* (Musée des Beaux Arts, Tournai) – an everyday seduction scene at an outdoor café table – which he has submitted to the 1880 Ghent Salon. He hopes that money from a sale will help with the cost of 'taking good care of oneself'. He also greets Maus as a fellow invalid, offering advice about the north coast health resort Berck-sur-Mer. In the pre-antibiotic era, middle-class travel was often an attempt to gain remission from fatal diseases like pulmonary tuberculosis. When the wet weather lifted, Manet seems to have been able to 'make up for lost time'. He painted Suzanne relaxing outdoors and on other days he worked on indoor still lifes and illustrated his letters to friends with watercolours of fruit and flowers from the garden.

My dear Maus, it would be foolish to tire yourself out with a long journey. But then, since you're getting better again, it wouldn't be such a bad thing. I'm really pleased to see you making a recovery it won't be long, I'm sure, before you're completely well – I'm still happily installed in Bellevue I still have my ups and downs but even so I must say that I'm content and I plan to stay here until the end of October or 15 November I'm doing little if any work apart from that it's been continually rainy or windy for some time I hope that when we get some settled sunny weather I'll be seized by a furious desire to work and make up for lost time.

I've sent the painting for the show, Chez Père Lathuile, to Ghent. I'm not counting on success, all I ask is that the painting sells because it's expensive taking good care of oneself – I remember the figure you were talking about; it was painted ages ago – it must belong to a dealer. –

Let me have your news and good wishes from time to time

Ed[ouard] Manet

As a seaside resort where you'll find hydrotherapy, doctors etc, I can recommend Berck-sur-Mer.

14ᵗʰ sept 1988.

21036 Pacific Coast Hwy.
Malibu 90265

213 456 9780

My dear Ken,

 I am now living in a lovely cosy
little house on the very edge of Western
Civilisation, — it ends about 12 inches from
my window. I have a little studio here,
and i'm painting portraits. I still have
Montcalm of course + the laser printer is
up there, — but my fax machine is here
so I can communicate in a _new_ way
with my friends. I love the way
really advanced technology is bringing
back the hand again, — another aspect
of intimacy from new technology.
 Write me, this new use of the
phone is terrific for deaf people. I
see the messages now.

much love

David

Fax 456 6251

David Hockney (b.1937) to Kenneth E. Tyler
14 September 1988

Headed 'DH AT THE BEACH', this fax was sent from the 'cosy little house' with a small studio attached that David Hockney bought in Malibu in the mid-1980s as an alternative workspace to his studio-home on Montcalm Avenue in the Hollywood Hills. 'Here,' said Hockney, 'I'm on the edge of the largest swimming pool in the world.' A few feet away, the Pacific Ocean was 'like fire and smoke, endlessly changing, endlessly fascinating'. Always interested in the picture-making applications of new technology, Hockney had been experimenting with photocopiers, Polaroid cameras and laser printers. Fax machines, which came into widespread office use around this time, were 'another example of a machine which no one has thought of making art with', as well as alleviating the problems caused by his advancing deafness. Hockney started to create pictures in the form of multi-sheet faxes that could be installed in a gallery to his instructions without the artist being present. He delivered an entire exhibition in this way for the 1989 São Paulo Bienal.

Hockney is in the early stages of his fax fixation when he writes to the master printmaker Kenneth E. Tyler, who is also a tireless innovator in printmaking technology. Artists with whom Tyler has worked include Helen Frankenthaler, Jasper Johns, Roy Lichtenstein and Robert Rauschenberg, but he has had a particularly long and close association with Hockney, starting soon after the latter moved from Britain to Los Angeles with the 1965 lithograph series *A Hollywood Collection*. In 1978 Tyler worked with Hockney on prints made from coloured and pressed paper pulp; most recently, he has printed his *Caribbean Tea Time* (1985–87), a set of 2-metre-high panels.

'Although I've always had a lot of high-tech gear,' Hockney reflected in 1988, 'I'm actually a believer in low-tech. I've always believed in the hand, along with the heart and eye.' Thirty years later, he would still be co-opting the newest new technology for making art, drawing on an iPad and reaffirming its counterintuitive capacity for 'intimacy', for 'bringing back the hand'.

21036 Pacific Coast Hwy
Malibu 90265

My dear Ken,

I am now living in a lively cosy little house on the very edge of Western Civilisation, – it ends about 12 inches from my window. I have a little studio here, and I'm painting portraits. I still have Montcalm of course & the laser printer is up there, – but my fax machine is here so I can communicate in a new way with my friends. I love the way really advanced technology is bringing back the hand again, – another aspect of intimacy from new technology.

Write me, this new use of the phone is terrific for deaf people. I see the messages now.
much love

David

MoUvEmEnT

DADA

BERLIN. GENÈVE. MADRID. NEW-YORK. ZURICH.

PARIS.

CONSULTATIONS : 10 frs

S'adresser au Secrétaire
G. RIBEMONT-DESSAIGNES
18, Rue Fourcroy, Paris (17ᵉ)

DADA
Directeur : TRISTAN TZARA

D₀O⁴H²
Directeur :
G. RIBEMONT-DESSAIGNES

LITTÉRATURE
Directeurs :
LOUIS ARAGON. ANDRÉ BRETON
PHILIPPE SOUPAULT

Mᵐᵉ AMENEZ'Y
Directeur : CÉLINE ARNAUD

PROVERBE
Directeur : PAUL ELUARD

391
Directeur : FRANCIS PICABIA

'Z'
Directeur : PAUL DERMÉE

Dépositaire
de toutes les Revues Dada
à Paris : Au SANS PAREIL
37, Av. Kléber Tél. : PASSY 25-22

9, rue
Emile Augier
Paris XVI

le 8 Novembre 1920

Mon cher Stieglitz,

Loffite, directeur de "La Sirène" va
publier un livre important, je viens
vous demander si vous voulez y collaborer
en m'envoyant prose, poèmes, avec votre
portrait — Je serai très heureux que vous
figuriez dans ce livre qui sera certainement
le plus considérable qui ait été fait depuis
longtemps — Nous y serons les uns à
côtés des autres et jurons en le parcourant
nous rappeler toutes nos idées et même nos rêves
des années passées — Très affectueusement —

Francis Picabia

P.S. En ce qui concerne votre portrait vous pouvez nous
envoyer photo dessins ou reproductions ?

Francis Picabia (1879–1953) to Alfred Stieglitz
8 November 1920

Dada started life during the First World War as a subversive reaction by artists against all the time-honoured cultural standards that had failed to prevent Europe's descent into meaningless slaughter and destruction. After the war, the Romanian artist Tristan Tzara – the leading spirit and spokesman of Dada – moved to Paris, as guest of his fellow Dadaist Francis Picabia. Just as the Treaty of Versailles was reconfiguring Europe, Tzara aimed to initiate a 'Dadaglobe', an anarchic reinvention of the post-war world order. To get things going, Picabia introduced Tzara to Jean Cocteau (see page 149), who in turn probably introduced them to the financier and editor Paul Laffitte, an early investor in French cinema who in 1917 had launched the publishing house Éditions de la Sirène.

In November 1920, Tzara and Picabia began drumming up contributions to a projected *Dadaglobe* anthology. An official 'Mouvement Dada' letterhead was printed. Mimicking the style of a global corporation, with its branches in Berlin, Geneva, Madrid, New York and Zurich, it suggests that this anarchic, anti-authoritarian movement is poised for world domination.

Picabia had the task of contacting potential American contributors. After jumping ship from a French naval vessel in 1915, he had spent a year in New York, where he collaborated with the photographer Alfred Stieglitz (see page 151). He duly included Stieglitz in his list. In New York, meanwhile, Marcel Duchamp (see page 45) and Picabia's estranged wife, Gabrielle, did what they could to fill the 'American Dada' section of the publication. Duchamp's friend Man Ray wrote back enclosing three portrait photographs, but Stieglitz did not respond. Since Picabia's letters opened with a generic request for prose pieces and/or poems, Stieglitz probably felt he could not offer anything suitable.

..

Mouvement DADA
Berlin, Genève, Madrid, New-York, Zurich.

14 rue Emile Augier
Paris XVI

My dear Stieglitz,

Laffite, the director of *la Sirène*, is going to publish an important book. I'm asking whether you would like to contribute to it by sending me prose pieces, poems, with a picture of yourself – I'll be very happy to feature you in this book which will certainly be the most notable to have been produced for a long time – We'll be side by side with each other there and will enjoy bringing back to mind all our ideas and our ideal of earlier times – With all good wishes –

Francis Picabia

PS As regards your portrait you can send us either drawings or objective reproductions [photographs] –

Dear Enno,

I just returned from Utah.
I'm happy to hear you enjoyed
my work in Emmen. But hope they
will not destroy it. It seems that
John Weber did not find time to visit
my work — that is unfortunate,
because I have so few photos of
the work. Both Beeren + Zijlstra
have yet to let me know what's
going on. So, I really appreciate
your serious concern and
interest in the project. For one
thing, the project is outside the
limits of the "museum show". There
are a few curators who understand
this. As Jennifer Licht says, "art
is less and less about objects you
can place in a museum" yet, the ruling
classes are still intent on turning
their Picassos into capital. Museums
of Modern Art are more and more
banks for the super-rich.

Robert Smithson (1938–73) to Enno Develing
6 September 1971

Robert Smithson's first affiliation as a young artist in New York was to abstract expressionism. Then, in the mid-1960s, he began to work in a minimalist idiom, constructing crystalline metal and glass sculptures, into which he incorporated rough mineral matter like rocks and industrial scree. Smithson became interested in large-scale earthworks as a form of reparation for human damage to the landscape. In 1970, near a defunct oil-drilling site on the Great Salt Lake, Utah, he designed *Spiral Jetty*, a gigantic curving promontory heaped up from stones, salt and soil. The following year he created a two-part earthwork, *Broken Circle / Spiral Hill*, near Emmen in the Netherlands. Concerned that the local museum director Sjouke Zijlstra should ensure that this work is preserved, he wants to inspire Enno Develing, a researcher at the Gemeentemuseum in the Hague, to appreciate its importance in the context of current art debates and to keep an eye on things. Two years later, Smithson died in a plane crash, while inspecting an earthwork site in Texas.

Dear Enno,

I just returned from Utah. I'm happy to hear you enjoyed my work in Emmen. But hope they will not destroy it. [...] So, I really appreciate your serious concern and interest in the project. For one thing, the project is outside the limits of the 'museum show'. There are a few curators who understand this. As Jennifer Licht says, 'art is less and less about objects you can place in a museum'. Yet, the ruling classes are still intent on turning their Picassos into capital. Museums of Modern Art are more and more like banks for the super-rich. [...] Art should be an ongoing development that reaches all classes. As it is now artists are treated like colonials, who are systematically ripped off. Of course, there are artists who support this reactionary condition by making abstract paintings and sculpture that can be converted into an exchange currency by the ruling powers.

By making portable abstractions, the middle class artist plays right into the hands of mercantilist domination [...] Conceptual art is like a credit card that has nothing to back it up. Abstract painting is like money that has nothing to back it up. That's why so-many galleries are going bank rupt. The over consumption of modern museums have made them insolvent.

Having said this, I now return to my project in Emmen. I must maintain *Broken Circle* and *Spiral Hill* by keeping on grip on its physical development. The show is not over, as far as I'm concerned. Although I have film footage of the construction of the work, I have yet to get aerial shots of the work. Still shots from carefully planned angles have yet to be shot. I would love to return to Holland to work on the project. I hope Sjouke Zylstra realizes the importance of this project, and will keep it from being destroyed. I don't know yet, if I will able to get to Prospect. Hello to Trudie

Bob

Giverny par Vernon
eure

Chère Madame

Je n'ai pas encore
eu la possibilité de
venir vous voir d'après
mon entente, n'étant
venu à Paris que pour
et pour quelques heu
seulement, qui étaient
prises d'avance.
Vous avez su com
mes ennui chez Petit
depui s'être tant donné
de mal on ne voit
pas droit d'être
joué de cette façon.
il avait été question
d'une exposition
chez Durand e-

Claude Monet (1840–1926) to Berthe Morisot
May 1888

Claude Monet and Berthe Morisot had known each other and regularly exhibited together since the first Impressionist exhibition in Paris in 1874. In the years that followed, as Impressionist paintings switched from being the butt of jokes to coveted, high-value collectors' items, both artists enjoyed commercial success. Essential to this process was the dealer Paul Durand-Ruel, who invested heavily (and sometimes lost badly) in promoting Impressionist art. By 1888 he had opened a gallery in New York and was planning a second show there. Monet had fallen out with him, however, and was about to negotiate the sale of his recent landscapes for a very large sum to Theo van Gogh, Vincent van Gogh's art dealer brother. He was also exhibiting with Durand-Ruel's ambitious rival, Georges Petit. Durand-Ruel, meanwhile, had handed over the running of his Paris gallery to his sons. The exhibition that Monet intended to boycott went ahead, opening on 25 May 1888, with paintings by Morisot, Renoir, Pissarro and Sisley. 'Monsieur Manet' is Morisot's husband, Eugène Manet, brother of the artist Édouard.

..

Giverny near Vernon

Eure

Dear Madame,

I have not yet been able to come to see you since my return, having gone to Paris only yesterday, and for only a few hours, during which I was busy with previous engagements.

You have heard about all the trouble we had with Petit. After working so hard it is not pleasant to be treated in this way. There was talk about an exhibition at Durand's; this project was not at all to my liking, and on reaching Paris I gave it up at once for many reasons that it would take too long to go into.

But this morning Renoir tells me that this exhibition is taking place, indeed that it opens on Saturday, and that the young Durand, without even having consulted me, proposes to put in pictures of mine owned by him and by various collectors. Considering that I am going to oppose this by every means at my disposal, since this is my right if it is a paying exhibition, I think it is my duty to let you know this in advance, not in order to influence you in any way, but because I don't want you to be surprised and to believe that I am a quitter, as they will certainly say. I have given evidence of my good intentions, and I have proved to you that my greatest wish was to exhibit with you.

I expect to visit you as soon as I come to Paris for a day or two, and I hope that you will be kind enough to come to Giverny one day.

Be assured, you and M. Manet, of my friendship,

Claude Monet

MEXICO, JUNE '78

DEAR PARR'S,... LIEBE FAMILIE PARR,

AFTER WE HAVE BEEN 3 WEEKS IN
NEW YORK WE WENT DOWN SOUTH
TO MEXICO... THE BEST WE DID...!
YOU CAN'T BELIEVE HOW GOOD WE FEEL
OVER HERE, THE CLIMAT FOOD NATURE
THE PEOPLE'S BEHAVOURS, SHORT IT'S
JUST WHAT WE LIKE AND MAKE US
FUNCTION SO GOOD.
THERE IS SOMETHING THERE.. LIKE AIR
EVERYWHERE WHICH MAKES US FEELING
CONFIDENTIAL, BITCH. SLOWLY WE ADOPT
NATURE AND DISCOVER GREAT THINGS.
LIKE JUMPING BEENS WHICH YOU CUT
AND BY OWN ENERGY THERE MOVING,
JUMPING FOR MOUTH....
PICKS (KILLING AND) EATING RATTLE SNAKS...
NOT TO FORGET... TEQUILA OR BETTER MESCAL
A UNREVENGED DRINK FROM THE GOD'S
... I BELEAVE.
ALL TOGETHER. IT'S A FRUITFUL TRIP.

TO YOU. DID YOU HAD A GOOD TRIP
BACK HOME?! WHAT WE IMAGE ABOUT
IT MUST BE LIKE LEAVING IN A SATELITE
THE EARTH...
ONES WE HOPE HAVING THIS EXPERIENCE
AND IT SEEMS TO BE POSSIBLE NEXT YEAR.
WE WILL HAVE A GREAT TIME, ALL OF US!
AS WE BUROT ALL READY ON THE CARS) WE
DID SEW A FEW DAY AGO, AS SOON AS
WE ARE BACK IN HOLLAND, WE WORK OUT

I OFFERS ME IN A SECOND) I DON'T KNOW YOU ALL PAGE. BUT SHE IS URES'H A GREAT

I HERE A SPACE TO NIGHT

Ulay (b.1943) and Marina Abramović (b.1946) to Mike Parr
June 1978

The performance artists Marina Abramović and Ulay (Frank Uwe Laysiepen) began working and living together in 1976. They expressed their aims as 'No fixed living place, permanent movement, direct contact, local relation, self-selection, passing limitations, taking risks, mobile energy'. An early collaboration, *Breathing In, Breathing Out*, in which each artist could breathe only what the other exhaled, was characteristic of the extremes to which their performances pushed the body (in this case almost twenty minutes of increasing concentrations of CO_2 inhalation).

In Vienna in April 1978 for the International Performance Festival, Abramović and Ulay met the Australian artist Mike Parr. Their letter to Parr from Mexico, mostly written by Ulay, is a mix of wish-you-were-here enthusiasm, advice about applying for an artist residency in Europe and a request for 'bumerangs' – props for a future performance (see page 77) to be posted to Ulay's Amsterdam gallery, De Appel.

DEAR PARR'S ... LIEBE FAMILIE PARR,
AFTER WE HAVE BEEN 3 WEEKS IN NEW YORK WE WENT DOWN SOUTH TO MEXICO ... THE BEST WE DID ... ! YOU CAN'T BELEAVE HOW GOOD WE FEEL OVER HERE, THE CLIMAT, FOOD, NATURE THE PEOPLE'S BEHAVOIRS, SHORT IT'S JUST WHAT WE LIKE AND MAKE US FUNCTION SO GOOD.

THERE IS SOMETHING THERE ... LIKE AIR EVERYWHERE WHICH MAKES US FEELING COMFETEBAL, RICH, SLOWLY WE ADOPT NATURE AND DISCOVER GRAET THINGS, LIKE JUMPING BEENS WHICH YOU CUT AND BY OWN ENERGY THERE MOVING, JUMPING FOR MOUTH ... PICKS KILLING AND EATNG RATTLE SNAKS ... NOT TO FORGET TEQUILA OR BETTER, MESCAL A UNBELIVEBEL DRINK FROM THE GOD'S ... I BELEAVE [...]

DID YOU HAD A GOOD TRIP BACK HOME?! WHAT WE IMAGEN ABOUT IT MUST BE LIKE LEAVING IN A SATELITE THE EARTH ...

ONES WE HOPE HAVING THIS EXPERIENCE AND IT SEEMS TO BE POSSIBLE NEXT YAER. WE WILL HAVE A GRAET TIME, ALL OF US! AS WE WROT ALLREADY ON THE CARD WE DID SEND A FEW DAY AGO, AS SOON AS WE ARE BACK IN HOLLAND, WE WORK OUT ALL POSSIBILITY'S FOR BEING ARTIST IN RESIDENCE IN THE NETHERLANDS, IF POSSIBLE FOR YOU MIKE AS WELL AS FOR YOUR FAMILY?! [...]

I ALMOST FERGOT, WE DO HAVE A BIG REQUEST TO YOU, BY NAME ... *BUMERANG*. WE WOULD LIKE TO HAVE 10 THE SAME BUMERANGS ORIGINALLY FROM WOOD, THE RETURNING ONES AND IF POSSIBLE SOME LITERATURE OR DOCUMENTATION ON IT. IF IT WILL BE POSSIBLE, SEND US THOSE TO OUR ADRESS: *P.O. DE APPEL, BROUWERSGRACHT 196, AMSTERDAM, THE NETHERLANDS* IN ABOUT ONE MONTH I SEND YOU MONEY FOR IT, AS WHAT WE IMAGEN IT WILL BE A 100 DOLLAR. IF IT IS MORE PLEASE LET ME KNOW. IF IT IS LESS, MAKE A FAMILY PARTY WITH A DRINK ON US. LET'S KEEP IN CONTACT ...

LOVE FROM MEXICO (SOUNDS LIKE JAMES BOND)

Ulay Marina
I don't have a space to right but I love you all kiss M.

Mike Parr,
P.O. Box M56,.
Newtown South, nsw 2042.
Australia. 24.7.1978

Dear Marina/Ulay,

Parr's very very pleased to hear from you. we got the
card ok and i've had the girl's kicking right under my nose for about a
month but i'm still very slow off the mark. today(about 4½minutes ago)
i got your letter with the news about mexico and the tequila etc which
sounds very good indeed. i am really so pleased you've kept in touch.
since being back we've had a very hectic time but now it is coming under
control. got the same house back in this suburb of sydney we previously
rented and now everything is going ok. our 3rd winter in a row. got back
and we all headed up to queensland which is the northern part of australia
to get car and dog. very strange after the heavy civilization matrix
europe(but not so strange after the country south of yugoslavia). 1000km's
in a typically crazy australian train-very slow and we had the cheapest
arrangement and all night there was a country football team off to the
big match in some northern ant town of 11½people drinking and swopping
stories anf gum trees anf goannas and drink vomiting-technicolor yawn we
call it here till the sun came wandering over hill that look like the
end of the world and spaces that crawl to the edge of the horizon line
that make you feel in a dream. at breakfast just as we were knawing eggs
a woman became epileptic besides us and started swallowing her tongue
and tearing up the vacuums round the cowboys heads. she ate my spoon as
we were saving here. her little son crawled under a table and ate a piece
of bread. in a little town with maybe 30people she got out and wandered
away in the dust. maybe the countryside is a little bit like mexico.
these anglo saxons from 150yrs ago are very strange when they're inbred.
mexico sounds amazing. i have a friend in the country felipe ehrenberg who
you may know because he was many yrs in europe-very nice but when you
receive this perhaps you'll be in amsterdam and mexico will be another
life you remember when you're old sitting in the sun. we very much hope
that all can be organized for you to come here. i keep talking to nick
waterloh about it but you must write to him as quickly as you can and start
a dialogue about all arrangements. i'll include his address here though i'm
sure you'll have it maybe i'll put it at the bottom of the letter because
if i stop now i'll have to have another cup of coffee. we hope we hope you'll
be here next year. this is a big place and you can stay here without any
problem at all we have a little car which you can use and while you're by
whatever means it does not matter how we much take you for a long trip out
into the interior of australi that is such amazing country you could not
imagine it and stretches endless and barren like stones had been falling
endlessly from the sky for thousands of years in the deserts and many times
you can go all day or 2 days 3days without seeing a human being or a shelter
in all that great distance. i think it would be very strange with you and
i would love to be with you on such a trip to sit round a fire at night and
watch your faces. about a boomerang i understand exactly and i(m sure
there is no problem in getting you one this weekend i will go with tess and
try to get you an authentic one and will send it to the de appel address
i'm sure it costs no where near $100 so i think you should wait before
sending money because maybe it is very little. i do not know how to throw
them so as to make them return but it is a 'knack' where you get a flick
into your wrist maybe like the kind of rhythmm you must have to crack a
whip along the ground. i'm sure that there must be a lot of information on
them. its a very ancient weapon and i think widespread once in paleolithic
times even in europe but now the aboriginals here must be the last people
on earth to have it. all this is nova express stream of c. from my head
and hope that you can frame it into sense. it has been a very lucky day
for me because simultaneous with your letter was one from the australian
foreign affairs in canberra informing all my stuff had returned from
hungary including the prints of my films so that makes life easier and the
people who bought them will maybe think mike parr is not such a rat. i am
fighting the battle to get money to finish the 3rd part which is a big
film of a couple of hours but here the government is crazily going backwards
and soon we'll be eating the money and operating on one another because onl
meat is cheap you got to try hard i suppose to be a surrealist but here tb
try so hard they're soft in the head. love from insatiable parrs

Mike Parr (b.1945) to Marina Abramović and Ulay
24 July 1978

The Australian artist Mike Parr replies to a letter he has just received from fellow performance artists Marina Abramović and Ulay (see page 75), whom he recently met in Europe. All three share a desire to push performance to physical extremes. The 'technicolor yawn' Parr relates from his train journey echoes his 1977 piece *The Emetics; I Am Sick of Art*, in which he swallowed then regurgitated acrylic paint in Mondrian's red, yellow and blue palette. In 1979 Abramović and Ulay came to Australia for the 3rd Sydney Biennale, returning in 1980 to spend five months in the outback. Their 1981 performance *Gold found by the artists* included a gold-covered boomerang (perhaps one of those Parr promised to supply) and a live python.

Dear Marina/Ulay,

Parr's very, very pleased to hear from you [...] today (about 4½ minutes ago) i got your letter with the news about mexico and the tequila etc which sound very good indeed. i am really so pleased you've kept in touch. since being back we've had a very hectic time [...] we all headed up to queensland which is the northern part of Australia to get car and dog. very strange after the heavy civilization matrix of Europe (but not so strange after the country south of yugoslavia). 1000km's in a typically crazy australian train – very slow and we had the cheapest arrangement and all night there was a country football team off to the big match in some northern ant town of 11½ people drinking and swopping stories an[d] gum trees an[d] goannas and vomiting – technicolor yawn we call it here till the sun came wandering over hill and look like the end of the world and spaces that crawl to the edge of the horizon line that make you feel in a dream. at breakfast just as we were knawing eggs a woman became epileptic besides us and started swallowing her tongue and tearing up the vacuums round the cowboys heads. she ate my spoon as we were saving here [...] in a little town with maybe 30 people she got out and wandered away in the dust. maybe the countryside is a little bit like mexico [...] we very much hope that all can be organized for you to come here [...] we mu[st] take you for a long trip out into the interior of australia [...] i would love to be with you on such a trip to sit round a fire at night and watch your faces. about a boomerang I understand exactly and i'm sure there is no problem in getting you one this weekend [...] its a very ancient weapon and i think widespread once even in paleolithic times even in europe but now the aboriginals here must be the last people on earth to have it. all this is a nova express stream of c[onsciousness] from my head and hope that you can frame it into sense [...] love from the insatiable parrs

Ecc.mo et diuino precettor mio M. Michelagniolo

Pche dicontinuo io uitengo stampato inelmia occhi et dentro almio cuore. nomi essendo uenuta occasione di auergli affare qualche seruitio penolle dare noia sie lacausa che molto tempo fa io nollo scritto. ora uenendo M. giouanni da udine aurremo et pesserssi stato certi pochi giorni a fare penitenzia i casa mia, mie parso ap proposito di comfortarmi alquanto inello scriuere questi mia parecchi uersi a V.S. ricordandole quanto io lamo. Comolto mio marauiglioso piacere itesi alli passati giorni come pcer to, uoi ueniui a rimpatriarui che tutta questa cita pur gradi mente lo desidera e maggior mente questo nostro gloriosissimo Duca il quali sie tanto amatore delle mirabil uirtu uostre et e ilguibenig mo et ilpiu cortese signiore che mai formassi et portassi laterra che uenite hormai asinire questi uostri felici anni inella patria uostra cotanta pace ecotanta uostra gloria. sebene io neo riceuuto qual che stranezza da iddito mio signiore. lequali mi e parso diriceuere a gra torto. pcerto cegnioscho questo nonessere stato causa ne disua tia stima ne manto mia. et che questo sia iluero le dico pcerto che mai nosu huomo isua patria piu cordialmente amato chesono io et il simile iquesta mirabilissima Corte e questo dispiacere che miuiene senza causa suto suede lo essere potenzia digualche malignia stella alla qual potenzia io nocegmoscho altro remedio che ilrimener si tutto inel uero et imortale iddio. ilquali priego che cotento uicirt da egualche anno ancora. Difirenze alli 14 dimarzo 1559 —

sempre alli comadi di V.S. paratiss.mo

Benuenuto Cellini

Benvenuto Cellini (1500–71) to Michelangelo Buonarroti
14 March 1560

Benvenuto Cellini was under house arrest in Florence, serving a four-year sentence for sodomy, when he wrote to Michelangelo (see page 23), encouraging the aged artist to return from Rome to his native city. The motive behind Cellini's enthusiasm for this idea is hard to fathom: it is as if he, rather than Michelangelo, has something to gain – perhaps an easing of the conditions of his sentence if he can use his personal influence to win back Italy's most celebrated artist. Michelangelo must have wondered how Cellini could, almost in the same breath, describe Duke Cosimo de' Medici as both 'the most benign and kind Lord ever seen on this earth' and the man responsible for the 'unfair treatment' he complains of having received.

Cellini claims that it is the desire to express his love for Michelangelo that made him pick up his pen, but he seems quickly to forget this as his preoccupation with his own wrongs and reputation takes centre stage. Cellini was much in his own thoughts, since he was using his enforced confinement to dictate his autobiography, looking back over forty years of high artistic achievement as a goldsmith and sculptor, his many brushes with fame, power and danger, sexual adventure and the occasional murder. The *Vita* would become a classic of Italian literature.

...

My most excellent and divine master Messer Michelangelo, I keep you ever imprinted on my eyes and in my heart, and if it's a long time since I last wrote, it's simply because no occasion to serve you has arisen and I didn't want to cause you unnecessary inconvenience.

But now, since maestro Giovanni da Udine has been doing a few days' penance at my home on his way to Rome, it seemed appropriate to comfort myself a little by writing to your Lordship these numerous lines, reminding you how much I love you. It was with very great and marvellous pleasure that I heard in the past days that you were returning for certain to your native land, something that all this city greatly wishes, and most of all the duke himself who is a great admirer of your marvellous virtues and the most benign and kind Lord ever seen on this earth. Come now and spend your last happy years in your homeland, surrounded by great peace and glory! Even if I have received some unfair treatment from this Lord, I believe undeservedly, I know for certain that they were provoked neither by his Illustrious Excellency nor by me. I tell you emphatically the truth that never was there a man in his homeland more cordially loved than me, and similarly in this most admirable court. And this displeasure, arrived without reason, can only be explained by some malign star, to whose effect I know of no remedy other than putting myself completely before the true and immortal God whom I pray may keep you happy for some years to come.

Florence, on this day 14 March 1559 [1560 new style]
Always most ready to obey your lordship

Benvenuto Cellini
To the most excellent messer Michelangelo Buonarroti,
greatly superior than myself and worthy of the highest respect.
In Rome.

A favourable opportunity now offers itself of sending ~~the~~ you the Perspective drawing lent to me by Mr Shane who ~~~~ wished me to send it You when done with; the bearer hereof is a native of our Village and my Shoe maker perhaps never twenty miles from home before.

I inserted a sentence in my last letter to You which I ~~am~~ now sorry for after I sent it, (Shane I was disappointed at Your ~~~~ writing only upon half that large piece of paper) ~~but~~ and upon recollection I wonder how I could be so ungratefull for I'm exceedingly thankful for what there was.

I think You told me that You made Your Aqua Fortis with spt of Nitre with two parts Water, I suppose you ment the acid spt. I bought some Aqua Fortis at a neighbouring Town and belive have spoilt one plate with it not knowing how strength is was of.

Yours as ever
J Constable

View from my Window.

John Constable (1776–1837) to John Thomas Smith
January–March 1797

By way of practical preparation for one day taking over his father's grain and coal business, John Constable spent his late teens working in a windmill and learning the shipping trade along the River Stour in his native East Anglia. He wanted to be an artist, but, as he wrote to John Thomas Smith in 1797, he feared that he was destined 'to walk through life in a path contrary to that which my inclination would lead me'. The twenty-year-old Constable had met Smith the previous year while on a business trip to Edmonton, near London. Smith was a highly skilled printmaker, who specialised in historic buildings and topographical views. In 1796 he was preparing a series of etchings of picturesque cottages and landscapes, published as *Remarks on Rural Scenery.* To Constable's mother's annoyance, Smith encouraged his artistic ambitions and gave him the first instruction he'd received from a successful professional artist.

Constable writes from his parents' house in East Bergholt, including a drawing of the view from his window that he feels sure will appeal to Smith. His sketch of an outhouse also anticipates the great landscape paintings of his maturity, like *Flatford Mill* and *Dedham Lock*, with their balance of trees, open sky and human presence, and location close to his childhood home. It sounds as if, as a beginner trying to follow Smith's advice on etching, he has had problems getting the right concentration of nitric acid (*aqua fortis*) used to 'bite' the copper plate. Two years later, Constable's younger brother Abram stepped up to the task of running the family business, releasing him to study art in London. In 1802, he returned to East Bergholt to make 'laborious studies from nature' and begin the development of his own distinctive idiom of 'natural painture'.

[...] A favourable opportunity now offers itself of sending you the Perspective drawing lent to me by Mr Thane who wished me to send it to you when done with; the bearer hereof is a native of our village and my sho maker perhaps never twenty miles from home before.

I inserted a sentance in my last letter to you which I was sorry for after I sent it (Where I was disappointed at your writing only upon half of that large piece of paper) and upon recollection I wonder how I could by so ungratefull for I'm exceedingly thankful for what there was.

I think you told me that you made your Aqua Fortis with sp[iri]ts of Nitre with two parts water. I suppose you ment the acid sp[iri]ts. I bought some Aqua Fortis at a neighbouring Town and belive have spoilt one plate with it not knowing what strength it was of.

<div align="right">
Yours as ever

J Constable

View from my Window
</div>

Chapter 3

Gifts & Greetings

know how much I admire your

g my sculpture work as a gif

r lucidity & intelligence have

eaks into a slow, sad smile or

rp. 'Your book on witchcraft' I

ship remains anon but sends

es — really for an advanced H

nd I'm sorry for taking so long

which seems to be the vulga

book all about you which has

cats & a parrot, but I still hat

g my show. I'm touched that y

eeing you and your family the

e window tightly closed, I ca

nd my respects to Mrs Breue

oon. My best to you and Barb

irthday Party of ME Thursday

present you, should you wish

UNTITLED #216, 1990
PHOTOGRAPH BY CINDY SHERMAN

3/8/95

Dear Arthur,
 Thank you for your
sweet phone message
concerning my show.
I'm touched that you
took the time to call.
Your thoughts mean a lot
to me and I'm sorry for taking so long in
acknowledging that. I do hope to see you both
sometime soon. My best to you
 and Barbara, Cindy

©CINDY SHERMAN. COURTESY METRO PICTURES, NEW YORK
©FOTOFOLIO. BOX 661 CANAL STA., NY, NY 10013
Z332

Arthur Danto
420 R.S.D.
NYC 10025

Cindy Sherman (b.1954) to Arthur C. Danto
8 March 1995

On 14 January 1995 an exhibition of fifteen photographs by the American photographer Cindy Sherman opened at Metro Pictures gallery in Manhattan. Sherman was at the start of a busy year, with forthcoming exhibitions in Washington, São Paulo and at the Venice Biennale, but it is probably this relatively small-scale New York show that she is referring to in her postcard to the critic and philosopher Arthur C. Danto.

Danto is a long-time admirer of Sherman's work and, in his roles as art critic of *The Nation* and philosophy professor at Columbia University, an influential advocate. In 1991 he wrote the text for her catalogue *Cindy Sherman: Untitled Film Stills*, which presented in book form the photographic series that first brought her fame. Dressed and made up as various instantly recognisable types of classic B movie actresses posing for publicity shots, Sherman created images that were eagerly seized on by post-modernist commentators. Her photos of herself in different roles (almost always titled *Untitled*) were not self-portraits in the traditional, essential sense but seemed to say that the way we choose to present ourselves determines who we are, or, in Danto's phrase, that 'persons are essentially systems of representation'. 'She's got this incredible plasticity,' he enthused, 'you wouldn't recognise her in the street … I don't think she has done a portrait of anybody, these are all imaginary creatures. The Girl capital "G" in this situation, in that situation, she's in danger, she's in love, she's opening a letter, like the starlet who has no identity other than the identity the director gives her.'

More recently, Danto provided the text for *Cindy Sherman: History Portraits* (1993). As in *Untitled Film Stills*, Sherman parodied (mostly) female stereotypes, this time based on celebrated paintings by Renaissance artists. Her exhibition of enormous colour prints from the *History Series* at Metro Pictures in 1990 included portraits based on Raphael's *La Fornarina*, Leonardo da Vinci's *Mona Lisa* and Caravaggio's *Bacchus*. For *Untitled #216* (1989), she dressed up as the Madonna in Jean Fouquet's fifteenth-century *Melun Diptych*, who has lifted one full breast out of the bodice of her sumptuous gown (Fouquet reputedly modelled his figure on the French king's mistress) in order to feed the Christ Child.

'I was getting disgusted with the attitude of art being so religious or sacred,' Sherman recalled. 'I wanted to imitate something out of the culture, and also make fun of the culture as I was doing it.' In *Untitled #216* she demurely grasps a ballooning plastic breast. As if to affirm that the postcard to Danto comes from the real Sherman rather than the parody Madonna, she has neatly excised this prosthetic.

..

Dear Arthur,

Thank you for your sweet phone message concerning my show. I'm touched that you took the time to call. Your thoughts mean a lot to me and I'm sorry for taking so long in acknowledging that. I do hope to see you both sometime soon. My best to you and Barbara,

Cindy

Cher Monsieur - Il me donne un plaisir prodigieux de vous presenter, s'il vous plait, thaumotrope
for their 'motion in art' shindig but would only offer to supply 3 guards to insure its safe-
ty. I did not feel this was adequate for such a treasure & so the world must still wait. The
sender of this temoignage remains anon but sends you his love.

a l'image d'apollinaire en travestie when you twirl it fast enough he breaks into a slow, sad smile or the trace of one xxx

ape the dolorous gesture but I have not been quick enough to catch this phenomenon. The "Rorelse Ikonsten" people wanted this so far

there are those who claim that they see a tiny bird of dazzling plumage pop out of the turban and

Joseph Cornell (1903–72) to Marcel Duchamp
1959–68

Joseph Cornell did not call himself as an artist, preferring the term 'designer'. During the 1930s he did actually work as a textile designer in New York, but it was the art form he invented and made his own – the wooden box containing miniature installations of apparently random but poetically related objects and images – that gave him his unique place in modern American art.

In 1931, passing the window of Julien Levy's Gallery, Cornell was intrigued by a display of surrealist art. He began to raid junk shops for old wooden boxes and miscellaneous objects – toys, tools, documents and letters – anything that caught his eye – and to assemble his first artworks. Levy gave him a solo exhibition in November 1932. Cornell learned woodworking in order to construct his own boxes and began making surrealist films. Alongside expatriate artists such as Salvador Dalí (see page 15) and Max Ernst, and younger Americans like Dorothea Tanning, he was seen as a leading figure in surrealism's inter-war flowering in the United States. Cornell refused to be corralled with the surrealists, however, pointing out that he didn't share their preoccupation with the erotic and the Freudian unconscious.

His letter to Marcel Duchamp (see page 45), tightly typed in French and English around all four edges of the notepaper, is not a flight of surrealist fantasy (compare Tanning's letter to Cornell on page 47) but an offbeat yet rational arrangement of ideas that might well appeal to its addressee. The thaumatrope Cornell enclosed as a *témoignage* or 'token of friendship' was modelled on a Victorian toy. A disc bearing different images on its two faces is pierced by strings that the user twists then tugs. As the disc spins, the two images – sometimes a bird and a cage, here a coin-rubbing resembling the French poet Guillaume Apollinaire – merge in dynamic optical illusion.

In 1959 Duchamp moved to West 10th Street, close to the Marshall Chess Club, where he could practise the passion that absorbed him as much as – sometimes more than – art-making. Since Cornell's envelope is unfranked, the gift may never have reached Duchamp – but then, he was famous for his insistence that, in art, it is always the thought that counts.

Dear Sir – It gives me very great pleasure to present you, should you wish, [with a] thaumatrope with a parody portrait of Apollinaire when you twirl it fast enough he breaks into a slow, sad smile or the trace of one xxx there are those who claim that they see a tiny bird of dazzling plumage pop out of the turban and ape the dolorous gesture but I have not been quick enough so far to catch this phenomenon. The 'Horelse Ikonsten' people wanted this for their [']motion in art' shindig but would only offer to supply 3 guards to insure its safety. I did not feel this was adequate for such a treasure & so the world must still wait. The sender of this token of friendship remains anon but sends you his love.

Chihuahua 14.
Mexico.

Dear Kurt

I want to tell you that I have just
come to the end of your very beautiful
book on Witchcraft & I would like to say
how very much delight your lucidity &
intelligence have given me. Naturally it
is very difficult to give a complete
opinion by letter & I am also far more
interested in what you have to say on the
subject than what I do! All through
the book I was most moved & touched
by the scrupulous honesty with which
you treated each subject & the great
rarity of someone writing on Magic
without any attempt at mystification
which seems to be the vulgar habit—

I feel I would like to Write to
you & unfortunately this being

impossible I must content myself with
a very inadequate letter—

I am still imprisoned
in this foul & filthy place
I have 2 beautiful children, 4
dogs, 2 cats & a parrot, but I still
hate this place & suffer from the
enforced isolation being a communally
sociable creature—

Please give my salutes to
Arlette & again my admiration
& all possible good wishes for
yourself
 yours
 Leonora Carrington

Leonora Carrington (1917–2011) to Kurt Seligmann
1948

At art school in London in 1937, Leonora Carrington had an affair with the German artist Max Ernst, who introduced her to surrealism. After Carrington's parents tried to have Ernst arrested, the couple escaped to France. Displacement, separation and mental breakdown followed for Carrington, but by the early 1940s – now married to the Mexican poet-diplomat Renato Leduc – she was part of a group of surrealist artists in Mexico. With Salvador Dalí's presence in New York and a steady stream of artist exiles from wartime Europe, including the printmaker Kurt Seligmann (see also page 29), surrealism was entering a new, American phase.

Alongside the Freudian unconscious, the occult was a prime source of surrealist imagery. Before arriving in New York from Paris in 1939, Seligmann had been known for prints of paranormal fantasies, such as *Black Magic* and *The Witch*. He had also accumulated a large collection of antiquarian books on subjects such as witchcraft, alchemy and palmistry. Seligmann became a self-taught expert and writer on the occult.

Carrington's own occult interests can be seen in her 1945 dream painting *The House of Opposite* (West Dean College, Sussex). Around this time, living in 'foul and filthy' Chihuahua with her next husband, photographer Csizi Weisz, and infant sons Gabriel and Pablo, Carrington often turned to Seligmann for advice on the occult. She tells him how much she has enjoyed the copy of his book *The Mirror of Magic*, which he has sent her on publication in 1948.

...

Chihuahua 194.
Mexico

Dear Kurt,

I want to tell you I have just come to the end of your beautiful book on Witchcraft & I would like to say how very much delight your lucidity & intelligence have given me. Naturally it is very difficult to give a complete opinion by letter & I am also far more interested in what you have to say on the subject than what I do! all through the book I was most mooved & touched by the scrupulous honesty with which you treated each subject & the great rarity of someone writing on Magic without any attempt at mystification which seems to be the vulgar habit –

I feel I would like to talk to you & unfortunately this being impossible I must content myself with a very inadequate letter –

I am still emprisoned in this foul & filthy place I have 2 beautiful children, 4 dogs, 2 cats & a parrot, but I still hate this place & suffer from the enforced isolation being a commonly sociable creature –

Please give my salutes to Arlette & again my admiration & all possible good wishes for yourself

Yours
Leonora Carrington

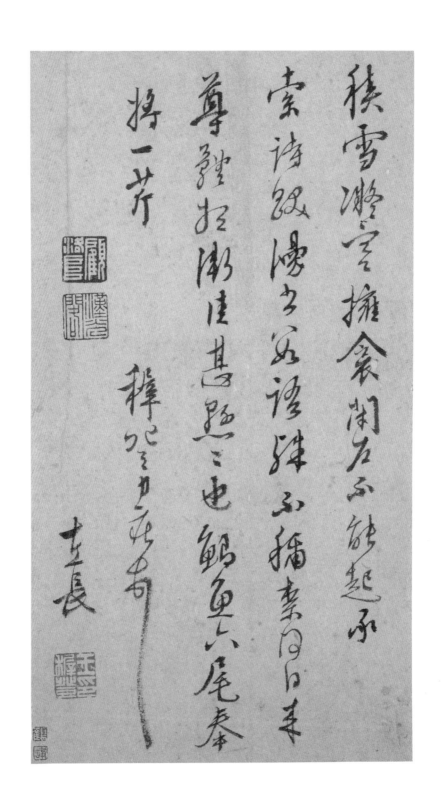

積雪瀰空擁衾閉戶不能起承

寵詩跋湯之窘語詳而播素甚羙

尊體起潮佳甚照二也鵝魚六尾奉

將一芹

　　　　　　　　　　稽穎之月廿四奇

　　士長

Wang Zhideng (1535–1612) to a friend
early 17th century

In Chinese culture, calligraphy or *shūfǎ* ('method of writing') is one of the 'Three Perfections' – an art form not only equal to painting and poetry but integral to the painter or poet's art. The characters are written with an inkbrush in descending columns, from right to left. Wang Zhideng is said to have been a child prodigy, proficient in both calligraphy and poetry by the age of ten. He lived in Suzhou in Jiangsu Province, an old-established city whose textile industries had made it the richest in China. It was also a centre of culture where Wang had access to collections of work by the great painter- and poet-calligraphers of earlier generations. During the middle part of the Ming Period (1368–1644), scholars in Suzhou had been the most admired of all calligraphers. Wang Zhideng based his own calligraphy on that of Wen Zhengming, an influential teacher who was considered one of the 'Four Masters' of the era. After Wen Zhengming's death in 1559, Wang became Suzhou's leading poet-calligrapher.

Some of Wang Zhideng's best-known works are frontispieces for handscrolls, like an album of fundraising essays produced in 1610 for the Buddhist monastery of Fuyuan. Standing on an island in a lake near Suzhou, the buildings were in a decrepit state, 'overgrown with thorns and brushwood'. 'If the old Fuyuan Monastery could be revived,' runs the poem with which Wang Zhideng rounds off his essay, 'The sound of the spring and the shade of the pines would fill the monastery gate.' In this informal get-well letter to a friend, accompanied by a gift of fish, Wang's 'tall and slightly pinched' characters have been described as graceful but lacking the strength and rhythmic boldness that connoisseurs enjoyed in Wen Zhengming. On the other hand, laid up on a snowy day in a freezing house, he may simply have been feeling – as he explains in his letter – too cold and ill to do his best.

..

Surrounded by thick snow and in a freezing house,
wrapping myself with a blanket, with the window tightly closed, I can't even get up.
To compose poetry or prose, trying to write several words,
Just doesn't work at all.
I sincerely hope that you are getting better and better day by day.
I send you a gift of six carp.

Sincere greetings to you,

Wang Zhideng

June 26, 1994

Dear Don;

How are you and your family? This is to let you know that you'll be receiving my sculpture work as a gift in a short while. This work was exhibited in Philadelphia Civic Center Museum for "American Woman Artists Show" sponsored by the group called "FOCUS", there during April 27 ~ May 26.

I'll be in New York before long, and I'm looking forward to seeing you and your family then.

Best regards,

Yayoi

Yayoi Kusama (b.1929) to Donald Judd

26 June 1974

Yayoi Kusama had already had several exhibitions in her native Japan when she moved to New York in 1958 and began work on a series of vast abstract paintings she called *Infinity Nets.* From childhood she had experienced hallucinations in which her entire visual field was filled with dots or patterns. The 'nets' of her new paintings – some of them 40 feet long – were constructed from innumerable small paint marks, one of several strategies Kusama would develop for controlling and containing the panic her hallucinations caused. She worked obsessively, often through the night. Her first solo exhibition in New York, at Brata Gallery in October 1959, was reviewed by Donald Judd, a former art student turned 'mercenary' critic. He thought Yayoi's work 'the best paintings that were new in any way ... besides from Newman and Rothko and the older people' and bought one for $200. For Kusama, Judd became 'my first close friend in the New York art world'. He helped her with her US residency application and during the early 1960s lived in the same building in downtown Manhattan.

Judd started exhibiting his own paintings, then in 1962 abandoned his 'half-baked abstractions' for sculpture. Using sheet metal and wood, he constructed what he called 'specific objects' – objects intended simply to exist rather than to represent, suggest or symbolise. 'Judd had no money to buy art materials,' Kusama recalled, 'so he would go to a nearby construction site, collect wood that was lying about and carry it home.' Kusama watched from the window and signalled if the police appeared. Then suddenly, as 'pioneer and leader of Minimalism', Judd 'grew famous before our very eyes'. At the same time, Kusama's collages and sculptures made from humble mass-produced objects like egg boxes were influencing American Pop artists. She organised happenings and, in the politically charged climate of the late 1960s, a number of nude anti-Vietnam War protests. Her health at that time had gradually begun to decline, and in 1973 she returned to Japan for short-term convalescence, but 'failing to get any better' decided to stay.

Writing from Tokyo in June 1974, she addresses her airmail letter to Judd in New York. She mentions showing work in a recent festival of women's art in Philadelphia, and that she is sending the sculpture in question – a ceramic plaque in the form of intertwined, snakelike red coils, meticulously pitted with Kusama's characteristic dots – as a gift.

...

Dear Don;

How are you and your family? This is to let you know that you'll be receiving my sculpture work as a gift in a short while. This work was exhibited in Philadelphia Civic Center Museum for 'American Woman Artists Show' sponsored by the group called 'FOCUS', there during April 29 – May 26.

I'll be in New York before long, and I'm looking forward to seeing you and your family then.

Best regards,
Yayoi

40-41 221ST STREET
BAYSIDE, N. Y.

hot ⟹ but

Dear ERICH,

zänks a lot für die wonderful
boxes — really for an advanced Hobbyist
as I am — it's grand —

— NOW — listen: boy!

You are cordially invited to attend the
birthday Party of ME Thursday 26 afternoon
we will have lots of drinks, this time
ME too

shake hands
yours old

George Grosz

If you got any new
Together —
bring em' along
will' ye ?

George Grosz (1893–1959) to Erich S. Herrmann
July 1945

George Grosz invites his friend Erich Herrmann to his fifty-second birthday party in July 1945, promising 'lots of drinks, this time ME too', as if Grosz will also be celebrating the end of a spell of abstinence. The boxes for which he thanks Herrmann might have contained cigarettes or cigars – in another letter, he hopes that his friend has brought back some of his favourite English pipe tobacco from a trip to London.

Grosz's Anglophile tastes went back to his years as a young artist in Germany during the First World War, when he changed his name from Georg to George in protest at anti-British propaganda. In his satirical pen-and-ink drawings and paintings, excoriating the German military, bourgeoisie and anyone whose actions were shaped by prejudice, mindless obedience or social pretension, he wanted his art to achieve the kind of moral impact that William Hogarth's had had in eighteenth-century England. He aimed for 'Hardness, brutality, clarity that hurts!' In 1918 he joined the Berlin Dada group (see also page 69), whose members were variously exploring 'visibly shattered' art forms, such as collage and photomontage, as a means of addressing 'the thousandfold problems of the day'.

In 1932 Grosz travelled to New York as a visiting professor at the Art Students' League. Back home, as a radical artist and a communist, he was both appalled and personally threatened by the rise of Nazism. As it became clear that Adolf Hitler, appointed *Reichskanzler* in 1933, was determined to seize dictatorial power, he emigrated to the United States. Living in the more liberal society of which he had long dreamed, Grosz lost his satirical drive for 'clarity that hurts'. But his work was respected and collected. Grosz eventually returned to live in his native Berlin in May 1959, where he died a few weeks later from injuries sustained falling downstairs, apparently after 'lots of drinks'.

40-41 221st Street
Bayside, N.Y.

Dear ERICH,
zänks a lot für die wonderful boxes – really for an advanced Hobbyist as I am – it's grand –
- NOW – listen: boy!
You are cordially invited to attend the birthday Party of ME Thursday 26 afternoon
we will have lots of drinks, this time ME too
shake hands
yours old

George Grosz

If you got any new Tagebüch
bring em' along
will' ye?

Yoko Ono (b.1933) and John Lennon (1940–1980) to Joseph Cornell

23 December 1971

In September 1966 the Japanese-American artist Yoko Ono arrived in London for the Destruction of Art Symposium – a gathering of radical experimental artists of all persuasions – and decided to stay. A few weeks later, at her exhibition *Unfinished Paintings and Objects* at the Indica Gallery, she met the British rock star John Lennon. Ono too was a star in her own world of performance art, happenings and avant-garde music. Her *Cut Piece*, in which she sat Buddha-like on stage while members of the audience gradually cut off her clothes, first performed in Kyoto in 1964, became the closest thing to a classic to come out of the 1960s' experimental art scene. In 1968 Ono and Lennon began a relationship and long-term creative collaboration in which music, performance and anti-Vietnam War protest gained a world stage through their combined fame and gift for seizing the popular imagination. They married in March 1969. The first of their Bed-Ins for Peace – a celebrity variant of the sit-in student protests that had swept European and American universities in 1968 – took place in their honeymoon suite in the Amsterdam Hilton.

After Lennon left the Beatles in September 1969, he and Ono lived for two years in a Berkshire country mansion, Tittenhurst Park, where they formed the Plastic Ono Band, recorded a series of albums and continued their anti-war activism. In December 1969 they organised a billboard campaign in twelve international cities, featuring posters with the message 'War Is Over! If You Want It – Happy Christmas from John and Yoko' in giant letters. *Imagine* – the last album Lennon recorded before he and Ono moved to New York in autumn 1971 – carries Ono's famous cover image, a double exposure in which a cloud floats across Lennon's dreamily idealistic face.

Convinced that the press were not taking their protests seriously, Lennon decided that the most effective way to get their political message across to the public was 'with a little honey'. Written with Ono and released in December 1971, the single 'Happy Xmas (War Is Over)' became a Christmas standard. This 'war is over' Christmas card, jointly signed to the artist Joseph Cornell (see page 87), adds a civil rights dimension to the protest by showing the Statue of Liberty giving the Black Power clenched-fist salute.

Reclusive yet mysteriously well connected in avant-garde circles, Cornell would have known Ono from her pre-Lennon life in New York. He recalled how Ono and Lennon visited him at his home on Utopia Parkway in the suburb of Queens, that Ono was wearing a see-through dress, and that he agreed to sell them ten collages on condition she gave him a kiss on the cheek.

..

Happy Xmas from J + Y

Joseph Cornell
3708 Utopia Pkwy
Flushing, N.Y.

JOAN MIRÓ
"SON ABRINES"
CALAMAYOR
PALMA MALLORCA
 26/VIII 63.

 Cher ami, merci beaucoup,
pour le livre qui vous a été consacré
et que j'ai reçu par l'intermédiaire de
Monsieur Gili, de Barcelone.
 Je l'ai regardé avec un très grand,
plaisir, vous savez l'admiration que j'ai
pour votre oeuvre.
 Avec tous mes hommages à mme
Breuer, je vous envoie mes meilleures
et sincères salutations,

 Miró.

MARCEL BREUER
& ASSOCIATES

AUG 28 1963

BREUER	
BECKHARD	
EMSILE	
GATJE	
SMITH	
FILE NO.	

Joan Miró (1893–1983) to Marcel Breuer
26 August 1963

A short thank you note from an artist to an architect. Marcel Breuer (see also page 177) has sent Joan Miró a book about his buildings, probably *Marcel Breuer Buildings and Projects, 1921–1961*, which was published in New York in 1962. He apparently asked a mutual friend, the Barcelona-based architect Joaquim Gili, to deliver his gift. The Catalan Miró writes to the Hungarian-born, German-speaking Breuer in French. He does not claim to have read the book (his English was far from fluent), but he has 'looked through it with great pleasure', perhaps not appreciating – or at any rate not commenting on – the fact that it deals with a building on which he had himself worked five or six years earlier, the UNESCO headquarters in Paris.

In 1957 Miró was one of eleven artists commissioned to decorate the UNESCO building, for which he designed two large outdoor ceramic murals, the *Wall of the Sun* and the *Wall of the Moon*, which were fabricated by his long-time collaborator the ceramicist Josep Llorens Artigas. Though he tells Breuer 'you know how much I admire your work', the colourful murals, with their mysteriously animated signs and dreamlike forms, drawn freehand with Miró's distinctive curves and intersections (evident also in his note), were meant as an antidote to the uncompromising geometries of Breuer's modernist idiom and grey concrete fabric.

..

Joan Miró
'Son Abrines'
Cala Mayor
Palma Mallorca

Dear friend, many thanks for the book all about you which has been delivered to me by monsieur Gili of Barcelona.

I have looked though it with great pleasure, you know how much I admire your work.

With my best wishes to you, and my respects to Mrs Breuer,

Miró

Chapter 4

'The best I have painted'

Patrons & Supporters

Guercino (1591–1666) and Paolo Antonio Barbieri (1603–49) to unknown recipient
1636

In Greek mythology, when Sisyphus, the crafty king of Corinth, arrives in the Underworld, he is condemned to push a boulder up a hill. No sooner has he reached the summit than the rock rolls down, forcing Sisyphus endlessly to repeat his labours. Around 1636 the Bolognese painter Giovanni Francesco Barbieri (known as Guercino, 'the squinter') made numerous drawings of Sisyphus, exploring ways of showing a middle-aged male body struggling with an impossible burden. In some, Sisyphus carries the boulder on his back; in others he heaves it uphill. In one, sketched on the back of a letter, he clasps the rock to his chest. Guercino may have been preparing for a painting of Sisyphus commissioned by Count Girolamo Ranuzzi (now lost). He later returned to the theme in *Atlas Supporting the Celestial Globe* (Museum Bardini, Florence).

The draft letter Guercino reused (he rarely ran short of fresh paper) was written by his younger brother, Paolo Antonio, to a patron. Paolo was also an artist, though he stuck to modest subjects such as still lifes, to which Guercino sometimes added figures. Paolo mentions Guercino's painting *Abigail Appeasing the Wrath of David* (now lost) and seems to be interceding on his behalf to correct some misunderstanding. But the draft is too fragmentary to give much more than a general impression of an artist facing the familiar problem of finding a tone between robust professionalism and servility.

..

[...] speaking to the brother of your lordship, [...] he told me that it satisfied him and I, to serve you, will address the correction. I was very happy that the painting [...] of Abigail was satisfying to His most Eminent Cardinal Antonio [Barberini] and also to others who saw it, but my brother [...] heard some advice from Cardinal Antonio and from Cardinal Spada in response to those letters he gave your lordship. I am sorry I did not have something to propose from my own hand, as I would happily send it to your lordship so that he would make one most to your liking, but you know that little impedes me [...] to work [...] Regarding a drawing from my brother, in his letter he promised to do something and I will not forget to remind him [...] I will see to it to procure you one, as I wish to serve you in all I may do. Confidentially, [...] your lordship that my brother has been very ill since yesterday. Some words mentioned in the first letter which you say, that are quickly written, and what more are [...] speaking in your service, where from a friend one should not [...] expect such words, much less from your lordship whom has always been served in all that he has commanded. But I made myself available to mitigate whatever I could and for [...] end with every affection of the heart to your lordship [...]

I helped however I could to mitigate, and he replied that he was [...] to see [...] if the expressions corresponded to the words. And I kiss you [...]

I have come to the conclusion that the "art world" has to join us, women artists, not we join it. When women take leadership and gain just rewards and recognition, then perhaps, "we" (women and men) can all work together in art world actions. Until the radical rights of women to determine such actions is won, all we can expect is tokenism.

When men follow feminist leadership to the extent that women have followed male leadership, then sexism is on its way out. Also, until we see women getting from 40 to 60% of the financial rewards, museum and gallery exhibitions, college jobs, etc., etc., etc., it is still tokenism. When women artists attain this, then we'll know the sexist system is over.

Hopefully women artists will not be satisfied with parity, but will continue to search for alternatives. Women's goals must be more than parity. The established patterns in the art world have proven frustrating and mostly non-rewarding to women a artists since the ideal feminist stance of alternate structures is contradicted by the status quo. But such an ideal of non-elitist milieus will only prove itself over a long period. While we claim the right to search for alternatives, we don't intend to let the rewards of the system remain largely in male hands.

Women artists have only recently emerged from the underground (the real underground, not the slick storied underground of the 60's) waging concerted political actions. Our future is to maintain this political action and energy.

Nancy Spero
New York, Feb. 1976

Nancy Spero (1926–2009) to Lucy Lippard
February 1976

During the 1970s the American artist Nancy Spero and critic Lucy Lippard were active in the women's movement, questioning and countering the male dominance of the art world (most high-profile exhibitions at that time consisted mostly or exclusively of works by male artists). Spero had started her career as a painter, exhibiting in New York galleries, but in the mid-1960s she turned to more ephemeral media and political, non-commercial forms of art. From 1974 onwards, women's experience became the central focus of all her work. Assembling an eclectic range of material from historical narratives, literature, visual culture and mythology, she combined drawing, printmaking and collaged ephemera in scroll-form panoramas. When she wrote to Lippard in early 1976, she was working on *Torture of Women*, a series of first-hand accounts of female torture victims in which the brutal texts are accompanied by mysterious, quasi-mythological female figures.

Lippard had spent the past six years curating an unprecedented series of exhibitions featuring only women artists. She had also recently written a book about the sculptor Eva Hesse (see page 117), who became an important figure for feminist art after her early death in 1970. With its impassioned but public tone, Spero's letter reads like a statement or manifesto (Judy Chicago's letter to Lippard on feminist themes is much more personal; see page 133). In her championing of 'the radical rights of women', Spero echoes suffragette political rhetoric of the 1900s. Her rejection of 'tokenism' and insistence that the 'search for alternatives' is more important than 'parity' remain live arguments today.

I have come to the conclusion that the 'art world' has to join us, women artists, not we join it. When women take leadership and gain just rewards and recognition, then perhaps, 'we' (women and men) can all work together in art world actions. Until the radical rights of women to determine such actions is won, all we can expect is tokenism.

When men follow feminist leadership to the extent that women have followed male leadership, then sexism is on its way out. Also, until we see women getting from 40 to 60% of the financial rewards, museum and gallery exhibitions, college jobs, etc., etc., etc., it is still tokenism. When women artists attain this, then we'll know the sexist system is over.

Hopefully women artists will not be satisfied with parity, but will continue to search for alternatives. Women's goals must be more than parity. The established patterns in the art world have proven frustrating and mostly non-rewarding to women a artists since the ideal feminist stance of alternate structures is contradicted by the status quo. But such an ideal of non-elitist milieus will only prove itself over a long period. While we claim the right to search for alternatives, we don't intend to let the rewards of the system remain largely in male hands.

Women artists have only recently emerged from the underground (the real underground, not the slick storied underground of the 60's) waging concerted political actions. Our future is to maintain this political action and energy.

Nancy Spero
New York, Feb. 1976

Pierre-Auguste Renoir (1841–1919) to Georges Charpentier
15 October c.1875–77

In March 1875 a group of painters, including Pierre-Auguste Renoir and Claude Monet (see page 73), organised an auction of their work at the Hôtel Drouot in Paris. The previous year they had exhibited together in what became known as the First Impressionist Exhibition. They were attracting attention, but their prices were still very low. Renoir sold twenty paintings for an average of 112 francs each – less than 5 per cent of what an established artist could expect. The publisher Georges Charpentier bought three of them. Over the next five years, he became Renoir's most supportive patron.

As well as commissioning portraits of his family, Charpentier asked Renoir along to his regular Friday salon. Guests included writers such as Gustave Flaubert and Émile Zola, whose novel *L'Assommoir* Charpentier invited Renoir to illustrate, and influential liberal politicians – potential contacts, Renoir hoped, for public commissions. Renoir was producing what would become some of his best-loved paintings, among them *Ball at the Moulin de la Galette* (Musée d'Orsay, Paris) and *A Girl with a Watering Can* (National Gallery of Art, Washington), but his financial problems went on. There were endless notes to Charpentier and his wife, requesting help with the rent (400 francs a month) and living expenses. In this one, Renoir embraces the postman who delivers the money.

The Charpentiers' patronage had the effect of distancing Renoir from his fellow Impressionists, with whom he stopped exhibiting. In October 1878 he completed a large family portrait, *Madame Charpentier and Her Children* (Metropolitan Museum of Art, New York), which Marguerite Charpentier was determined to see displayed in the official Salon exhibition. 'The Charpentiers are pushing Renoir,' Camille Pissarro observed. The portrait was duly accepted. 'Madame Charpentier wanted it to be in a very good position,' Renoir later recalled, 'and Madame Charpentier knew the members of the jury, whom she lobbied vigorously.' Renoir had spent a month on the painting, for which he was paid 1500 francs. There would be no more waiting for the postman.

received letter from Cognac.

but if even so you want to be kind, keep 150 francs for me for the end of the week [and] I'll do to you the same as to the postman,

kind regards
Renoir

4/5/63

Dear Ellen,

I finally finished the two works
you photographed at my Broad St.
studio. The original cartoons are enclosed
here along with some photos of
earlier work. I don't seem to have
black & white
photos of anything from 1951 to my
recent work. I hope these are of
help.

Come see us when you're in this
area. Isabel sends regards.

Ray

P.S. Ileana will take the "I know how
you must feel, Brad" & someone
has "My Heart is always with you
probably has photos of the finish

ALTHOUGH HE HOLDS HIS
BRUSH AND PALETTE IN HIS
HANDS, I KNOW HIS HEART
IS ALWAYS
WITH ME!

Roy Lichtenstein (1923–97) to Ellen H. Johnson
5 April 1963

On a visit to Roy Lichtenstein's studio in early 1963, the art historian Ellen Hulda Johnson was interested in two works-in-progress that eventually turned into the large painting *I Know How You Must Feel, Brad* (Ludwig Forum für Internationale Kunst, Aachen) and the screenprint *Girl at the Piano*. Both were based on figures of American girls in romantic comic strip frames, which Lichtenstein cut out and enclosed with this letter. It was only a couple of years since he had begun to base his paintings on comic strips, even reproducing in oil and acrylic paint the Ben-Day dot method of colour printing, but he was already being billed as a star of the new phenomenon of American Pop. His first solo exhibition, at Leo Castelli's New York gallery in February 1962, sold out before it opened.

Brief though it is, Lichtenstein's letter preserves traces of an intricate network of art-world contacts. Johnson was a lecturer at Oberlin College, a Cézanne and Picasso scholar who also advised the college on acquisitions and exhibitions of contemporary American art. He might reasonably have guessed that the photographs she took in his studio would play a part in her efforts to give Pop art a historical (i.e. validating) lineage. The comic strip source material is exactly the kind of supporting evidence that would appeal to an art historian (rather than, say, a dealer). In 1966 Johnson published an article on Lichtenstein in which she described *I Know How You Must Feel, Brad* as 'a powerful, commanding painting', comparable to Ingres' magisterial 1851 portrait of Madame Moitessier (National Gallery of Art, Washington). In his debt to popular culture and technical concern with colour division, she saw Lichtenstein as an American heir to the French pointillists, whose work was 'as far removed from the original comic as Seurat's paintings are from Chéret's posters'.

In the autumn of 1962 Castelli's ex-wife, the Romanian-American art dealer Ileana Sonnabend, opened a gallery in Paris, which would serve as a gateway to the European market for Castelli's artists. A scene-setting group exhibition in May 1963, *Pop art américain*, was followed in June by another solo show for Lichtenstein, which included *I Know How You Must Feel, Brad*. This painting has become – as Johnson both intuited and helped to bring about – one of the best-known and most widely reproduced examples of 1960s American Pop.

...

Dear Ellen,

I finally finished the two works you photographed at my Broad St. studio. The original cartoons are enclosed here along with some photos of earlier work. I don't seem to have black & white photos of anything from 1951 to my recent work. I hope these are of help.

 Come and see us when you're in this area. Isobel sends regards.

Roy

P.S. Ileana will take the 'I know how must Feel, Brad' and someone in Kansas C. has 'My Heart is always with you'. Leo probably has photos of the finished work

Monsieur

Voyci la Peinture de S. Laurens en escurial
faictte selon la Capacité du maistre toutesfois
aucdg mon aduis, Plaira a Dieu que l'extrauagance
du Sugect puisse donner quelque recreation a sa Mat.te
La montaigne s'appelle la roma de S. Juan en
Malagon, elle est fort saulte et erte, et fort
difficile a monter et descendre, de sorte que nous
auions les Nuees dessous nostre veue bien bas,
demeurant en sault le ciel fort clair et serain,
Il i at en la Summité un grande Croix de bois
laquelle se decouure ayssement de Madrit, et il y à de
Coste une petite Eglise dediée a S. Jean qui ne se
pouuoit representer dedans ~~nostre~~ le tableau, car
nous l'aurons derriere le dos, ou que demeure un
Eremite que voyez aucg son borico, Il n'est pas
besoing que en bas est le Superbe bastiment de S.te
Laurens en escurial aucg le Villaage et ses allées
d'arbres aucg la fresneda et ses deux estangs et
le chemin vers madrid qu'apparoist en sault proche
de l'orizont, la montagne couuerte de ce nuage se
dit la Sierra tocada pource quelle a quasi tous
jours comme un voyle alentour de sa teste
Il y quelque tour et mayson à Coste ne me souuenant
pas de leur nom particulierement, mais Je scay que
le Roy s'alloit par occasion de la Basse
montagne tout contre à main Gauese este la Sierra
y puerto de butrago voyla tout ce que Je puis
dire sauce Sugect demeurant a jamais

Peter Paul Rubens (1577–1640) to Balthasar Gerbier
April/May 1640

Written from Antwerp in the spring of 1640, this is almost the last surviving letter from Rubens's copious correspondence as international artist and diplomat. He died a few weeks later, aged sixty-two. Employed on grand state commissions by the British king James I, the Flemish artist, who routinely travelled from court to court in pursuit of his art, was later entrusted by James's son Charles I with secret diplomatic missions. In autumn 1628 he arrived in Madrid, where he spent the next few months producing paintings for King Philip IV and negotiating a peace treaty. He was accompanied by two other artist-diplomats, Balthasar Gerbier and Endymion Porter, and became friendly with Philip IV's court artist Diego Velázquez. One day Rubens and Velázquez climbed into the mountains north of Madrid, where they could look down at the sprawling royal palace of El Escorial.

Rubens did a drawing on the spot, on which Pieter Verhulst – 'a very mediocre artist', in his view – later based a painting. This is the work that Gerbier, now in his role as Charles I's trusted art consultant, wants to acquire for the royal collection. As Rubens describes Verhulst's painting, so that Gerbier can relay the information to the king, the mountain landscape, place names and experience of being up above the clouds come back to him, vivid and precise.

Monsieur:

Here is the picture of St Lawrence in Escorial, finished according to the capacity of the master, but with my supervision. Please God, the extravagance of the subject may give some pleasure to His Majesty. The mountain, which is called La Sierra de S. Juan en Malagon, is very high and steep, and very difficult to climb and descend, so that we had the clouds far below us, while the sky above remained very clear and serene. There is, at the summit, a great wooden cross, which is easily seen from Madrid, and nearby a little church, dedicated to St John, which could not be represented in the picture, for it was behind our backs; in it lives a hermit who is here seen with his mule. I need scarcely say that below is the superb building of St Lawrence in Escorial, with the village and its avenues of trees, the Fresneda and its two ponds, and the road to Madrid appearing above, near the horizon. The mountain covered with clouds is called La Sierra Tocada, because it almost always has a kind of veil around its top. There is a tower and a house on one side; I do not remember their names particularly, but I know the King used to go hunting there occasionally. The mountain at the extreme left is La Sierra y Puerto de Buitrago. This is all I can tell you on the subject, remaining ever, Monsieur

Your very humble servant,
Peter Paul Rubens

I forgot to say that at the summit we found forze venyson, as you see in the picture. [Note in another hand, in English: he means deare, wich is called venson when putt in crust.]

Dear Leo, Have your series finished —
9 in all and 1 separate piece if you need it.
They are shaped this way □ & can go 2 on the facing wall 3 on each side & 1 on the small inner wall making the total 9 —
I am really terribly happy over them & think that you will be pleased by them.
Now they must have some time to dry —
Will have them stretched

Cy Twombly (1928–2011) to Leo Castelli

c. January 1964

In the winter of 1963 the young American artist Cy Twombly painted a series of nine large canvases, titled *Discourses on Commodus*. Twombly had been living in Rome since 1957. The invitation to show at Leo Castelli's gallery was a rare chance to reconnect with the New York art scene. In the 1960s Castelli was one of the most successful commercial gallerists in the world, giving first shows to Jasper Johns, Roy Lichtenstein (see pages 33 and 109) and other soon-to-be-famous practitioners of Pop, minimalist and conceptual art. When he took on an artist, he provided solid financial support. Twombly thanks him for paying for an expensive sculpted head of the Roman emperor Aurelius Commodus that has inspired his new series. He thinks – or wants to think – of Castelli as a friend, sending 'fond regards' to his new family (Castelli remarried in 1963) and thanks to his co-director, Ivan Karp.

Like much of Twombly's work, the *Commodus* series draws on classical history. But the violence of Commodus' reign and death – red paint scrawled and splattered on a flat grey ground – echoes the very recent assassination of President John F. Kennedy in November 1963. When Twombly's exhibition opened in March 1964, however, the reviews were bad. In the Pop era his expressionist brushwork looked like yesterday's art, and why was a contemporary American painter immersing himself in 'old Europe'? Not a single painting sold.

Twombly's bouncy optimism – 'I am really terribly happy over them' – turns to despondency. Over the next few years, he paints less. The *Commodus* series has to wait until his retrospective at the Whitney Museum of American Art in 1979 for its next appearance in the United States. Now, at last, as the *New York Times* remarks, 'Mr Twombly has his moment'.

..

Dear Leo, Have your series finished – 9 in all and 1 separate piece if u need it. They are shaped this way [sketch of upright rectangle] & can go 2 on the facing wall 3 on each side & 1 on the small inner wall making the total 9 –

I am really terribly happy over them & think that you will be pleased by them. Now they must have some time to dry – Will have them stretched but very good dry wood (if possible) – Plinio [De Martiis] wants to do all 9 in color for a small book as soon as they are able to be stretched. Any way if you would like to make plans as to the time – Maybe in March as we talked of because they can certainly be sent by the middle of Feb – What else? Did you want drawings and how many do you think of –? Thank you so much for giving the check on the Commodo. I lost my head for it but it inspired this series so maybe it is good to loose my head & gain a new – My fond regards to your nice new family – & also thank Ivan for his always kind help.

love – Cy

My dear Mr Clarke

I send To day
to Mr Knoedler
the last of the
three pictures that
you are to have
for The Union League

I consider it

2
the best that I
have painted.
the Point Prouts Neck is
The western light
I got round the
Point of Prouts Neck
overlooking the bay
Old Orchard —

You will see

[Jan. 4, 1901]

of Old Orchard
on the right hand
of The Picture.

I have not put
any price on these
Pictures — Mr Knoedler
will have Them for
Sale in a week or

so — This makes
every picture that
I have (but two.
One at The Cumberland
Club. Portland me —
One in my studio

Yours very truly
Winslow Homer

Mr Thomas B Clarke
22 East 34 St New York

Winslow Homer (1836–1910) to Thomas B. Clarke
4 January 1901

At Prout's Neck, a rocky peninsula on the coast of Maine, Winslow Homer had his seafront studio fitted with a wide balcony, where he could paint looking out across Saco Bay. After moving here from New York City in 1884, he had adapted a former carriage house to serve as his workplace-home, relocating the entire building (as Jackson Pollock would do with his shed on Long Island) for greater seclusion. Homer had made his name in 1866 with a scene from the American Civil War, *Prisoners from the Front* (Metropolitan Museum of Art, New York), showing a group of captured Confederate soldiers staring down a Union officer. During the 1870s he had worked very much in the *plein-air* (outdoor) idiom practised in coastal art colonies in the Netherlands, France and England, where Homer spent 1881–2 in the north-east fishing port of Cullercoats.

The seascapes he painted at Prout's Neck turned from the worlds of waterside labour and leisure to the unpeopled drama of the elements, as in *Northeaster* (1895; Metropolitan Museum of Art, New York), where a wind-driven wave crashes explosively onto a dark ledge of rock. Paintings of this kind, including the recent work he describes to Thomas B. Clarke, *West Point, Prout's Neck* (1900; Clark Art Institute, Williamstown), made Homer rich. The self-portrait sketch in his letter seems to indicate lights on the far shore of the bay, visible from his balcony; in the painting, he edited out these signs of human life.

Humorous and self-assured, his brief business note also sketches a moment in New York's cultural history. Homer's dealers, M. Knoedler & Co., sold contemporary and Old Master paintings into the great private and institutional collections of the day. The former linen magnate, now full-time art dealer Clarke not only chaired the Union League Club's art committee but also advised the financier John Pierpont Morgan, a phenomenally generous benefactor to the Metropolitan Museum of Art, of which he would become president in 1904.

..

Scarboro Me

my dear Mr Clarke

I send today to M. Knoedler The last of the three pictures that you are to have for the Union League
I consider it the best that I have painted. Title 'West Point Prouts Neck. Me' The western light I get from the Point of Prouts Neck overlooking the bay & Old Orchard – you will see on the right hand of the picture. I have not put any price on these pictures – M Knoedler will have them for sale, in a week or so – This makes every picture that I have. (but two. (One at the Cumberland Club. Portland Me – & one in my studio

Yours Very Truly
Winslow Homer
Mr. Thomas B Clarke
5 – East 34 New York NY

Dear Dr. Papanek _Mono_

Heard from Michigan + California. Both are yes! Spent a difficult weekend since I heard Friday from Mich. I was unhappy. Today I feel great, Will finish and see you soon.

My dad is ill, nothing serious I hope.

I have needed the pills on ~~Fifth~~. Chet is fine.

Love

Eva

Eva Hesse (1936–70) to Helene Papanek
6 April 1959

Eva Hesse was in the last term of her degree at Yale School of Art and Architecture when she suffered a recurrence of the anxiety and depression for which the psychotherapist Helene Papanek had been treating her since she was seventeen. On 14 March 1959 she told Papanek that, after waking up unable to breathe, she'd been admitted to Yale Mental Health Center but discharged, in her view, too early. Papanek wrote straight back, 'I am very sorry to hear that you are so upset and anxious … I thought that you were alright'. Hesse confirmed that her panic had been triggered by coursework and relationships, adding 'But it is more than that. I am afraid.'

On 27 March Hesse saw Papanek in New York, confessing to suicidal feelings. Papanek gave her some anti-psychotic medication. 'Thankyou!!' wrote Hesse two days later, 'speaking to you was very helpful.' The pills were also working. Papanek informed Hesse's physician at Yale, Dr Lawrence Friedman, about her relapse. She diagnosed 'a vicious circle of clutching at others, feeling guilty about it, and needing more support because of her guilt feelings'. Friedman, too, had hoped that Hesse was on the mend, noting that she had completed a philosophy paper and secured a summer job, but he acknowledged the new crisis. She had already been to him for a Compaxine prescription. Papanek must have received his letter the same day as another from Hesse: 'I have had a few good days but am sinking again.' Papanek replied, 'Whenever you want to see me and can come to New York, let me know.' This letter crossed with Hesse's postcard – the last in this intense, frank, painful burst of correspondence but by no means the end of the story – in which she mentions job offers, family news and a boyfriend, and reassures Papanek, 'I feel great!'

In 1964, after meeting the American minimalist sculptor Sol Lewitt, Hesse turned from painting to sculpture. She evolved a personal form of minimalism, using irregular textures, organic shapes and anatomical references in place of machine-smooth finishes and anti-expressionistic coolness. Experimenting with fabric, fibreglass and latex, she wanted her work to embody 'absurdity or extreme feeling'. Hesse was only thirty-four when she died of a brain tumour. Her work has been posthumously very influential for sculpture and especially for feminist interpretations of the body in art.

..

Dear Dr Papanek

Heard from Michigan & California. Both are yes!
 Spent a difficult weekend since I heard Friday from Mich. & was unhappy. Today I feel great! Will write and see you soon.
 My dad is ill, nothing serious I hope.
 I have needed the pills on & off. Chet is fine.

Love
Eva

Sept. 5 th

Dear Mr Beatty

I have long been wanting to write to you, & have hardly known how. It is so long ago that I had the pleasure of meeting you in Paris that you may have forgotten the conversations we had at that time. I then tried to explain to you my ideas, principles I ought to say, in regard to jurys of artists, I have never served because I could never reconcile it to my conscience to be the means of shutting the door in the face of a fellow

Mary Cassatt (1844–1926) to John Wesley Beatty
5 September 1905

Born into a prosperous family in Allegheny City (now in Pittsburgh), Cassatt sailed for Europe in 1864 to study art, settling in Paris in 1874. After Edgar Degas asked her to participate in the fourth Impressionist exhibition in 1879, she was firmly identified with the group and shared in the financial success orchestrated by the dealer Paul Durand-Ruel. In 1894 she bought the Château de Beaufresne, from which she wrote this letter to John Wesley Beatty, director of the Carnegie Institute in Pittsburgh.

Politely declining Beatty's invitation to be a juror for the institute's annual art exhibition, she explains how the jury system suppresses creative originality. She cites the Salon des Indépendants, set up in 1884 as an alternative to the official Salon with the motto *'sans jury ni récompense'* ('without jury nor reward'). Cassatt offers to assist the Carnegie Institute in other ways – an offer made good by her later service on its Foreign Advisory Committee.

Mesnil-Beaufresne
Fresnaux-Montchevreuil
Mesnil-Théribus (Oise)

Dear Mr Beatty,

I have long been wanting to write to you, & have hardly known how. It is so long ago that I had the pleasure of meeting you in Paris that you may have forgotten the conversations we had at that time. I tried to explain to you my ideas, principles I ought to say, in regard to jury's of artists, I have never served because I could never reconcile it to my conscience to be the means of shutting the door in the face of a fellow painter. I think the jury system may lead, & in the case of the Exhibitions at the Carnegie Institute no doubt does lead to a high average, but in art what we want is the certainty that the one spark of original genius shall not be extinguished, that is better than average excellence, that is what will survive, what it is essential to foster – 'The 'Indépéndents'' in Paris was originally started by our Group, it was the idea of our exhibitions & since taken up by others, no jury's & most of the artists of original talent have made their debut there in the last decade, they would never have had a chance in the official Salons. Ours is an enslaved profession, fancy a writer not being able to have an article published unless passed by a jury of authors, not to say rivals –

Pardon this long explanation, but the subject excites me, it seems to me a very serious question in our profession, these are my reasons for never having served on the jury of the Institute, if I could be of the least service in any other way I would most gladly. I would consider nothing a trouble to serve the Institute of which you are so devoted a Director. As to sending pictures, this year I have none, they have been sold in Paris and I could not ask the owners to send them so far as it would seem to them.

With my sincere regrets and my renewed excuses, believe me, my dear Mr Beatty

Most sincerely yours
Mary Cassatt

Dear Lou. — It was good to get your letter. I hardly know what to advise — The housing shortage in N.Y. (as every place is) is terrific — don't think there is any thing to be had — possibly a cold water flat on the lower East side.

We are about 100 miles out on Long Island three hours on the train. Have been here thru the winter and we like it. We have 5 acres a house and a barn which I'm having moved and will convert into a studio. The work is endless — and a little depressing at times. — but I'm glad to get away from 57th street for a while. We are paying $5000 for the place. Springs is about 5 mile out of East Hampton (a very swanky wealthy summer place). — and there are a few artists — writers etc. out during the summers. There are a few places around here at about the same price.

Jackson Pollock (1912–56) to Louis Bunce
2 June 1946

Jackson Pollock had his first solo exhibition at Peggy Guggenheim's Art of This Century Gallery in November 1943. His contract with Guggenheim meant freedom to paint full-time (he had previously supported himself by decorating lipstick cases and other odd jobs). As he modestly reports to his friend and former fellow student Louis Bunce, his work has been receiving 'fairly good responses' (in 1944 the Museum of Modern Art bought his painting *She-Wolf*). In October 1945 Pollock married the artist Lee Krasner (see page 211); the following month, the couple left the 'wear and tear' of New York for the village of Springs on Long Island. Pollock grumbles about the move and sounds eager for art-world banter (he mentions Thomas Hart Benton – his and Bunce's traditionalist mentor at the Art Students' League). On the floor of the barn at Springs, which Pollock relocated and converted into a studio, according to the plan he outlines to Bunce, he would create his first 'drip paintings'.

Dear Lou, –

It was good to get your letter. I hardly know what to advise – the housing shortage in N.Y. (as every place is) is terrific – don't think there is any thing to be had – possibly a cold water flat on the lower East side.

We are about 100 miles out on Long Island three hours on the train. Have been here thru the winter and we like it. We have 5 acres a house and a barn which I'm having moved and will convert into a studio. The work is endless – and a little depressing at times. – but I'm glad to get away from 57th Street for a while. We are paying $5000 for the place. Springs is about 5 miles out of East Hampton (a very swanky wealthy summer place). – and there are a few artists – writers etc. out during the summer. There are a few places around here at about the same price.

As you already know I have been able to paint all thru the war – and am very grateful for the opportunity and tried to make the most of it. Have had fairly good responses from the public (interested in my kind of painting) and from a critical point of view. Moving out here I found difficult – change of light and space – and so damned much to be done around the place, but feel I'll be down to work soon [...]

Baziotes', I think is the most interesting of the painters you mentioned – Gorky has taken a new turn for the better – from Picasso thru Miro – Kandinsky and Matta. Gottlieb and Rothko are doing some interesting stuff – also Pousette-Dart [...]

There is an intellgent attack on Benton in this months magazine of art. – it's something I have felt for years. He began coming around before I moved out here. Said he liked my stuff but you know how much meaning that has.

Best to Ede and John and let us hear further on your plans here!

Jack.

Leonardo da Vinci (1452–1519) to Ludovico Sforza
c.1482

Around the age of thirty, Leonardo da Vinci moved from his native Florence to Milan, where he sought employment by Ludovico Sforza, the city's *de facto* ruler. Aware of Ludovico's military ambitions, Leonardo uses his ten-point letter of application (neatly written by a professional scribe) to underline his talents as an engineer. Almost as a postscript, he mentions that he is also as good an artist 'as any other'. Leonardo was appointed 'engineer and painter' to the Sforza court, remaining in Milan until 1500.

My Most Illustrious Lord,

Having now sufficiently seen and considered the achievements of all those who count themselves masters and artificers of instruments of war [...] I shall endeavour, while intending no discredit to anyone else, to make myself understood to Your Excellency for the purpose of unfolding to you my secrets [...]

1. I have plans for very light, strong and easily portable bridges with which to pursue and, on some occasions, flee the enemy [...]

2. I know how, in the course of the siege of a terrain, to remove water from the moats and how to make an infinite number of bridges, mantlets and scaling ladders [...]

3. Also, if one cannot, when besieging a terrain, proceed by bombardment either because of the height of the glacis or the strength of its situation and location, I have methods for destroying every fortress [...]

4. I have also types of cannon, most convenient and easily portable, with which to hurl small stones almost like a hailstorm [...]

5. Also, I have means of arriving at a designated spot through mines and secret winding passages [...]

6. Also, I will make covered vehicles, safe and unassailable, which will penetrate the enemy and their artillery [...]

7. Also, should the need arise, I will make cannon, mortar and light ordnance of very beautiful and functional design [...]

8. Where the use of cannon is impracticable, I will assemble catapults, mangonels, trebuchets and other instruments of wonderful efficiency [...]

9. And should a sea battle be occasioned, I have examples of many instruments which are highly suitable either in attack or defence [...]

10. In time of peace I believe I can give as complete satisfaction as any other in the field of architecture, and the construction of both public and private buildings, and in conducting water from one place to another.

Also I can execute sculpture in marble, bronze and clay. Likewise in painting, I can do everything possible as well as any other [...]

And if any of the above-mentioned things seem impossible or impracticable to anyone, I am most readily disposed to demonstrate them in your park or in whatsoever place shall please Your Excellency, to whom I commend myself with all possible humility.

Egon Schiele (1890–1918) to Hermann Engel
September 1911

Egon Schiele had his first solo exhibition at Galerie Miethke in Vienna in the spring of 1911. The show contained a group of dream paintings, including *Revelation* (Leopold Museum, Vienna), in which two haggard figures seem to cling to each other, their bodies, swathed in multi-coloured robes, forming a luminous pyramidal mass at the centre. It was bought by a dentist, Dr Hermann Engel, who had been introduced to Schiele by one of his early advocates, the critic Arthur Roessler. Schiele was then living in the small town of Krumau (now Český Krumlov) but soon had to decamp in the face of outrage at his use of local girls as models for his sexually explicit nudes. By the end of the summer he was back near Vienna, where he seems to have received an enquiry from Engel.

If Engel was hoping for an easy-to-follow explanation of the strange painting he had bought from this disreputable young artist, he must have been perplexed by Schiele's letter, which speaks the rhapsodic language of mystical thought ('bodies have their own light', 'astral light', 'flows hypnotised'). He did some work on Schiele's teeth, however, for which Schiele settled up by painting a portrait of his daughter, Trude (Lentos Kunstmuseum, Linz). It presents a confident young woman with a magnificent tangle of dark hair, but Trude was so upset by the portrait that she stabbed it with a knife. Hermann seems to have been hardly more responsive to Schiele's art, later simply giving away the paintings he had bought from him, including *Revelation*.

Dear Dr E.

'Revelation!' – The revelation of a certain being; it can be a poet, an artist, a man of knowledge, a spiritist. – Have you ever felt the impression a great personality can make in the world? That would be one. – The painting must emit light from itself, the bodies have their own light, which they consume during their lifetime; they burn; they are unlit. – The figure backwards? – The one half should thus show portrayed the vision of such a great person, that the one who influences kneels down in rapture, bends over before the great one who looks without opening its eyes, who decays, out of whom streams astral light orange or other colour, in such excess that the one who is kneeling flows hypnotised into the great one. – On the right everything is red, orange, deep brown and on the left is the being similar to him, which resembles the great one on the right differently. – (Positive and negative electricity unite.) It should thus mean that the small one on his knees melts into the radiant one. That gives you some idea about my painting. 'Revelation!'

Egon Schiele.

William Hogarth (1697–1764) to T.H.
21 October 1746

The actors David Garrick and James Quin were two stars of the eighteenth-century
London stage, with very different physiques and performing styles. A generation
younger than Garrick, Quin was 'a very natural reciter of plain and familiar dialogue',
who struggled in tragic Shakespearean roles, 'bellowing' and 'growling' his way through
Othello. Garrick shot to fame in 1743 in the title role of *Richard III*, to which he brought
a new Romantic freedom and matinée-idol charisma, both very evident in William
Hogarth's 1745 portrait of him in the role (Walker Art Gallery, Liverpool). The torqued
S-shape of the actor's pose, as he gestures dramatically towards the viewer, is based on
Hogarth's theoretical 'Line of Beauty'. In June 1746 Hogarth published a print of the
painting, which Garrick would sign for his fans.

Hogarth's letter to a certain 'T.H.', a member of a literary society in Norwich,
expresses his abiding interests in both human individuality and classic proportion, and
may have been a response to criticism of his print. The date, October 1746, coincides
with the only season when Quin and Garrick played together, at the Covent Garden
Theatre, London.

..

To T.H.
to be left at the
Post office at Norwich

S[i]r

If the exact Figure of Mr Quinn, were to be reduc'd to the size of the print of Mr Garrick it would
seem to be the shortest man of the two, because Mr Garrick is of a taller proportion.
 examples
 Let these figures be doubled down so as to be shewn but one at once, then let it be ask'd
which representes the Tallest man.

<div align="right">Yours W H</div>

Düsseldorf, den 16. November 1966

Sehr geehrter, lieber Monsignore Mauer!

Ihre Auskunft über „Innsbruck" hat mich gefreut und ich bedanke mich für ihren Brief.

Die Edition Block ist äußerlich gesehen eine Kassette in den Maßen wie auf der beiliegenden Karte beschrieben. Von mir gemeint ist, dass man das ganze Objekt in irgendeiner Weise auseinander legt und in einen tiefen Rahmen oder Kasten einrahmt. Wichtig ist für mich, dass man alle Teile zur gleichen Zeit zusammensieht.

Text I Text II Zeichnung mit 2 braunen kreuzen in Ölfarbe.

kassette halb.fig.kreuz

Es ist einfach. aber für mich eine wichtige Arbeit ein ziemliches Mysterium. Ihr schön gedruckt

Joseph Beuys (1921–86) to Otto Mauer
16 November 1966

Monsignor Otto Mauer was an unlikely figure in the European experimental art scene of the 1960s. As a Catholic priest and resister during the Nazi era, he had survived multiple arrests. After the war, he became a prelate at St Stephen's Cathedral in Vienna, then, in 1954, took over the management of an art gallery next door. Over the next two decades, Mauer turned the Galerie St Stephen into a showcase for performance, installation and conceptual art, including work by the German sculptor, performance artist and activist Joseph Beuys. He also built up a large modern and contemporary art collection for the gallery.

In November 1966, Beuys writes to Mauer, perhaps as a potential collector, about a multiple he is planning to produce with Edition Block, a new publishing venture launched by the Berlin gallerist René Block. It will relate to Beuys's 'Braunkreuz' series, named after a reddish-brown household paint that he has been using in many of his works since 1958. Like other materials favoured by Beuys – felt, wood, congealed fat – 'Braunkreuz' ('Brown cross') paint is both very ordinary and vaguely sacramental, suggesting blood, earth, rusting iron. At this date, Beuys is teaching at the Staatliche Kunstakademie in Düsseldorf and is widely recognised as a leading voice in the 'expansion of art' into everyday life – a shamanic performer whose public 'Actions' combine disparate objects with texts chalked on a blackboard and active dialogue between artist and audience. Beuys's latest Action, titled *Eurasia Siberian Symphony 1963*, took place at René Block's gallery on 31 October 1966. Alluding to Cold War geopolitics and the post-war partition of Germany, it featured a stuffed hare straddling the upper edge of a blackboard, on which Beuys chalked an inverted T – a half cross – like the middle shape sketched in this letter.

Declaring that 'The future belongs to multiples', Block has turned to Beuys for one of his first publishing collaborations. For his part, Beuys will embrace the idea of multiples, going on to produce many more. 'I am interested in the dissemination of physical vehicles in the form of editions,' he reflected. 'If you have all of my multiples, then you have all of me.'

..

Dear Monsignor Mauer!

I was delighted by your enquiry regarding 'Innsbruck' and I thank you for your letter.

The Block Edition has the outward appearance of a cassette, its measurements as per the description in the enclosed card.

My intention is that the whole object may be taken apart in some way, and framed in a deep frame or box.

It's important for me that all the parts should be visible at the same time.

Drawing with 2 brown crosses in oil paint

It's simple, but for me an important work, a real mystery [...]

Dear Sam,

So now you have "Tundra" and "The Lake" I am very glad I think my paintings will be around quite a while as I percieve now that they were all concieved in purest melancoly.

The drawing that you have is called "The Galleries" as upstairs in a church "the balconies divisions" almost floating position of attention I think the drawing has the quality of that experience a particular twilit melancholy. I like it very much I like your paintings too and hope that if my work ever received the recognition of a "show" that you will send them all.

I hope all is well with you. I do not worry about you because I have great confidence in you.

I am staying unsettled and trying not to talk for three years. I want to do it very much.

I stored my small paintings (old, no good) with Mr. Kimbal Blood #275 Sherman Conn. 06784 phone 203·EL4·8828 I wish you would mail him my drawings

I cannot thank you—words failing—for your encouragment and support. Cannot write without trying.

Best wishes always
Agnes.

My address
c/o Rose Caputo Att. 15 Park Row 38
New York NY 10038

Agnes Martin (1912–2004) to Samuel J. Wagstaff
1967–8

Agnes Martin was in the midst of an eighteen-month road trip around her native Canada and the United States when she wrote to her friend and collector Sam Wagstaff about two paintings he had recently bought. *Tundra* (1967; Harwood Museum of Art, Taos) was in fact the last painting Martin had made before quitting the studio in lower Manhattan where she had worked for the past ten years. She sold up, put her paintings in storage and set off in a truck. It would be five years before she painted again.

Wagstaff was curator at the Wadsworth Atheneum in Hartford, Connecticut, where in 1964 he had organised the exhibition *Black, White, and Gray*. Featuring work by twenty-one new-generation American artists, including Martin, Jasper Johns, Roy Lichtenstein, Ad Reinhardt, Cy Twombly and Andy Warhol, it was the first survey of minimalist painting and sculpture. During the 1960s Martin's paintings had taken on a distinctively meditative, minimal form based on pencilled grids within a 6ft square canvas.

The 'purest melancholy' out of which Martin tells Wagstaff that her paintings – apparently so restful and reflective – were conceived relates to her lifelong struggle with schizophrenia. Her plan of 'staying unsettled and trying not to talk for three years' has an element of self-therapy. In 1968 she returned to northern New Mexico, where she had previously lived. In an isolated spot near Taos she built a house and studio from mudbrick and logs, where she 'untroubled her mind at last and attained the imperfect grace of redemption'.

Dear Sam

So now you have 'Tundra' and 'The Lake' I am very glad. I think my paintings will be around now quite a while as I perceive now that they were all conceived in purest melancholy.

The drawing that you have is called 'The Galleries' as upstairs in a church 'the balcony divisions.' almost floating position of attention I think the drawing has the quality of that experience a particular twilit melancholy. I like it very much! I like your paintings too and hope that if my work ever recieved the recognition of a 'show' that you will send them all.

I hope all is well with you. I do not worry about you because I have great confidence in you.

I am staying unsettled and trying not to talk for three years. I want to do it very much.

I stored my small paintings (old, no good) with *Mr. Kimbal Blood #275 Conn. 06784* phone 203. EL4.8828 I wish you would mail him my drawings

I cannot thank you – words failing – for your encouragement and support. Cannot write without trying

Best wishes always
Agnes.

My address
c/o Rose Caputo Att. 15 Park Row
New York NY10038

but, of course he was right. Anyway, you know...in this time of great change, when tedious work is becoming unnecessary, and new ways have to be provided for people, artmaking and art become essential. If the relationship of the artist to her community changes, then people can "be involved" in art in a way they are not now, and the artist can cease to be victim, the barriers between art forms will break down, the barriers between art "roles" will end. Anyway, that's what I'm thinking about. I am asking; What has to be accomplished during this decade so that the woman artist no longer has to be double victim, victim as artist and as woman. Obviously, we need to intro- duce our historic context into the society...ie. make women's art history available in every school, develop a new way to speak about women's art and have that go on on a large scale, send teams of women trained in feminist educational techniques into the schools around the country ao help women make contact with themselves and work out of themselves, disseminate lots of information on what 's going on, the new ways of thinking...all of that hopefully will happen out of the workshop. There are some fantastic women coming into it/ God, I wish you were with us. Then, we'd really have the market cornered.

 Enough...Love and kisses and all that,

Judy

This is definitely not a "cool" letter....

Somewhere over the..... oh, no!
← Corny!

Judy Chicago (b.1939) to Lucy Lippard
Summer 1973

Judy Chicago's three-page typewritten letter to the critic and curator Lucy Lippard (see also page 105) opens with a tongue-in-cheek response to Lippard's exhibition of conceptual art by women at California Institute of Arts (CalArts) in Valencia. In 1971 Chicago and Miriam Shapiro had set up the Feminist Art Program at CalArts. With twenty-one of their students, they created *Womanhouse*, repairing a run-down Hollywood mansion to house multiple feminist installations and performances. *Womanhouse* became the first feminist art project to achieve national coverage. In 1973 Chicago co-founded the Feminist Studio Workshop in Los Angeles, after which she spent four years producing *The Dinner Party* (Museum of Modern Art, San Francisco), a triangular table with settings representing thirty-nine famous historical women. Her letter to Lippard, in which she says 'I will be withdrawing from public life', marks this transitional moment.

Hiya, Lucy my dear ...

I saw your show at Cal-Arts yesterday and was pleasantly surprised to say that I liked it ... you can imagine how my direct Jewish soul has trouble with all the intellectuality of most concept art ... no guts, you know, and if it isn't mushy, I can't understand it ... At any rate, I thought the show was really interesting, and certainly different from male concept art, more personal, more subject matter oriented, certainly more feminine [...]

You know, a lot of people have hassled me in the last several years about whether my 'political activity' was interfering with my art, and it always made me feel vaguely guilty [...] I suddenly realized that the guilt was similar to the guilt I used to feel when people implied that I was somehow stepping out of 'female role' ... there is really an 'artist role' and I am determined to break out of it [...] That role demands that the artist, like the woman, be victim ... dependent upon the approval of the Establishment [...] Anyway, you know ... in this time of great change [...] artmaking and art become essential. If the relationship of the artist to her community changes, then people can 'be involved' in art in a way they are not now, and the artist can cease to be victim, the barriers between art forms will break down, the barriers between art 'roles' will end [...] I am asking; What has to be accomplished during this decade so that the woman artist no longer has to be double victim, victim as artist and as woman? Obviously, we need to introduce our historic context into the society ... i.e. make women's art history available in every school, develop a new way to speak aboat women's art and have that go on on a large scale, send teams of women trained in feminist educational techniques into the schools around the country to help women make contact with themselves and work out of themselves, disseminate lots of information on what's going on, the new ways of thinking ... all of that hopefully will happen out of the workshop. There are some fantastic women coming into it/ God, I wish you were with us. Then, we'd really have the market cornered.

Enough ... Love and kisses and all that,
Judy

Chapter 5

d I'll have my arms around you
ght. I cant remember of what
gs for no other woman and tha
for a moment your tender fee
s 'Hey beautiful' left is an incl
more than the accidental real
hich she has made so person
ether forever once and for al
d – no both hands – & just loo
a note! Love Oh I am looking
aks and loves, intelligent flow
me – it's never been like this
piece bathing costume for me
ering. I cry and you remain so
s like some smooth girl bathe
me comfort now and helps m
e and it will be so dark when
you that I can always love yo

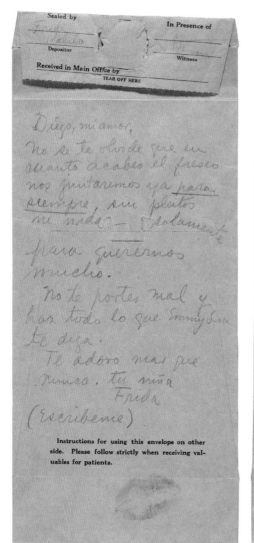

Sealed by ___ In Presence of

Frida
Pablo
_____ _____
Depositor Witness

Received in Main Office by ___
TEAR OFF HERE

Diego, mi amor,
No se te olvide que en
cuanto acabes el fresco
nos juntaremos ya para
siempre, sin pleitos
ni nada — Solamente
para querernos
mucho.
No te portes mal y
haz todo lo que Emmy Lou
te diga.
Te adoro más que
nunca. tu niña
 Frida
(escríbeme)

Instructions for using this envelope on other
side. Please follow strictly when receiving val-
uables for patients.

Frida Kahlo (1907–54) to Diego Rivera
1940

Frida Kahlo and the Mexican mural artist Diego Rivera first met in 1928 and married the following year. Their intense relationship was strained by Rivera's multiple affairs and Kahlo's abortions; they divorced in 1939 but remarried in October 1940. Kahlo suffered life-long ill health after being badly injured in a road accident as a girl (during her short life she had thirty-two surgical operations) and was never able to have children. Not long before her second wedding to Rivera, she had been in St Luke's Hospital, San Francisco, for observation. She wrote this note on the envelope in which she had deposited her watch and jewellery for safe-keeping while in hospital, then left it for Rivera to find in the studio in which he was working on his Pan American Unity fresco for San Francisco Junior College. Kahlo was about to leave for New York. She playfully advises Rivera not to disobey their young friend, the artist Emmy Lou Packard, who has been living with the couple in Mexico and is acting as Rivera's chief assistant on the fresco.

Diego, my love,
Remember that once you finish the fresco we will be together forever once and for all, without arguments or anything, only to love one another.
Behave yourself and do everything that Emmy Lou tells you.
I adore you more than ever.

Your girl
Frida
(Write to me)

Wednesday

Hey beautiful
 Just got your letter – oh for just a
chance to love you – could I love you – can't
figure out whether I like the radio on or off –
Je t'aime – God you mean a lot to me – it's
never been like this before in my life. I cleaned
the studio – made the bed – I like it so much –
the white palette things are sort of in the
middle of the room – I can't paint against
the wall like you had them – I'm using the
paint off your palette – I feel so close to you –
I'm still working on that green & black thing –
so slow and it's so big – started a couple more
little – nothing much – I keep thinking we
could live here together but I mustn't think at
all. Drank a bottle of bourbon with Guston last
night – talked about painting – we don't agree at
all but he was nice – he doesn't like Gorky or
de Kooning – likes Mondrian & more intellectual or
classic or whatever you call them things. I
would like to paint a million black lines all
crossing like Beckmann – to hell with classicism –
this is only momentary – beautiful – agony & not

138 Love

Joan Mitchell (1925–92) to Michael Goldberg
Summer 1951

Arriving in New York in 1949, Joan Mitchell became involved with the Eighth Street Club, a gathering place for abstract expressionist artists. She met Willem de Kooning, Franz Kline, Philip Guston – all of an older generation – and a former soldier and abstract painter of her own age, Michael Goldberg. In May 1951 they both participated in the *Ninth Street Show*, organised by the future gallerist Leo Castelli, and began an intense relationship. This letter, from the ecstatic dawning days of their affair, was probably written from Mitchell's new Manhattan studio. Her reference to Patti Page's hit single 'Would I Love You' ('Oh, for just the chance to love you'), query about exhibiting at the New Gallery, and comment that 'it stays light so long' date it to summer 1951 (Mitchell's first New York solo show opened at the New Gallery in January 1952). Mitchell, who had private means, promises Goldberg money as well as love. Perhaps unconsciously, her last line also echoes Page's song: 'To take you in my arms / Has always been my goal'.

Wednesday

Hey beautiful

Just got your letter – 'oh for just a chance to love you – could I love you' – can't figure out whether I like the radio on or off – Je t'aime – God you mean a lot to me – it's never been like this before in my life. I cleaned the studio – made the bed – I like it so much – the white palette things are sort of in the middle of the room – I can't paint against the wall like you had them – I'm using the paint off your palette – I feel so close to you – I'm still working on that green & black thing – so slow and it's so big – started a couple more little – nothing much – I keep thinking we could live here together but I mustn't think at all. Drank a bottle of bourbon with Guston last night – talked about painting – we didn't agree at all but he was nice – he doesn't like Gorky or de Kooning – likes Mondrian & more intellectual or classic [...] it would be so wonderful to see you. I can't leave you money for a little while – a week or so – then I will. I'm drinking the beer you left on the windowsill – & I'm kissing you – this I do all the time. How long will it be?? [...] I sat in the park this morning & you were with me and we talked about things that we had never mentioned & much we had and I held your hand [...] I like [changed to 'Fuck'] the New Gallery anyway – what do you think of all this – should I have show there – without you it's impossible – Quiero morir – but I won't [...] someday we'll line a room with canvas & you'll have an enormous brush & lots of black & white & cad[mium] red deep & you'll paint them all at once and I'll have my arms around you. Goodnight – je t'aime.

J.

Rome ce 19 octobre.

ma bien aimée, ma bonne julie. vous êtes un ange sur la terre.
combien vous me faites sentir mes torts, que j'ai de peine d'avoir
douté un moment de vos tendres sentiments à mon égard.
mais aussi quel bonheur et bien d'entendre de vous même
ce tendre reproche. non ma belle ne regrettez pas d'avoir
épanché votre cœur avec celui qui vous adore, et qui n'existe
et ne vit que par vous et pour vous. ma charmante amie,
n'ayez donc plus de regrets avec moi, je n'aurai jamais pour
vous le moindre secret vous verrez toujours mon âme toute entière,
que de votre côté il en soit de même. toutes moi le saviez
plaisir, comme le moindre petit chagrin, je vous consolerai du
mieux que je le pourrai, jusqu'à ce que les nœuds les plus
tendres nous unissent à jamais. c'est moi qui suis malheureux
ma tendre amie de ne vous plus voir, il vous est impossible
de vous l'imaginer, au point que si j'en avais les moyens
je repartirais pour paris, uniquement pour vous mon aimable
amie; j'ai relu cent fois cette charmante écriture au crayon,
je vais continuellement de la lettre au portrait, et me semble
vous voir, je vous parle mais hélas, vous ne me répondez pas
je suis à chez moi d'un triste silence interrompu par le bruit
d'une cloche ou d'une pluie qui tombe par torrents accompagné
d'un tonnerre qui a l'air de présager le bouleversement du
monde entier. je me couche à neuf heures du soir et jusqu'à

Jean-Auguste-Dominique Ingres (1780–1867)
to Marie-Anne-Julie Forestier
18 October 1806

In June 1806 Jean-Auguste-Dominique Ingres became engaged to the seventeen-year-old Julie Forestier. Ingres had studied with the great French Romantic painter Jacques-Louis David and was already enjoying professional recognition of his own. He had had five paintings accepted for the 1806 Salon, including *Napoleon I on the Imperial Throne* (Musée de l'Armee, Paris). He had also been awarded the Prix de Rome and was about to leave for Italy.

Ingres' arrival in Rome in October was soured by the news that his Salon paintings had not gone down well with the art establishment. His mentor David had dismissed the portrait of Napoleon, which would later become a defining image of the era, as 'unintelligible'. Ingres realized that he was under pressure to prove himself as an artist before he could think of returning to Paris. The prospect of a long separation from Julie, on top of her father's disapproval of their relationship and Ingres' general loneliness as a new arrival in a foreign city, all colour his letter, along with a certain self-pitying Romantic miserableness. The following summer Ingres broke off their engagement, blaming the bad press his Salon paintings had received. In the event, he remained in Italy for the next eighteen years.

My beloved, my good Julie, you are an angel on earth. How you make me aware of my failings! How sorry I am to have doubted for a moment your tender feelings toward me, but also what happiness is mine to hear your tender assurances. No, my dear, do not regret having poured out your heart with the one who loves you and who exists and lives only through you and for you. My charming friend, do not express regrets toward me. I will never keep any secret from you, you'll always see my whole soul. May it be the same on your part. Tell me the least pleasure as well as the smallest sorrow. I will comfort you the best I can, until the tenderest vows unite us forever [...] I have read a hundred times this lovely writing in pencil; I shift continually from the letter to the portrait. I seem to see you, I speak to you, but, alas, you do not answer; at my home there is only a sad silence interrupted by the sound of a bell or rain falling in torrents, accompanied by a thunder that seems to foreshadow the destruction of the entire world. I go to bed at nine o'clock at night and until six o'clock when I get up, I do not sleep, I roll over in my bed, I cry, I think of you constantly, and I go look at your portrait, which calms me a little [...] How cruel to you is your father! [...] He is not like our good mother Forestier, who loves us completely, doesn't she, my dear? [...] We mislead her, it is true, but what harm are we doing? None. Were she to know it, she could not even scold us, and so, my darling, do not deprive me of all that gives me comfort now and helps me to bear, though with great difficulty, the awful void [...]

WOOD LANE HOUSE,
IVER HEATH,
BUCKS.

June 1913

My darling of women — do forgive the wretched letters I've sent you today — at last I have peace to sit down & write to you as I would. I ask & I went for a walk tonight to exercise me — to walk for bodies & bent on stiffs thro' Black Park. Such a pure green enchanted region now; ? trees like slim smooth girls bathed in a soft light ... is rather a failure but the ... trees on ... the wood minded him of ... her ... lovely little legs and ... made him feel for ... her ... arms to her ... about ... him.

We found a gold crest's nest with a few eggs in — they are the smallest eggs of any English bird — you can't think how absurdly tiny — & all in a nest like a mossy feathery cradle caught up in a hanging fir bough. Bunty must go & see it.

Has the wild ducks on the lake who are charming fellows. As soon as you arrive near the water they set out from the other side, where they ... you coming, & swim hurriedly to greet you. Having landed ... of they come, sidling & making the most ... & ... sounds expectant of good — you'll love them Bunty sweet — such good birds.
expectant ducks

How is the little father — I hope you get on happily — I have nearly finished the trees on the right & father's portrait & tomorrow should work very hard to get on with the three other drawings.

I had such coloured dreams last night — I can't remember of what or of who but I felt you with me & I can only make a guess further — oh Baby me how dear you are to me, how sweet our days are together. Your beauty of character shows each time & more & more. When I think of the things you might pick out in my idle talkings & ... & most partly as ... against me. And when I think how hard & battling a life you lead compared with most people & how patient, I felt of pluck you are I am at once put to shame & filled with pride & joy. My Bunty my Bunty how I can love you, I thank you that I can always love you more & more ...

Paul Nash (1889–1946) to Margaret Odeh
25 June 1913

Margaret Odeh grew up in Cairo. In her early twenties she settled in England, where she became involved in the suffragette movement and co-founded the Women's Training Colony for former prostitutes. She met Paul Nash around the time of his first solo exhibition, in London in 1912. The following summer Nash and his artist brother John (Jack) were staying at their parents' Buckinghamshire home and working towards a joint exhibition. Nash's frequent letters to Odeh (on 25 June he wrote several times) mix descriptions of his diligent work routine with gentle erotic fantasies. He appreciates her 'hard & battling life' as a social campaigner and, as in his ink-and-watercolour drawings of this time, turns a lyrical gaze on the landscape. In successive phases of his work, including surrealistic photos of ancient trees and paintings of airborne magnolia blooms, Nash would retain a consistent preoccupation with the spirit of place.

Nash and Odeh married in 1914. When war broke out in August, Nash enlisted in the Artists' Rifles. He was invalided out of the army in summer 1917 but returned to the Western Front in November as an official war artist. His painting *On Menin Road* (Imperial War Museum, London), in which the woodland is a Golgotha of shattered stumps, became an abiding image of mechanised warfare's impact on nature.

Wood Lane House,
Ivor Heath,
Bucks

My darling of women do forgive the wretched letters I've sent you today – at last I have peace to sit down & write to you as I would. Jack & I went for a walk tonight to exercise our two well fed bodies & bent our steps thro Black Park Such a pure green enchanted region now: trees like some smooth girl bathed in a soft light My drawing is rather a failure But the trees in the wood reminded him of her lovely little legs and made him sigh for her arms to be about him.

We found a gold crest's nest with a few eggs in they are the smallest eggs of any English bird you cant think how absurdly tiny – & all in a nest like a mossy feathery cradle caught up in a hanging fur bough [...]

I had such coloured dreams last night. I cant remember of what or of who but I felt you with me & can only make a guess further. Oh Baby one how dear you are to me, how sweet our days are together. Your beauty of character shows each time more & more. When I think of the things you might pick out in my idle talkings & preachings & most justly be angered at. And when I think how hard & battling a life you lead compared with most people & how patient & full of pluck you are I am at once put to shame & filled with pride & joy. My Bunty my Bunty how I can love you. I thank you that I can always love you more & more. [...]

Your dear lover & naughty

Paul

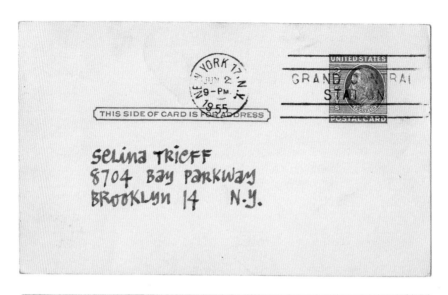

SeLina TRicFF
8704 Bay PaRkWay
BROoKLyn 14 N.Y.

Ad Reinhardt (1913–67) to Selina Trieff
18 February 1955

Selina Trieff was a twenty-year-old art student at Brooklyn College when she received this Valentine card – five days late – from her tutor. Ad Reinhardt was an established artist, represented by the Betty Parsons Gallery, which had earlier launched the careers of Jackson Pollock, Mark Rothko and other abstract expressionist painters, but the job at Brooklyn provided useful financial stability. He had started out in the 1930s painting in a cubist-derived idiom that he described as 'all-over-baroque-geometric-expressionist patterns'. By the early 1950s, however, he was producing his minimal yet deceptively subtle 'brick paintings', in which coloured rectangles float calmly on a single-colour ground. What he wanted, he said, was to create 'a pure, abstract, non-objective, timeless, spaceless, changeless, relationless, disinterested painting'.

Unlike Pollock or de Kooning's work, there is always a sense of rational deliberation in Reinhardt's abstract art. You can't imagine either of them crafting a Valentine message like his. Turned on end, his card to Trieff relates to the division of space in a work like *Abstract Painting: Red* (Museum of Modern Art, New York), constructed with interlocking with T-shapes, squares and rectangles in different shades of red, the brushmarks so carefully blended that the surface looks smooth. Reinhardt's letter-play also carries echoes of his notoriously gnomic critical pronouncements: 'The end of art is art-as-art. The end of art is not the end.' Here as elsewhere it can be difficult to tell exactly how provocative or serious he means to be. Is this Valentine card a genuine love message from a middle-aged tutor to a young student, a good-humoured game or something of both? Did anything happen? Reinhardt had married for the second time in 1953 and had a one-year-old daughter, Anna. Trieff would meet her future husband in a photography class a year or so later. She went on to have a long career as an artist and teacher, though not in Reinhardt's manner. 'As much as I liked abstract expressionism,' she said, she 'never felt part' of it.

BE
MY
SELINA
VAL
ENT
INE
TRIEFF
SELINA

Darling,

SARAN-WRAP

Drawing PAD

Small pads-lined
Large pads-lined
for writing notes;
not for dug.

Peanuts; Bloomsdale

Myntz, or something like....
saron wrap

A recently discovered coffee
stained drawing; thought
to be of Nevo, as a child.

I love you, J.

Jules Olitski (1922–2007) to Joan Olitski
c.1981–2004

Most days, Jules Olitski went to his studio at 2 p.m. and worked on through the night. When he left in the morning to sleep or go fishing, he would scribble a note for his wife, Kristina (also called Joan). Shopping lists, expressions of love, touches of humour – like the coffee stain adapted in biro to resemble a Roman head ('thought to be of Nero, as a child') – these notes are documents of a daily life shared in so many of its details that there would seldom be a need or opportunity to commit the big questions to paper.

Olitski was born in Russia. His father, Jevel Demikovsky, had been executed by the Soviet authorities a few months before his birth. The following year, his mother took him with her to New York, where she remarried. Olitski later adopted his hated stepfather's name. After serving in the US army during the Second World War, he studied art in Paris, working with the sculptor Ossip Zadkine and experimenting with painting while blindfolded. In the 1960s, back in New York, he changed his heavily built-up way of painting. Staining, pouring and spraying intense, thin colour onto canvas, moving on to domestic mops and squeegees, and to larger and larger canvases, he became one of the most commercially successful of the younger generation of Colour Field abstract painters.

Olitski's calm, expansive abstract paintings belied his rackety life outside the studio. After long-term alcoholism and two divorces, in 1960 he married Kristina Gorby, who helped him deal with his drink problem. Olitski regarded his working routine as another aspect of his addictive personality: 'It's like when I drank. Enough was never enough.' The foodstuffs he lists in this note could be items for one of the picnics he liked to host in a bunker-like former bank in Brooklyn, which also served as a painting store. The Saran Wrap plastic film he also requests (twice) may be required for either food or art materials. The coffee-stain drawing is an affectionate gift – part persuasion, part thank you – for a life partner who clearly has her work cut out.

Darling,

SARAN-WRAP
Drawing PAD
{Small pads – lined}
{Large pads – lined}
{for writing notes;}
{not for drg.}
Peanuts; Krasdale
(Myntz. or. something like …
saron wrap

A recently discovered coffee stained drawing; thought to be of Nero, as a child.

I love you, J.

Mon très cher ami

La cire et le sucre valent bien le bronze et le marbre — Notre Seigneur a-t-il une ligne écrite? et la réalité de l'esprit l'emporte sur la réalité accidentelle des faits. Je n'écrirais plus si mes livres ne me valaient pas ce ciel où tombent comme la vôtre. Pour moi toutes les choses arrivent la veille de 25 décembre. Votre lettre est une étoile. Pourquoi me demandez vous la permission de se faire une joie? Figurez vous que j'habite une clinique — (La chambre des tortures) La 2e fois j'essaye de vivre sans opium (on me le coupe — c'est très dur) Je m'obstine à confondre une âme infirme avec des troubles nerveux.

Écrivez — Écrivez moi. Si je saute les étapes, c'est que mon œuvre est moi même et que vous êtes l'ami de mon œuvre.

Je vous embrasse Jean Cocteau

Jean Cocteau (1889–1963) to unknown recipient
December 1928

On 5 December 1928 Jean Cocteau had himself admitted to a high-class clinic in Saint-Cloud, a suburb of western Paris, in a second attempt to cure his opium addiction. He had started using the drug after the sudden death from typhoid of his lover Raymond Radiguet five years earlier and had first sought treatment in March 1925. The bill for his current, very expensive spell of rehab was being covered by the fashion designer Coco Chanel. Denied all access to drugs, Cocteau was unable to sleep for twelve successive nights. After the first week, he began to correspond with friends. Gertrude Stein replied with the gift of a houseplant, Picasso sent some drawings. Cocteau's new lover, Jean Desbordes, was separately undergoing treatment in the same clinic. Another inmate was Raymond Roussel, a fabulously rich and hyper-eccentric experimental writer, with whom Cocteau began to communicate by letter. Written on a drawing made during 'these terrible nights' in mid-December, this letter reads like a reply to fan-mail from a new admirer that Cocteau has received just before Christmas. Desbordes, to whom it has been thought to be addressed, would not need to be informed that Cocteau is in a clinic or that he is 'trying to live without opium' for the second time.

In April 1929, when Chanel stopped paying the bills, Cocteau discharged himself and returned to Paris. He immediately began writing *Opium: Diary of a Cure* and in just eighteen days also wrote *Les Enfants terribles* (Children of the Game), which was published in July. It tells the story of a brother and sister, Paul and Elisabeth, who create an alternative reality – 'the Game' – into which their friends and lovers are drawn. The rules that apply in their 'strange world of childhood', writes Cocteau, are like 'the waking dream of opium eaters'.

My dearest friend

Wax and sugar are worth just as much as bronze and marble – has Our Lord left a single written line? and the reality of the spirit counts for more than the accidental reality of facts. I will stop writing if my books do not repay me with these friendships that fall from heaven, like yours. For me, all good things happen on Christmas Eve. Your letter is a star. Why do you ask my permission to bring me joy? You must realise that I'm living in a clinic – (The torture chamber) For the 2nd time I'm trying to live without opium (they've cut me off entirely – it's really hard) to be honest I persist in confusing soul sickness with nervous disorders.

Write – Write to me. If I'm racing ahead, it's because my work *is* me, and you are the friend of my work.

I kiss you
Jean Cocteau

I only have a sheet of scrap paper covered with a drawing made during these terrible nights at St Cloud

photograph. I know what he means —
I wonder if you'll ever see them — & if
you do whether you'd feel anything —
they are very simple — not at all appar...
— & small size — Hardly for walls

Then there is a wonderful Rodin
drawing — a Woman — I call it
"Mother Earth" I have which few have
ever seen — that too. I want you
to see —

From 10 Till after
midnight we walked on
Fifth Ave. — Along the Park —
the while talking — I was watching
the fascinatingly weird trunks of the
trees — weird because of the

electric lighting — I've often wanted
to make a photograph of what I saw
— I've watched them for 20 years —
they have always fascinated me — the
shapes — a sort of intertwining —
with Night as an envelope — The huge
buildings merely suggested way beyond the
Park — a haze over Park & distance —

But I don't do so many things I
want to do. —

We walked quite a distance
down. First up — Life — 29,
he — you — I — all talked up —
not as things or individuals —

just as one talks about the Sky &
Ocean — & trees — Stars too —

Alfred Stieglitz (1864–1946) to Georgia O'Keeffe
9 June 1917

Alfred Stieglitz wanted to put American photography on a level with European avant-garde art, and to promote both through exhibitions. The Little Galleries of the Photo-Secession, which he opened in 1905 with the photographer Edward Steichen at 291 Fifth Avenue, Manhattan (known simply as 291), introduced American audiences to modern art. He gave Auguste Rodin, Henri Matisse and Pablo Picasso their first exhibitions in the United States (including Matisse's first ever sculpture show in 1912). Stieglitz was also pursuing his own photographic work, though at this time he seldom exhibited.

In 1916 Stieglitz began showing work by the young artist Georgia O'Keeffe (see page 153), with whom he fell in love. Here he is writing to O'Keeffe after her solo exhibition at 291 in the spring of 1917, just before he closed the gallery for good. He describes photographs and ideas for photographs – around his parents' home near Lake George and wandering the Manhattan streets with a friend, Joseph Frederick Dewald. The scene he conjures – trees, streetlamps, nocturnal haze over Central Park – very much has the atmosphere of a Stieglitz photograph.

...

[...] Before starting to work – it means constant hustle if I ever hope to get ready to be out of here by June 30th – I want to grasp you by the hand – no both hands – & just look into your eyes – to see if they are full of sadness – or just a little less sad – this morning. –

Dewald was up at the house last night. He looked at some of my photographs – Trees – a few portraits – As we were looking at them I wondered why I hadn't thought of showing you some of those I did of trees – one particularly – Lake George – & one out of the back window – 291 – Snow – But when you were here I wasn't thinking of my work – I rarely do – rarely show it to any one – Dewald says there is too much love & too much of myself in many of the photographs. I know what he means. – I wonder if you'll ever see them – & if you do whether you'd feel anything – they are very simple – not at all aggressive – & small eye – Hardly for walls.

Then there is a wonderful Rodin drawing – a Woman – I call it 'Mother Earth' I have which few have ever seen – that too I want you to see –

From 10 till after midnight we walked on Fifth Ave. – Along the Park – the while talking – I was watching the fascinatingly weird trunks of the trees – weird because of the electric lighting – I've often wanted to make a photograph of what I saw [...] the shapes – a sort of intertwining – with night as an envelope – the huge buildings merely suggested way beyond the Park – a haze over Park & distance –

But I don't do so many things I want to do. –

We walked quite a distance down. First up. – Life – 291 – he – you – I – all talked up – not as things or individuals – just as one talks about the Sky & Ocean – & trees – Stars too [...]

I wonder if you are thinking of me — it seems
so still and so lonesome here in this room alone
——— the singing things singing outside
and it will be dark when I put the
light out

But I feel very close to you yet
anyway ... you seem to be with
me — Dearest
good night
a Kiss —

Georgia O'Keeffe (1887–1986) to Alfred Stieglitz
Summer 1918

Georgia O'Keeffe was embarking on a career as commercial artist in Chicago when, on a visit to New York in 1908, she went into Alfred Stieglitz's 291 gallery. Stieglitz was a pioneering photographer, editor and writer, probably the most influential figure in the emerging American avant-garde of the early twentieth century (see page 151). Six years later, temporarily back in New York, now as a trainee art teacher, O'Keeffe began work on a series of large charcoal drawings of 'things in my head'. A friend took some of these to show Stieglitz. He included them in a group exhibition at 291. 'Startled and shocked' to find her private images displayed on gallery walls, O'Keeffe went along to complain.

Stieglitz became infatuated with her. 'How I wanted to photograph you,' he wrote in June 1917, 'the hands – the mouth – & eyes – & the enveloped in black body'. After a final exhibition at 291 – O'Keeffe's first solo show – in 1917, Stieglitz began compulsively photographing his new muse. The following summer he left his wife Emmeline, whose wealth had underwritten his various ventures for twenty-five years, and moved into a small apartment with O'Keeffe. This short, simple love note, which has none of the soul-baring flourishes that are liberally sown through O'Keeffe's longer letters, dates from the earliest days of their life together.

O'Keeffe and Stieglitz married in 1924, but the time they actually spent in each other's company seems to have felt less enchanted than the rhapsodic letters they exchanged when apart. The charismatic Stieglitz could be self-absorbed and was reluctant to let O'Keeffe have the baby she craved. From 1929 she spent much of her time in New Mexico. That summer she wrote to him from Taos, 'I chose coming away because here at least I feel good – and it makes me feel I am growing very tall and straight inside … Maybe you will not love me for it – but for me it seems to be the best thing I can do for you.' Stieglitz confessed to her that her decision left him 'broken'.

After Stieglitz died in 1946, O'Keeffe preserved much of their correspondence, which she eventually deposited in the Beinecke Library, Yale, with instructions that this archive should remain sealed until twenty years after her death. In 2006, some 25,000 pages of intimate letters exchanged by O'Keeffe and Stieglitz, often daily for weeks at a time, entered the public domain.

..

I wonder if you are thinking of me – it seems so still and so lonesome here in the room alone –
the singing things singing outside and it will be so dark when I put the light out
but I feel very close to you yet
anyway – you seem to be with
me –
Dearest
good night
a kiss –

[in Stieglitz' hand?] There are basic differences between male & female –
In art there basic laws –

encore je vis quand je suis auprès
de toi. auprès de toi quand je
pense que j'ai avec toi le bonheur,
et je me plains, et dans ma lâcheté
je crois que j'ai fini d'être. malheureux
que je suis au bout. non tant qu'il
y aura encore un peu d'espérance si peu
me quitte il faut que j'en profite
la nuit plus tard, le mot après.

ta chère Camille pas celle qui va
te tuer, pas de bonheur à la toucher si
elle ne m'est le gage d'un peu de
ta tendresse.

ah divin beauté, fleur qui
parle, et qui aime fleur intelligente
ma chère, ma bien aimée à deux
genoux devant ton beau corps que j'étreins

ma pauvre tête est bien malade, et
je ne puis plus me lever le matin. ce soir j'ai
parcouru (verbeux) dans toutes nos endroits.
quelle mort me serait douce. et comme mon
agonie est longue. pourquoi ne m'as tu
pas attendu à l'atelier où vas-tu? à
quel douleur j'étais si j'ai de
moments d'ivresse où je souffre moins,
mais aujourd'hui, l'implacable douleur
reste. Camille ma bien aimée malgré tout,
malgré la folie que je sens venir et qui sera
votre œuvre si cela continue. pourquoi
ne me crois tu pas! j'abandonne mon
sculpture; si je pouvais aller
n'importe où, en pays où j'oublierais, mais
en y arrivant, il y a des moments en franchement
que je crois que je t'oublierai. mais un seul
instant et je sens ta terrible puissance.
aye pitié méchante, je ne puis plus continuer,
un jour comme toi, je ne puis plus passer
c'est fini, je ne travaillerai plus, déité mauvaise
et pourtant je l'aime avec fureur.
ma Camille sois assurée que je n'ai aucune
femme en amitié, et toute mon âme
t'appartient.

je ne puis te convaincre et mes raisons
sont impuissantes, ma souffrance
tu n'y crois pas, je pleure et tu
en doutes. je ne ris plus depuis longtemps,
je ne chante plus tout m'est insipide
et indifférent, je suis déjà mort
et je ne comprends plus le mal
que je me suis donné pour des choses
qui me sont si indifférentes maintenant
......... laisse-moi te voir
tous les jours, ce sera une bonne action
et peut-être qu'il m'en proviendra un
mieux, car toi seul peut me sauver
par ta générosité.
ne laisse pas prendre à la hideuse
d'une maladie mon intelligence, l'amour
ardent et si pur que j'ai pour toi
aussi pitié ma chère, et toi-même en sera
récompensée. Rodin

je t'embrasse les mains mon amie,
toi qui me donne des jouissances si élevées
si ardentes, près de toi, mon âme existe
avec force et dans sa fureur d'amour
ton respect est toujours au-dessus. le
le respect que j'ai pour ton caractère

pour toi ma Camille et une
cause de cette violente passion.
ne me traite pas impitoyablement
je te demande si peu.
ne me mens pas et laisse-toi voir
que ta main si douce me soit la
bonté pour moi et que quelquefois
l'âme à je la baisse dans mes
transports.
je ne regretterai rien. ni le
dénouement qui me paraît funèbre,
ma vie sera tombée dans un
gouffre, mais mon âme a eu
sa floraison tardive. Il
a fallu que je te connaisse. et
tout a pris ma vie inconnue
ma terne existence a flambé
dans un feu de joie. merci car
c'est à toi que je dois
...... la part de ciel que
j'ai eu dans ma vie.
tes chères mains laisse les sur
ma figure, que ma chair soit
heureuse que mon cœur sente encore
ton divin amour se répandre à
nouveau.
......... dans quel

Auguste Rodin (1840–1917) to Camille Claudel
c.1886

In 1880 the French state commissioned Auguste Rodin to create a pair of huge bronze doors for a museum of decorative arts. Deliberately evoking Lorenzo Ghiberti's 'Gates of Paradise' doors on the Baptistery of Florence Cathedral, Rodin took his subject from Dante's *Inferno*. The *Gates of Hell* would occupy him for twenty years, continuing after the museum was cancelled and involving a small army of assistants and models. In 1882 a sculptor friend asked Rodin to supervise a gifted student, Camille Claudel (see page 157), while he was abroad. Claudel joined Rodin's team on the *Gates of Hell*, for which he assigned her the difficult task of modelling expressive hands.

As Rodin became infatuated with Claudel, her features began to appear in figures intended for the *Gates*. She held out against his advances, however. For all his celebrity, he was much older than her and had a long-term mistress, Rose Beuret. Claudel was determined, in any case, to become a sculptor in her own right. 'My savage friend', begins this love letter, in which Rodin tries every conceivable angle, from respect to pity-me self-abasement, spiritual protestations and sensual suggestion. He merges metaphors, scrambles grammar, signs off and begins again. His image of himself 'on my knees in front of your dear body' is exactly the pose of the man in his sculpture *The Eternal Idol*, originally conceived for the *Gates*.

[...] I love you madly. My Camille, be assured that I have feelings for no other woman and that all my soul belongs to you.

I can't convince you and my reasoning is pointless. You don't believe in my suffering. I cry and you remain sceptical. It's a long time since I laughed, I don't sing any more, everything seems dull and uninteresting. I'm already dead [...] Let me see you every day, that would be doing a good deed, and perhaps a better one will come my way, since only you can save me with your generosity [...]

I kiss your hands, my dear friend, you who make me feel such high, intense delight when I'm near you, my soul feels full of strength and, in its fever of love, respect for you is always uppermost. The respect I have for your character, my Camille, is a cause of my violent passion [...]

I was fated to meet you and everything has taken on a strange new life, my colourless existence has burned bright with a fire of joy [...]

Let your dear hands rest on my face, so that my flesh can be happy that my heart feels once again suffused with your divine love. I live in such a state of intoxication when I am near you [...]

Your hand, Camille, not the hand that draws back, no happiness in touching it if it isn't a pledge of the slightest tenderness from you.

Ah, divine beauty, flower that speaks and loves, intelligent flower, my dear. My best and dearest, on my knees, in front of your dear body which I embrace.

R

Monsieur Rodin

Comme je n'ai rien à faire je vous écris encore. Vous ne pouvez vous figurer comme il fait bon à L'Islette. J'ai mangé aujourd'hui dans la salle du milieu (qui sert de serre) où l'on voit le jardin des deux côtés. Mme Courcelles m'a proposé (sans que j'en parle le moins du monde) que si cela vous était agréable

vous pourriez y manger de temps en temps et même toujours (je crois qu'elle en a une fameuse envie) et c'est si joli là ! Je me suis promenée dans le parc, tout est tondu, foin, blé, avoine, on peut faire le tour partout c'est charmant. Si vous êtes gentil, à tenir votre promesse, nous connaîtrons le paradis. Vous aurez la chambre que vous voulez pour travailler. La vieille sera à nos genoux, je crois.
Elle m'a dit que je

prendre des bains dans la rivière, où sa fille et la bonne en prennent, sans aucun danger. Avec votre permission, j'en ferai autant car c'est un grand plaisir et cela m'évitera d'aller aux bains chauds à Azay. Que vous seriez gentil de m'acheter un petit costume de bain, bleu foncé avec galons blancs en deux morceaux, blouse et pantalon (taille moyenne) au Louvre ou au Bon Marché (en serge) ou à Tours !. Je couche toute nue pour me faire croire

que vous êtes là mais quand je me réveille ce n'est plus la même chose.
Je vous embrasse
Camille.
Surtout ne me trompez plus.

Camille Claudel (1864–1943) to Auguste Rodin
Summer 1890 or 1891

After becoming Auguste Rodin's student, then his assistant and model, the young sculptor Camille Claudel at last became his lover. Their relationship was complicated by the need to screen it from Rodin's mistress Rose Beuret and from the public eye. Five or six years into their affair, in 1890–91, Claudel and Rodin found a hideaway in the Loire Valley where they could live together for weeks at a time undisturbed.

The Château de l'Islette was a sixteenth-century mansion, surrounded by water and parkland. They rented a set of upstairs rooms, some of which served as studio spaces. Rodin worked in the largest room on his monument to Balzac, while Claudel based her sculpture of a girl, *La Petite Châtelaine*, on the owner's granddaughter.

Claudel's letter to an absent Rodin invites him to imagine her at l'Islette. She moves through several registers of intimacy, addressing him formally as 'Monsieur Rodin' (Claudel uses the pronoun *vous*, whereas Rodin uses the informal *tu* in his early love letter to her; page 155), asking if he would 'be so kind' as to buy her a bathing costume and suggesting Parisian department stores where he might find the style and colour she wants. We in turn picture Rodin at the ladies' swimwear counter in Le Bon Marché, where the great sculptor of the human body might imagine Claudel as she describes herself in signing off, naked in bed awaiting his return.

Monsieur Rodin,

As I've nothing to do, I'm writing to you again. You can't imagine how good it is being at l'Islette. I ate my meals today in the middle dining room (which doubles as a conservatory), where you can see the garden in both sides. Madame Courcelles put it to me (not that I've mentioned any such thing) that, if you wanted to, you could sometimes eat there (I think she'd really love this), and it's so nice there!

I walked through the grounds – everything's been mown – hay, wheat, oats. You can walk all round. It's lovely. If you'll be so sweet as to keep your promise, we'll be in paradise.

You'll have whichever room you want for working in. The old woman will kiss your feet, I'd say. She's said that I can bathe in the river where her daughter and the housemaid bathe perfectly safely.

If it's all right with you, I'll do the same, since it's very enjoyable and it will mean that I don't have to go to Azay for a hot bath. It would be so kind if you could buy a little two-piece bathing costume for me, dark blue, trimmed with white, blouse and shorts (medium size), at the [Grands Magasins du] Louvre or Bon Marché (in serge) or in Tours!

I sleep completely naked, so that I can pretend you're there, but when I wake up it's not the same.

I kiss you,
Camille

Above all, don't deceive me any more.

Tues

my dear / think
of you all the time
I am in the middle
of a ptg & the post
goes in a moment
suddenly I missed
you & so here's
a note!
Oh I am looking
forward to seeing
you again

it is sunny & a
very high wind
such a gay day
Winifred is painting
happily, Bramwell
Rene / put their
suddenl put their
head in at my
window this morning
I love you dear

B

so nice to have your
letter this morning

Ben Nicholson (1894–1982) to Barbara Hepworth
Autumn 1931

In 1931 Ben Nicholson, at that time married to the painter Winifred Roberts, began a relationship with the younger sculptor Barbara Hepworth. The following year Nicholson and Winifred separated, and he and Hepworth moved into a studio in Hampstead, north London, where their avant-garde neighbours included Paul Nash and Henry Moore (see pages 143 and 169). This letter seems to date from the early days of Nicholson and Hepworth's affair, perhaps soon after the holiday in Norfolk they had shared in September with Moore, his wife Irina and other artist friends, who can be seen in snapshots enjoying naked ball games on the beach. Nicholson also mentions his friends and patrons Marcus and René Brumwell.

Tues

My dear

I think of you all the time I am in the middle of a p[ain]t[in]g & the post goes in a moment suddenly I missed you and so here's a note! Oh I am looking forward to seeing you again it is sunny & a very high wind such a gay day Winifred is painting happily –

Rene & Brumwell suddenly put their head at my window this morning

I love you dear

Ben

so nice to have your letter this morning

Dear Lord of the underworld, the Princess of Pastachuta & Zabaglione Rivera Ligure sends with her greetings the Enclosed handsome drawing of Ulric going to the dogs, it is by her own hand and although the heart was away on a holiday, careful investigation will reveal not only traces of black and white, but that subtle aroma of doubtful divinity which she has made so personally her own. She hastens to add (in case you should think ought to the contrary) that it is intended to embark 'Shipwreck' well on the way to glory. If you think this doubtful, write a post-haste letter & 10 more will be at your door. That is, unless in her effort to make things smaller, she has already succumbed, will you love your Princess when all that is left is an inch of Pastachuta?

Allegra

Eileen Agar (1899–1991) to Joseph Bard
Summer 1928

In 1926, the year she graduated from the Slade School of Art in London, Agar met the Hungarian writer Joseph Bard, at that time married to the formidable American journalist Dorothy Thompson. Between 1928 and 1930, Agar and Bard lived in Paris, where she became friendly with André Breton and other leading surrealists. After her rigorously academic art education, Agar's encounter with surrealism was a career-shaping revelation. This cryptic letter to Bard, written while holidaying in north-west Italy, enclosed a drawing titled 'Ulric going to the dogs'. The 'shipwreck' refers to Bard's novel *Shipwreck in Europe*, published in spring 1928. Agar pasted into her journal an American press notice, which observes that 'Mr Bard writes well about Freudian complexes' – as you'd expect of a 'Lord of the Underworld'. Pastachuta is pasta with a sauce of vegetables, meat and spices.

Thor's day

Dear Lord of the Underworld, the Princess of Pastachuta & Zabaglione Rivera Ligure sends with her greetings the enclosed handsome drawing of Ulric going to the dogs, it is by her own hand and although the head was away on holiday, careful investigation will reveal *not only* marks of black and white, but that subtle aroma of doubtful divinity which she has made so personally her own. She hastens to add (in case you should think ought to the contrary) that it is intended to embark 'shipwreck' well on the way to glory. If you think this doubtful, write a post-haste letter & 10 more will be at your door. That is, unless in her effort to make things smaller, she has already succumbed, will you love your Princess when all that is left is an inch of Pastachuta?

Chapter 6

. All now depends upon the In
y to morrow, have the kindnes
umbly entreat you, when you h
to believe that you were askin
for **'My 1244 guilders'** two mc
the actual drawings just what
painted some sheep into – An
cial carrier, to make up for the
ment of works of New Art, whi
ps note arrived or I should ha
the exact number of Plates w
d evidence of friendship. Witl
efore we can make a decision
am doing so because of wha
Professional Matters be able
ance this time he were to slip
moving from one roach infest
it's something like this with

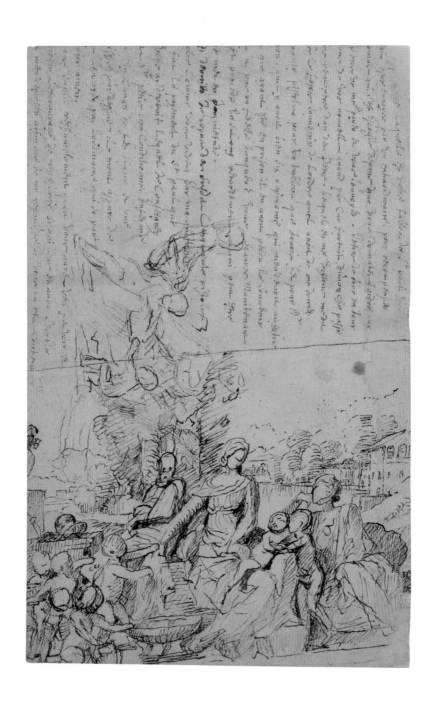

Nicolas Poussin (1594–1665) to Paul Scarron
c.1650

After moving to Rome from his native France in 1624, Nicolas Poussin made his reputation with paintings of subjects from classical literature. In contrast to the extravagance of Baroque art, Poussin developed a way of framing moments of drama and extreme emotion in harmonious, beautifully balanced landscape and architectural settings. In 1640, summoned by King Louis XIII, he returned to Paris, where he was courted by French art patrons, such as Paul Fréart de Chantelou. Through Chantelou, the well-connected poet and playwright Paul Scarron commissioned a painting from Poussin – a commission he did his best to defer, since he despised Scarron and his burlesque plays. In 1649, however, now once again settled in Rome, he finally started work on the painting that became *The Ecstasy of St Paul* (Musée du Louvre, Paris), to which this letter refers.

Sometimes thought to be addressed to Fréart de Chantelou and to concern a lost painting of St Paul, this letter is probably in fact to Scarron. Poussin was extremely sensitive to his clients' tastes and wishes, and, despite his dislike of Scarron, clearly feels that he owes him an apology or at least an explanation. The fragmentary draft of Poussin's letter fills the blank spaces around a drawing of the Holy Family, St Elizabeth and the Infant St John the Baptist surrounded by children, with a lake and a small Italian town in the background – the kind of landscape Poussin had made his own.

...

[...] chest in which your painting of St Paul must be dispatched to you by special carrier, to make up for the time that has passed since you instructed Messieurs Petits to pay me and send you the painting. I had been waiting daily for news from you when, by chance, I bumped into one of the Petits, who, seeing me, said that it made him remember that he'd been asked to give me 50 pistoles for a painting that I made for Monsieur Scarron – that he should have done this six weeks ago but that, having been in prison, he had forgotten all about it. Is there no such thing as an honest banker? You will know now that this is the cause of the interminable delay that has perhaps been bothering you [...] last I received the aforementioned 50 Italian pistoles, as you see, in settlement for the St Paul that I painted for you, which I consigned to those same Messieurs Petits in good condition, crated in a steel box inside a chest, which they promised to send you by regular carrier the next day. I humbly entreat you, when you have seen and considered this work, to write and tell me your honest opinion, so that – providing you like it – I can be happy.

My dear Sir

Mrs. F. & myself may probably take a drive to Town before our final return, but as it can not be tile after the opening of the Academy to Morrow, have the kindness to inform Strowger that the group of Hæmon & Antigone & the Hermaphrodite are the figures I chose for the Candidates, & that I told Thomas so, before I set out.

it is very odd if I did not inform You of the exact number of Plates wanting in my Friends Copy of Sepp; I think they are the four last plates, the Frontispice & prefatory stuff of the Fourth, with the Three first ones of the fifth Volume.

In hopes of seeing You soon, We are

My dear Sir
ever Your
F. & Mrs. Fuseli

- Monday 29 Sept. 23.

Henry Fuseli (1741–1825) to unknown recipient
29 September 1823

In 1764 Johann Heinrich Füssli arrived in London with serious literary ambitions. He had always had a gift for drawing, however, and was soon being encouraged by Sir Joshua Reynolds (see page 173) to pursue an artistic career. After studying classical and Renaissance art in Italy and a short-lived return to his native Zurich, Füssli settled in London, anglicised his name, and established himself as a history painter. By 1799, he had reached the top of the art establishment, becoming Professor of Painting at the Royal Academy, then Keeper in 1804. Written in a shaky hand at the age of eighty-two, this letter refers to the classical subjects of the paintings that students at the Royal Academy Schools will be required to submit and mentions the head porter, Samuel Strowger. The books in which Fuseli refers to missing ('wanting') plates are probably the five volumes of *Nederlandsche vogelen* (Dutch Birds), a luxury compendium of natural history engravings by Christiaan Sepp, Jan Christiaan Sepp and Jan Sepp. Sophia Fuseli was an artist, former artists' model and Romantic muse to her much older husband.

My dear Sir

Mrs F. and myself may probably take a drive to Town before our final return, but as it can not be till after the opening of the Academy to morrow, have the kindness to inform Strowger that the group of Haemon and Antigone and the Hermaphrodite are the figures I chose for the Candidates, & that I told Thomas so before I set out.

it is very odd if I did not inform you of the exact number of Plates wanting in my Friends coppy of Sepp; I think they are the four last plates, the Frontispice & prefatory stuff of the Fourth, with the Three first ones of the Fifth volume.

In hopes of seeing you soon, we are

My dear Sir
ever your
S. & Hy Fuseli

Sunday Nov 9th 1941.

Hoglands
Perry Green
Much Hadham
Herts.

De̶a̶r̶ ̶ I got your letter yesterday, enclosing Keynes reply & your letter to him about the C.A.S. drawings Jquire on exhibition at the Ashmolean

Its difficult for me to be sure without seeing the actual drawings just what has got mixed up. There were quite a few mistakes at first in the catalogue of the Temple Newsam exhibition, which I went through & corrected with Henday on the opening day — but I haven't got a copy of the corrected catalogue to help me. But you are right in thinking that the number of my drawings Mr Keynes got for the C.A.S. was six. & he bought for himself 3 from me at the same time. His three I sent to Leeds & am pretty sure I wrote on the back that they were lent by him, & I think his three were called in the Leeds catalogue.

① Air Raid shelter — Three sleepers.

(this is of 3 people sleeping something like this →

② Air raid shelter — Sleepers.

(more or less monochrome (drawing in mauvish blue grey)

③ Air raid scene

(a smaller drawing than the first two, of 3 figures, one standing one seated & one reclining with a background of 'blitzed' houses. — the figures are drawn o̶r touched up with pen & ink — the whole drawing is pinkish brown — or terracotta pink

This no③ seems as though it is one ̶s̶e̶n̶t̶ ̶b̶y̶ mistakes t̶o̶ Oxford & if it fits this description, it belongs to Mr Keynes. Do you know if

Henry Moore (1898–1986) to John Rothenstein
9 November 1941

In 1941 Henry Moore became an Official War Artist and was commissioned to produce drawings of people sheltering in London Underground stations during the Blitz. The same year John Rothenstein, director of Leeds City Art Gallery, gave Moore his first retrospective exhibition, at Temple Newsam House. Moore's letter refers to an exhibition of work acquired by the Contemporary Art Society at the Ashmolean Museum, Oxford, which included seven of his drawings. After the show, these were apparently returned to the wrong lenders. Moore tries to untangle the confusion as to which drawings belong to CAS and which to the economist John Maynard Keynes (a CAS trustee) and Kenneth Clark, director of both the National Gallery and the War Artists Advisory Committee.

Dear [John Rothenstein]

I got your letter yesterday, enclosing Keynes's reply and your letter to him about the C.A.S. drawings of mine on exhibition at the Ashmolean.

It's difficult for me to be sure without seeing the actual drawings just what has got mixed up […]

But you are right in thinking that the number of my drawings Mr Keynes got for the C.A.S. was six. And he bought for himself 3 from me at the same time. His three I sent to Leeds and am pretty sure I wrote on the back that they were lent by him, and I think his three were called in the Leeds catalogue.

1. Air Raid Shelter – Three Sleepers
(this is of three people sleeping something like this

2. Air Raid Shelter – Sleepers
(more or less monochrome drawing in mauvish blue grey.)

3. Air raid scene
(a smaller drawing than the first two, of three figures, one standing, one seated and one reclining with a background of 'blitzed' houses. – The figures are drawn or touched up with pen and ink – The whole drawing is pinkish-brown – or terracotta pink)

This no.3 seems as though it is one sent by mistake to Oxford and if it fits this description, it belongs to Mr Keynes. Do you know if he's had his three drawings sent back to him – or did he continue the loan of them, as the Leeds exhibition (or part of it) has gone on tour under the Adult Education Scheme – If 3 drawings were sent back to him, and yet the air raid scene at Oxford is one of his, then there's a mistake in his three, too.

The fifth Shelter Drawing you mention at Oxford, of two draped figures in a brick shelter sounds like one belonging to Kenneth Clark – it's something like this with more than usually realistic heads (for me) and it's as you say grey blue […]

I hope the other 5 are C.A.S. drawings, otherwise it's going to take a little time to sort things out – If you'd like a description of the six C.A.S. drawings I think with a little concentration I could remember them and do little drawings of them as above.

Yrs sincerely
Henry Moore

This shocking scoundrel to escape!

To think that, when we despaired of ever getting hold of him — because, as you pointed out, of the difficulties of extradition — he should of his own accord run right into your arms, is amazing! —

It would be unpardonable if by any chance this time he were to slip through the very close fingers of The New York Police.

I am most anxious to hear. Do let me have one word by cable to say that Sheridan Ford is properly in "Sing Sing" — or "no doubt" or however it is that "scamps tramps & jailbirds" do you express, are safely squared today!

With hearty congratulations upon such excellent work.

Believe me dear Mr Allen

Always sincerely

[signature]

James McNeill Whistler (1834–1903) to Frederick H. Allen
6 June 1893

James McNeill Whistler was one of few successful artists to have made a comparable impact as a commentator. In 1878 he sued John Ruskin (see page 199) for publishing a review in which the eminent Victorian critic accused him of 'flinging a pot of paint in the public's face'. Whistler used his moment of courtroom celebrity to mount a defence of the artist's autonomy. At his 'Ten o'clock' lecture in 1885, he took aim at attempts to co-opt art for fashion and home decoration, affirming that artists were concerned with 'the beautiful in all conditions and in all times', not with art's social significance. In 1889 he agreed to let an American journalist, Sheridan Ford, edit a book of extracts from his letters about the Ruskin trial.

Ford, who had written on Whistler for the *New York Herald,* hoped to become his American agent. Soon after he began work on the book, however, Whistler decided to publish it himself. Ford went ahead anyway, and *The Gentle Art of Making Enemies* was published in Antwerp in February 1890. Whistler immediately took legal action; Ford's book was suppressed, and his own came out, with the same title, in June. Undeterred, Ford published a pirated edition in Paris under an alias. This too was suppressed, and he returned to the United States.

Characteristically, Whistler would not let the Ford affair drop until he was convinced he had won. His letter to the journalist Frederick Allen is jokily hyperbolic (Sing Sing is a notorious maximum-security prison), but underneath the posturing ('This shocking scoundrel') a certain ruthlessness shows through.

110 Rue du Bac, Paris

Dear Mr Allen, Sheridan Ford left in the 'City of Paris' for New York under an assumed name and Mr Alexander cabled to you immediately. This most desirably fast.

Since then I have waited for the news of his arrest – surely you have not allowed This shocking scoundrel to escape!

To think that when we despaired of even getting hold of him – because, as you pointed out, of the difficulties of extradition – he should of his own accord run right into your arms, amazing! –

It would be unpardonable if by any chance this time he were to slip through the very clever fingers of the New York Police.

I am most anxious to hear. Do let me have one word by cable to say that Sheridan Ford is properly in 'Sing Sing' – or 'the Tombs' or wherever it is that scamps tramps & jailbirds de son espèce [of his kind], are safely sequestered!

With hearty congratulations upon such excellent work.

believe me dear Mr Allen

Always Sincerely
Jms McNeill Whistler

London Oct. 16. 1773

My Lord

I was out of town when your Lordships note arrived or I should have answered it immediately. Mr Pars says the Picture of the Lake of Como will be quite finished in a weeks time when he will send it as directed to St. James, Square, the price will be the same as that which was in the Exhibition which was eight Guineas.

I fear our Scheme of ornamenting St. Paul, with Pictures is at an end, I have heard that it is disapproved off by the Archbishop of Canterbury and by the Bishop of London For the sake of the advantage which would accrue to the Arts. by establishing a fashion of having Pictures in Churches, six Painters agreed to give each of them a Picture to St Pauls which were to be placed in that part of the Building which supports the Cupola, which was intended by Sir Christopher Wren to be ornamented either with Pictures or Bas relliefs as appears from his Drawings. The Dean of St. Paul and all the Chapter are very desirous of this scheme being carried into execution but it is uncertain whether they will be able to prevail on those two great Prelates to comply with their wishes.

I am with the greatest respect
Your Lordships most humble
and obedient Servant
Joshua Reynolds

Joshua Reynolds (1723–92) to Philip Yorke
16 October 1773

Before Joshua Reynolds's return from his visit to Italy in 1750–52, portrait painting in Britain had been seen essentially as a luxury industry serving the social elite, rather than an art form. Reynolds had other ideas. Often working a seven-day week, he built up a lucrative practice, introducing poses derived from classical sculpture and Old Master painting into his portraits of eighteenth-century grandees. His particularly sympathetic portrayal of children can be seen in the double portrait he painted around 1761 of Amabel and Mary Jemima Yorke (Cleveland Museum of Art, Ohio), daughters of the aristocratic writer and politician Philip Yorke.

At the same time, Reynolds was striving to raise artists' professional status through the establishment of a British academy along the lines of the Académie Française. In 1768, when the Royal Academy of Arts was founded, he became its first president. An early exhibition at the Academy featured work by William Pars, including the first Alpine landscapes to be seen in England. The painting due to be delivered to Yorke's London townhouse is a very reasonably priced view of Lake Como (Reynolds by this time was charging £160 for a portrait). Reynolds was always looking for opportunities to put painting at the heart of public life, like the abortive scheme he discusses with Yorke (now 2nd Earl of Hardwicke) for installing art in St Paul's Cathedral.

...

London

My Lord

I was out of Town when your Lordships note arrived or I should have answered it immediately. Mr [William] Pars says the Picture of Lake Como will be quite finished in a weeks time when he will send it as directed to St James Square. The price will be the same as that which was in the Exhibition which was eight Guineas.

I fear the Scheme of ornamenting St Pauls with Pictures is at an end. I have heard that it is disaproved off by the Archbishop of Canterbury and by the Bishop of London. For the sake of the advantage which would accrue to the Arts by establishing a fashion of having Pictures in Churches, six Painters agreed to give each of them a Picture to St Pauls which were to be placed in that part of the Building which supports the Cupola & which was intended by Sir Christopher Wren to be ornamented either with Pictures or Basreliefs as appears from his Drawings. The Dean of St Paul and all the Chapter are very desirous of this Scheme being carried into execution but it is uncertain whether they will be able to prevail on those two great Prelates to comply with their wishes.

I am with the greatest respect
Your Lordships most humble
and obedient servant
Joshua Reynolds

ANNI ALBERS 3 NORTH FOREST CIRCLE NEW HAVEN 15, CONN.

March 15. 54

Miss Gloria S. Finn.
6124 33rd St. N.W.
Washington, D.C.

Dear Miss Finn,

Thank you for your letter asking my husband and myself
to take part in your rug project. I think we will have
to know a little more about your rugs before we can make
a decision.

Some of the questions that come to my mind are : what size
are the rugs to be? Who supervises the dying of the yarn?
is there any restriction in regard to the number of colors
to be used? At what prize are they to be sold and what is
the fee, in terms of percentage, we may count on ?
Could you send some photos of rugs of your workshop?
I think that would be easier that bringing them to New York.
Also I do not know when we can be there.

Thank you for your interest,

Sincerely yours,

Anni Albers

Anni Albers (1899–1994) to Gloria Finn
15 March 1954

In 1933, the textile designer Anni Albers and her artist husband, Josef, emigrated from Germany to the United States. They had both been teaching at the multi-disciplinary Bauhaus design school. After the Bauhaus closed, in the face of Nazi hostility, Josef accepted an invitation to become head of art education at the experimental Black Mountain College in North Carolina. Anni took charge of the weaving workshop, which she saw as 'a laboratory for experimental work in construction and design'.

At Black Mountain College, Albers began to weave textiles from a mixture of natural fibres and synthetic materials such as cellophane and aluminium, and to make jewellery from found objects. Her patterns evolved from Bauhaus-style abstract-geometric arrangements of colours to incorporate elements of the ancient Mesoamerican textiles she discovered on her travels with Josef.

Her letter to the young textile designer Gloria Finn dates from the Albers' time in New Haven, where Josef was appointed chair of Yale University's design department in 1950. It is a cautious but briskly professional response to a request from someone whose name and work are as yet unfamiliar to Albers. Finn's out-of-the-blue contact with Albers resulted, among other things, in their collaboration on one of Albers' best-known designs. *Rug* (1959; Johnson Museum of Art, Cornell University) has a pattern of Celtic-knot interlace on a russet ground – a bold statement of Albers' exploration of 'the event of a thread' through meandering, map-like lines. It was executed by Finn in the hand-tufting technique in which she specialised. Finn later married a British lawyer, Sir William Dale, became a stalwart of the Crafts Council and donated her collection of ancient Middle Eastern beads to the British Museum.

Miss Gloria S. Finn.
6124 33rd St. N.W.
Washington, D.C.

Dear Miss Finn,

Thank you for your letter asking my husband and myself to take part in your rug project. I think we will have to know a little more about your rugs before we can make a decision.

Some of the questions that come to mind are: what size are the rugs to be? Who supervises the dying of the yarn? is there any restriction in regard to the number of colors to be used? At what prize are they to be sold and what is the fee, in terms of percentage, we may count on? Could you send some photos of rugs of your workshop? I think that would be easier that bringing them to New York. Also I do not know when we can be there.

Thank you for your interest,
Sincerely yours,

Anni Albers

Sonntag. 17. April. Bantw. 29.4.

Mein lieber Breuer, als ich in
Hartfort war hörte ich ‡ von Russel
Hitchkock, dass du in Einzugen bist.
Nun sah ich aber Dorner und
es stellte sich heraus, dass du doch
in Harvard Univ. bist. Also wo
bist du endlich? [2] Ich habe mir
aus dem Grunde ‡ ~~mein~~ dir meinen
aufenthalt in New-York nicht
gemeldet. — Meine Ausstellung
in Julien Levy Gallerie ~~wird~~ wird noch
zwei Wochen dauern. Wirst du
die Zeit haben es zu besuchen
sodass wir uns hier sehen
Könnten. — Ich möchte gerne
dich wieder sehen. Schreibe
mir ein paar Worte und was
wir machen könnten um uns zu treffen.

Naum Gabo (1890–1977) to Marcel Breuer
17 April 1938

Born in Russia, Naum Gabo developed his concept of 'constructive' sculpture in the years following the Russian Revolution, when innovation in the arts was officially encouraged. Gabo believed that sculpture was about space rather than solid objects, and that his sculptures existed essentially as ideas, each of which could be realized repeatedly in different materials, places and sizes. When his years of displacement began with his move to Berlin in 1922, he carried with him a suitcase containing miniature versions of his work. In Germany, Gabo met artists and designers associated with the Bauhaus, including the architect Marcel Breuer (see also page 99). He also worked in Paris, designing sets and costumes for Diaghilev's Ballets Russes. With the rising threat of Nazism, Gabo settled in London in 1936. He was a charismatic and influential member of the avant-garde circle in Hampstead that included Barbara Hepworth, Ben Nicholson and Henry Moore (see pages 159 and 169), as well as other European exiles such as Breuer. Hepworth and Nicholson were witnesses to Gabo's marriage to Miriam Franklin, an American-born British national who was another reason for his relocation to London.

In April 1938 Gabo was in New York for the opening of his exhibition at the Julien Levy Gallery. Breuer had emigrated to the United States the previous year to take up a professorship of architecture at Harvard University, where, with his former Bauhaus director Walter Gropius, he would train a generation of American architects in modernist principles. Their mutual contacts included the architectural historian Henry-Russell Hitchcock and Alexander Dormer, a former German museum director who was now principal of Rhode Island School of Design. In these unsettled times, everyone seemed permanently to be on the move. Where are you *really*? Gabo asks Breuer. When can we meet up? Writing in idiosyncratic German, he gives Breuer his brother-in-law's New York address. After the war, Gabo too would sail for New York, where Miriam had grown up and where he felt sure that his ideas – still radical for the 1940s – would find a more receptive audience than in Britain.

My dear Breuer,

When I was in Hartfort I heard from Russel Hitchkock that yöu were in Europe. But nöw I've seen Dorner and it's become clear that yöu are in Harvard University. So where are yöu after all? Because öf this I did not tell you about my stay in New York – My exhibition at Julien Levy Gallery will be on for two more weeks. Will yöu have the time to visit it so that we can see each other – I would very much like to see you again. Write me a few words and we will make so that we cän get together. I intend to travel back to London in June. So I hope to have seen yöu before then. My address in New York is: 176, West 79 Str. But safer is – *c/o Joe Israels Empire State Bldg.* – because I'm furnishing the apartment and will perhaps möve in May.

Warmest greetings from both of üs änd from all the London friends
Gabo

Mijn Heer

Mijn Heer, met schroomen ist dat ick UE met
mijn schrijven kom besoucken, ende dat door't seggen
vanden ontfanger Uttenboogaert die noch tardeert aen
mijn betalinge hluwrjdes, soo dat den tresoorier volbregt
dat soo geert als dat door ... sch. sch. ...
worde. Soo geeyt mij den ontfanger Uttenboogaert
jin voor leeden woon dage dover op gheantwoort: als
dat volbregt alles Hackij Jaar die soltij int werk geseyt
geleyt dat tot nu toe. soo dat dat nu wederom over
4000 hguilders bij die soltij haentoony ter schuren is ende
bij dese ewarachtigen gelegentheyt so bidde ick UE mijn
soet weldjges Heer dat mijn sonderinsj nu in dese lesste
moget hluwrgemawcht worden op dat ick mijn roet
verdiende 1244 guilders ... moget een mael onfang
ende ick selsse UE UE met onderinsj dienste ende bljwtes
wien schap altijts sou ken de rehümpinseren met desen
ist dat ick mijn seer hartelick groet ende wentsche
dat UE God louch in galleen gesondheyt te
parderseyt

UE dienstwillige ende affectionnerende
Dienaar Rembrandt

ick woon op die buren amster inde
suyker backerij

Rembrandt van Rijn (1606–69) to Constantijn Huygens
mid-February 1639

In January 1639 Rembrandt bought a large house on the fashionable Sint Antoniesbreestraat in Amsterdam (now the Rembrandthuis Museum), into which he and his wife Saskia would move in May. For the time being, they were renting next door to a house called De Suyckerbackerij (the Sugar Bakery), on the Binnen (Inner) Amstel waterway, in a district of busy trading wharves and warehouses. Rembrandt and Saskia's grand new studio-home cost 13,000 guilders, but Rembrandt felt he could afford it and had earned the social prestige it would bring. Sustaining a good income from his art would always be a challenge, however, as his seven surviving letters to the poet, composer and diplomat Constantijn Huygens reveal. They deal with two paintings of Gospel scenes, showing the entombment and resurrection of Jesus, for which Rembrandt hoped to receive 2000 guilders from Frederik Hendrik, Prince of Orange, with Huygens acting as middleman.

After waiting a month for payment, Rembrandt reluctantly accepted 1600 guilders, which he expected to receive from the tax collector Johannes Wtenbogaert. Finally, the prince authorised Thyman van Volbergen to pay Rembrandt 1244 guilders. The payment seems to have crossed with Rembrandt's reminder to Huygens, in which he is careful to temper his impatience with the respectful formality with which artists were expected to address their social superiors. It has been noted that the number of corrections in this letter suggests that Rembrandt wrote it in a hurry, and that the script is more regular and less florid than in his previous six letters to Huygens, as if he were deliberately exercising self-control.

My [dear] Sir:

I hesitate to trouble you with this letter, but I am doing so because of what Wttenbogaert, the [tax] collector, told me after I complained to him about the delay in my payment. Volbergen, the treasurer, denied that dues were claimed annually. Last Wednesday, Wttenbogaert, the collector, replied to this that Volbergen had thus far laid claim to these dues every six months, so that more than 4000 k. guilders have deposited again at his office. And because of this true state of affairs, I beg you, kind Sir, to have my payment order prepared promptly, so that I will now finally receive my well-earned 1244 guilders. I shall forever seek to requite you, Sir, for this with reverence, service, and evidence of friendship. With this, I give you, Sir, my heart-felt regards and wish that God [grant] you long-lasting good health and gives you His blessings.

Your obliging and affectionate servant
Rembrandt

I reside on the Binnen Amstel in the sugar bakery

Samedi

Monsieur de Nemusière

c'est par la condition de votre
lettre que j'ai cru que c'était
de la part de l'administration
que vous me demandiez ce
Tableau — en effet, si
comme vous me le dites c'est
une personne qui le désir,
je pourrais y faire d'autres conditions,
et si cette personne continue
à le désirer, qu'elle veuille donc
dire quel prix elles pensait
y mettre, je verrai si je puis
le lui céder.

Je vous remercie beaucoup
de vous être occupé de cette
affaire dans mon intérêt.

Veuillez accepter mes salutations,
empressées

Gustave Courbet

Gustave Courbet (1819–77) to Philippe de Chennevières
April 1866

As a successful mid-career artist in the 1860s, Gustave Courbet had an ambivalent relationship with the French social and artistic establishment. He first achieved notoriety in the early 1850s with frankly observed, unsentimental paintings of peasant life. At a time when academic painting was expected to present either sweetly idealised or romantically heroic images, Courbet's art, statements and assertive red signature felt like a 'revolutionary catapult'. Critics savaged him for 'destroying art' with his 'egalitarian painting'. In 1855, as an introduction to an exhibition of his work, he published *The Realist Manifesto*, stating that his aim was 'to translate the customs, the ideas, the appearance of my epoch … to create a living art'. Realism in art was firmly aligned with socially progressive politics. By 1866, however, when his life-size nude *Woman with a Parrot* was hung in the *salle d'honneur* in the Salon, he was being courted by collectors, including the Ottoman ambassador in Paris, Khalil Bey, for whom that year he painted *Sleep*, showing a lesbian couple in bed (Musée du Petit Palais, Paris).

Philippe de Chennevières was a minor aristocrat and unshakeably right-wing arts administrator, who in 1861 became assistant curator at the Musée du Luxembourg, where modern French art acquired by the state was displayed. He loathed the idea of democracy in art, especially Courbet's kind, objecting that he misrepresented 'the good people of the earth'. If Courbet sounds guarded in his letter, he may well have been puzzled as to why de Chennevières had approached him in the first place about purchasing *The Return of the Deer to the Stream at Plaisir-Fontaine* (Musée d'Orsay, Paris). Neither 'democratic' not erotic in subject, this peaceful, wooded scene from Courbet's native region represents yet another side to his art, which evidently appealed to Empress Eugénie, wife of Napoléon III. Courbet must have known that the *'personne'* on whose behalf de Chennevières was hoping to negotiate the sale was a high-society client. If he has guessed her true identity, however, he does not let on. In the event, after exhibiting *The Return of the Deer* at the 1866 Salon, Courbet sold it for 15,000 francs to a stockbroker, Eric Lepel-Cointet.

Monsieur de Chennevières

The concise nature of your letter led me to believe that you were asking me for this painting in an official capacity – because if, as you tell me, it is a certain lady who wants [to buy] it, I would have made different conditions; and if this person still wants it, would she kindly let you know what price she is thinking of paying, and I will see whether I'm able to accept her offer.

Thank you very much for taking care of this matter on my behalf.

With all good wishes,

Gustave Courbet

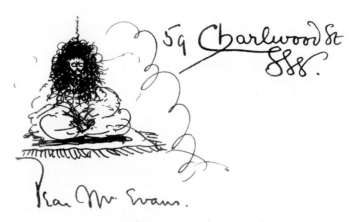

59 Charlwood St
888.

Dear Mr Evans.

There is no doubt
that I shall get the "Shaving"
to do. Chapman & Hall are
much taken with my work &
are willing to wait till the
Autumn to make a start.
All now depends upon the
I'mortal George. I am
collecting my Persianesques &c

Aubrey Beardsley (1872–98) to Frederick Evans
c.1893

The nineteen-year-old Beardsley was working as a clerk and hoping to become a writer when, in July 1891, he showed some drawings to the eminent artist Edward Burne-Jones (see page 35). 'I *seldom* or *never* advise anyone to take up art as a profession,' Burne-Jones told him, 'but in *your* case *I can do nothing else.*' Beardsley was soon working on a profitable commission to illustrate a new edition of Thomas Malory's medieval epic *Le Morte Darthur*. In 1893 he posed for a portrait by the photographer Frederick Evans. With his sensitive face in sharp profile, cradled in his improbably long fingers, he looks almost a caricature of the art-for-art's sake aesthete. Writing to Evans around this time, Beardsley mentions the Malory project and another, unrealized, scheme for a new edition of George Meredith's oriental fantasy novel *The Shaving of Shagpat* to be published by Chapman & Hall.

59 Charlwood Street

Dear Mr Evans,

There is *no doubt* that I shall get the 'showing' to do. Chapman & Hall are much taken with my work & are willing to wait till the autumn to make a start. All now depends upon the Immortal George. I am collecting my Persianesques etc to show him, I feel quite sure myself that he will like my work. This evening I dashed off a fine head of Shagpat – a most mysterious and Blake like affair which simply ought to fetch the master.

C & H will be willing to pay a good figure I can see.

I'm returning the Morte drawings you so kindly lent me.

Thanks so much for giving me the tip.

Ever yours
Aubrey Beardsley

Unless Meredith sticks to the head of Shagpat (as I fancy he will) the drawing shall be yours if you care for it.

Многоуважаемый Анатолий Васильевич

[handwritten letter in Russian cursive, largely illegible]

К. Малевич

Kazimir Malevich (1879–1935) to Anatoly Lunacharsky
November 1921

For a few heady years after the Revolution of October 1917, Russian avant-garde artists took a leading role in creating a visual language for the new Soviet state. Despite Lenin's distrust of avant-garde art, Anatoly Lunacharsky, the well-educated, art-loving People's Commissar for Education, actively involved artists in social and educational initiatives like the art school in the Belarusian city of Vitebsk, which Kazimir Malevich took over from Marc Chagall in 1919. With paintings such as *Black Square* (1915; Tretyakov Gallery, Moscow), Malevich had pioneered an uncompromisingly formal kind of abstraction. In Vitebsk he gathered together a group of artists and designers, Unovis ('Affirmers of new art'), to realize his radical ideas. On one occasion, to celebrate the anniversary of the Revolution, the city streets were decorated with circles, squares and coloured lines, much to the inhabitants' bemusement.

From 1921 onwards, official attitudes to avant-garde art rapidly hardened. The Communist Party newspaper, *Pravda*, carried frequent attacks on 'the new art' by people like Mikhail Boguslavsky, a small-time Party functionary. Malevich had visits from the Cheka (secret police), was accused of subversion and suffered the first of a series of arrests, being released only on production of a letter from Lunacharsky. His own letter to Lunacharsky makes clear his increasing frustration and vulnerability in Vitebsk. A few weeks later he left for Petrograd (now St Petersburg).

..

Dear Anatoly Vasil'yevich,

With regard to contemporary culture's barbaric treatment of works of New Art, which also include my works, which are equally respected in both the centre and the provinces (for example Vitebsk), I found all the artists' works dumped together with every kind of rubbish in some unsuitable room that looks more like a rubbish bin than a museum. In Vitebsk, however, there is a museum where the masks of Napoleon and Pushkin are preserved, as well as several Kirgiz necklaces, rings and dinnerware, a dried gourd for water, which are still valued by the local officials. [...] they see nothing in New Art, and have done nothing to protect it. So what can be expected of them when, even in the government newspapers, you often find all kinds of insults? Everywhere they spit at New Art and its representatives and, because of their blindness, think that New Art is a spittoon [...] For example, Boguslavsky in his article in issue number 224 of *Pravda* twisted the facts about 600 million roubles being spent on Futurist art, writing, 'Throw these parasites off the shoulders of the State.' Does this man really understand anything at all? And what does his article mean to people in the provinces? It means 'Away with them and lock them in cellars!' [...] I, for example, found myself in the cellar instead of a sanatorium and almost suffocated in there. But thank you – your letter about finding me a place at the sanatorium really helped. They discovered it when I was arrested. If even *I* was arrested, then the Cheka clearly don't have enough to do [...]
K Malevich

Red Hill July 16 /73

Dear Sir
Here annexed is a Sketch
of the Constable picture which I took
up at your request & painted some sheep
into — And in order to make it Clear
where my work begins & ends I have
indicated the Constable by black ink
and my work by red chalk -
Hoping this will answer the end
you propose I am yours faithfully

John Linnell Sen

James Muirhead Esqr

answer to letter of the 15th /3

John Linnell (1792–1882) to James Muirhead
16 July 1873

On 1 July 1873 John Linnell was visited by two art dealers. 'Mr Muirhead and Mr Brown bought picture said to be by Constable,' he noted in his journal. They asked him to make some alterations to the painting, and he agreed 'to put some sheep into the picture & make it a Constable & Linnell'. He would complete the work in two weeks and be paid £100 (about £6,300 today). Linnell's note to Muirhead, dated fifteen days after the meeting, bears out his reputation for businesslike efficiency: he has met his deadline and includes a colour-coded sketch of the painting 'to make it clear where my work begins & ends'.

At this stage in his career, Linnell was one of the most commercially successful artists in Britain. Sales of his portraits and landscapes had enabled him to build a mansion at Redhill in Surrey, where he home-schooled his nine children. He was aware that he had grown far richer painting agricultural scenes than the farmers of the land itself could ever hope to be. As a devout Christian, his feelings for the pastoral landscape were suffused with the biblical symbolism of flocks and shepherds, harvest and husbandry. Sheep to Linnell were always more than mere picturesque additions: in *Contemplation* (1864–5, Tate), a shepherd's peaceful flock seem to promise him undisturbed hours to get on with his uplifting reading.

In the 1820s, Linnell had been a loyal supporter of the visionary artists William Blake (see page 37) and Samuel Palmer, whom he helped out with money, contacts and commissions. After his youngest child, Hannah, married Palmer in 1837, relations between father- and son-in-law became more strained. Linnell also had an ambivalent relationship with John Constable (see page 81), becoming convinced that it was the older artist who was responsible for his failure, time and again, to be elected a Royal Academician. He seem to have felt no qualms about 'intervening' in a Constable landscape (which may or may not have been genuine).

...

Red Hill July 16 / 73

Dear Sir

Here annexed is a sketch of the Constable picture which I took up at your request and painted some sheep into – And in order to make it clear where my work begins & ends I have indicated the Constable by black ink and my work by red chalk.

Hoping this will answer the end you propose. I am yours faithfully

John Linnell sen[ior]
James Muirhead Esq
answer to letter of the 15th. /3

Hello mr lynes thank you very much

biographical information
 my life couldnt fill a penny post card
 i was born in pittsburgh in 1928 (like
 everybody else—in a steel mill)
 i graduated from carnegie tech
now i'm in NY city moving from one
roach infested apartment to another.

 Andy Warhol

Andy Warhol (1928–87) to Russell Lynes
1949

A twenty-year-old Andy Warhol writes to the photographer and assistant editor of *Harper's Bazaar*, Russell Lynes, with a (very) brief biography for the magazine, which has just given him one of his first professional commissions. In 1949 Warhol had finished his studies at Carnegie Institute of Technology in Pittsburgh and was setting up as a commercial artist in New York. Over the next ten years he would produce hundreds of illustrations for *Harper's*, whose fashion editor, Diana Vreeland, was determined to give the magazine a more contemporary feel and vigorous relevance than its rival *Vogue*. Warhol's crisp, whimsical illustrations of shoes, dresses, handbags, watches – all manner of fashion accessories – gave a distinctively playful top-spin to 1950' chic. This phase of his career would peak in his award-winning 1955–6 advertising campaign for Miller & Sons shoes. It wasn't until the early 1960s that he began to make paintings based on comic strips and adverts and to be identified with the new wave of Pop art in the United States.

Hello mr lynes thank you very much

biographical information
 my life couldn't fill a penny post card
 i was born in pittsburgh in 1928 (like everybody else – in a steel mill)
 i graduated from Carnegie tech now i'm in NY city moving from one roach
infested apartment to another.

Andy Warhol

Chapter 7

Travel

here at the moment, but we
Everything is quite simple and
the country from there to her
and there is always good rel

'I hope to get to Venice' the

nice men among the Italians
cture to interest you, I think th
hen you find it getting too co
na – a railway journey I dread
ose, provided you do not allov
ly is a great experience to be
udan and go to Thebes and
not to eat and drink with thei
The town is simple & comfo
xpect to be very much benef
d summer. Write us, we hope
etings. How the Mistral blows
to visit with the Gimpel's &

Villa Figini
Barzanò.
Monza
Italia

8 September 1885

My dear Hallam,

The Photograph arrived
quite safely, yesterday Evening, & I am
delighted with it. I am so much obliged
to you. I always felt sure she had beautiful
eyes, in spite of the 1st Photograph which
probably was so arranged by the wife or
other feminine party belonging to the Pho-
tographer who had got ugly eyes, & was
jealous of all pretty ones. As soon as I get back
to Sanremo I shall have the Likeness framed;
the face is so charming that even if it belonged
to Mrs Peregrine Pobbsquobb or any one else
& not Hallam Tennyson's wife it would be a
lovely portrait to look at. The arrangement
of the hair is perfect. — how strange that
9 out of 10 women cannot see that such
a simple matter improves their beauty, &

— on the contrary — prefer nourishing Goat
curls & other hideousnesses! Thank you
very dear boy, & likewise give
my thanks to your Audrey —
for you have both given me a real
pleasure. ‖ I leave here tomorrow, & return to
my native home at Sanremo — going by Milan
& Savona — a railway journey, which I detest — for I
am but very feeble. The Mundellas were coming
to see me tomorrow, but I wrote to put them off,
we meet at Milan: it is so not here now that
there is no fun for the time being. ‖ I send to Sanremo
120 of my 200 Tennyson illustrations, so 120 pretty
well completed. More about the whole work at
a few other times. ‖ I have just had a very nice letter
from your Uncle Edmund, & have made a Confidence
to him (& to the D. of Argyll — with whom I am in
Correspondence about Certain Nile stratification,)
which I shall repeat to you in worse, on the
next leaf. ‖ Lofter thinks of you all at Aldworth, &
should like to hear. Give my love to your Mother &
Father & to the Leonels & to your Audry.
You are fortunate indeed to be so happy in marriage,
yet I fancy the happiness is well merited, if only
for your Father & Mother's sake — not to speak of
your own, which you are by no means a bad one.
Good bye my dear Hallam —
Yours affectionately, Edward Lear

1

When leaving this beautiful blessèd Brianza
My trunks were all corded & locked except ONE:—
But that was unfilled, through a dismal mancanza,
Nor could I determine on what I should done.

2

For, out of three volumes, (all equally bulky,)
Which — travelling, — I constantly carry about,
Here was room but for two. So, though angry & sulky,
I had to decide as to which to leave out.

3

A Bible! a Shakespear! a Tennyson! — Stuffing
And Cramming and squeezing were wholly in vain.
A Tennyson! — Shakespear! and Bible! — All puffing
Was useless, and one of the three must remain!

4

And this was the end, (as is truth & no libel;)
I weary with thinking I settled my doubt
As I packed & sent off both the Shakespear & Bible
And finally left the "Lord Tennyson" out!

Villa Figini. Barzanò. Monza.
8 Septr. 1885

Edward Lear (1812–88) to Hallam Tennyson
8 September 1885

Edward Lear was an expatriate artist living in Rome, when the threat of revolution in Italy prompted him to return to England in 1849. He had recently published two very different books. *Illustrated Excursions in Italy* was a topographical album on the strength of which Queen Victoria asked Lear for drawing lessons. *A Book of Nonsense* contained seventy-two limericks and line-drawings featuring wildly eccentric characters in fantastical situations. It attracted little attention.

Back in England, Lear formed a long-lived friendship with the poet laureate, Alfred Tennyson, and his wife, Emily. Tennyson dedicated a poem to Lear's new book on his Greek travels; Lear told Emily that the pleasure Tennyson's poetry gave him was 'beyond reckoning'. When Lear returned to Italy in 1869, settling in San Remo, he embarked on a project to illustrate all of Tennyson's poems. It was still underway in 1885, when he wrote to the Tennysons' eldest child, Hallam (a future governor general of Australia), to thank him for a photograph of his bride, Audrey, and report on progress. He signs off with a poetic self-parody about travelling with an over-full trunk – of three large tomes, there is room for only two. 'A Bible! a Shakespeare! a Tennyson! – stuffing / And cramming and squeezing were wholly in vain […] I packed & sent off both the Shakespeare & Bible, / And finally left the "Lord Tennyson" out!'

My dear Hallam,

The Photograph arrived quite safely yesterday evening, & I am delighted with it. I am so much obliged to you. I always felt sure she had beautiful eyes, in spite of the 1st Photograph which probably was so arranged by the wife or other feminine party belonging to the Photographer who had got ugly eyes, & was jealous of all pretty ones. As soon as I get back to Sanremo I shall have the likeness framed; the face is so charming that even if it belonged to Mrs. Peregrine Pobbsquobb or anyone else & not Hallam Tennyson's wife it would be a lovely portrait to look at. The arrangement of the hair is perfect: – how strange that 9 out of 10 women cannot see that such a simple matter improves their beauty, & – on the contrary – prefer Goat curls & other hideousnesses! Thank you my dear boy, & likewise give my thanks to your Audrey – for you have both given me a real pleasure. || I leave here tomorrow, & return to my native 'ome at Sanremo – going by Milan & Savona – a railway journey I dread & detest – for I am but very feeble […] I send to Sanremo 120 of my 200 Tennyson illustrations, these 120 now pretty well completed. More about the whole work at a fewcher thyme […]

You are fortunate to be so happy in marriage, yet I fancy the happiness is well merited if only for your Father & Mother's sake – not to speak of your own, which you are by no means a bad cove.

Good bye my own Hallam.
Yours affectionately, Edward Lear.

July 19

There is little to be said for this place — it is so perfect. Nothing but praises. The heat is not at all bad and there is always good relief. It quite exceeds my expectations. There is beauty everywhere — comfort — freedom. Mind and body are at rest and I expect to be very much benefited by this. Rest your mind entirely of any "home" — possibilities. I hope you were not as depressed as I was in Paris. Every thing is quite simple and well now.

Just received word from Duchamp that Man Ray is coming over — arriving the 32nd.

Best of luck and wishes for you! Would be very glad to hear from you — here.

Yours

B. P.

Berenice Abbott (1898–1991) to John Henry Bradley Storrs
19 July 1921

It is as a photographer that Berenice Abbott is known today – for her ten-year project to photograph the streets and buildings of New York in the 1930s, for her definitive portraits of sitters such as James Joyce, Jean Cocteau and Eugène Atget, the modest photographic chronicler of late nineteenth-century Paris whose extraordinary *oeuvre* Abbott rediscovered and preserved. Abbott started out, however, by training as a sculptor. Encouraged by Marcel Duchamp (see page 45), whom she met while he was living in New York during the First World War, and the sculptor, poet and flamboyant eccentric Elsa von Freytag Loringhoven, Abbott left New York for Paris in March 1921. On the voyage she met John H. Storrs, an American sculptor who had studied with Rodin.

Through Storrs, Abbott found work as an artists' model. She taught ragtime dancing and sold a few sculptures but could not afford the classes she had hoped to attend with Antoine Bourdelle. In the artists' district of Montparnasse, she met up again with Duchamp and the experimental photographer May Ray, to whom Duchamp had introduced her in New York. In 1921 Ray too had left for Paris, disheartened at the failure of his and Duchamp's American Dada publication (see also page 69).

Abbott writes to Storrs from the small town of Brignoles on the Côte d'Azur, where she is taking a summer break from the city. Despite the euphoria of feeling 'completely liberated' in Paris – which includes, for Abbott, the freedom of express herself as a lesbian – her life there is not working out. In the autumn, on 'a sudden flash of intuition', she will take the train to Berlin, writing to Storrs in October, 'This is the first place I have been thrilled with – thrilled to tears … Energy – force – abounds in the air.' In the early 1920s, however, Germany was in a state of economic collapse. Unable to earn a living, Abbott returned to Paris. Meeting up with Man Ray in a nightclub, she heard how his creative career – unlike hers – was thriving. He had just sacked his studio assistant and offered Abbott the job. In 1926, after learning her trade as a photographer from Man Ray, she set up her own portrait studio in Paris.

..

There is little to be said for this place – it is so perfect. Nothing but praises. The heat is not at all bad and there is always good relief. It quite exceeds my expectations. There is beauty everywhere – comfort – freedom. Mind and body are at rest and I expect to be very much benefited by this. Rest your mind entirely of any 'homo' possibilities. I hope you were not as depressed as I was in Paris. Everything is quite simple and well now.

Just received word from Duchamp that Man Ray is coming over – arriving the 22nd.

Best of luck and wishes for you! Would be very glad to hear from you here.

Yours
B.A.

Georges Braque (1882–1963) and Marcelle Braque (1879–1965) to Paul Dermée and Carolina Goldstein
17 August 1918

In late July 1912, Georges Braque and his new bride, Marcelle, joined Picasso and his girlfriend, Eva Gouel, in the small Provençal town of Sorgues. Since 1908, the two artists – like 'mountaineers roped together', joked Picasso – had been jointly engaged in the reconceptualization of two-dimensional image-making that came to be known as cubism. In Sorgues for the summer, Picasso and Braque shared the cooking and discussed ways of reintroducing a sense of tangible objects into their increasingly abstract-looking work. Braque had started adding sand to his paint, Picasso found a piece of chair caning that he stuck onto a still-life painting. In a shop in nearby Avignon, Braque bought a roll of wallpaper with an illusionistic oak-grain pattern, from which he cut out pieces and glued them to a canvas – the start of a series of *papiers collés* or collages that turned out to be one of cubism's most endlessly productive contributions to modern art.

For the next few years, Braque and Marcelle stayed every summer in Sorgues. In 1914, on their return to Paris in August and the outbreak of war, Braque was called up into the French army. In the Battle of Carency, the site of ferocious landmine warfare in May 1915, he was hit in the head by shrapnel and blinded. As his wound healed and he recovered his sight, he returned to Sorgues for respite. It was eighteen months before he could paint again. In August 1918 – as German forces were finally in retreat along the Somme – Braque, now discharged from the army, was 'safely back' in Sorgues.

This holiday postcard of Avignon is addressed to the Belgian poet Paul Dermée and his wife, the Romanian-born poet Carolina Goldstein, who wrote under the pen-name Céline Arnauld. Both would soon be closely involved in the postwar international Dada movement (see page 69), whose anarchic leading spirit, Tristan Tzara, appointed Dermée as Dada's official representative in Paris. Arnauld contributed to numerous Dada publications, including Francis Picabia's journal *391*, and took part in Dada performances. Collage, the medium with which Braque had first experimented in Sorgues in 1912, and which he and Picasso named, together with its offshoot photomontage, would become favourite weapons in Dada's subversive armoury.

G Braque
Sorgues
(Vaucluse)

My dear friends

Safely back in Sorgues I send you friendly greetings. How the Mistral blows!

G Braque

My dear Carola write to me – I was delighted to hear good news about you both
Marcelle

26th July.
Bridge of Turk.

My dear Sir

I cannot give a satisfactory answer to your letter. as it depends entirely on the particular form of affection of throat or chest by which you are affected whether Italy will be good or bad for you. of Australia I know nothing. but as in all probability. both the accommodations and medical advice are inferior there, and assuredly you would find no architecture to interest you. I think the disadvantages ~~~~ countable the probable gain: the great thing is to keep your mind agreeably employed. and not to expose yourself rashly. with precautions – you may obtain. almost any climate in Italy you choose. provided you do not allow yourself to be led unwisely by any temptation into the shady side of a street, when you know you ought to keep the sunny one. – I think Italy – take it all in all – an excellent country for an Invalid; but

John Ruskin (1819–1900) to unknown recipient
26 July 1853

John Ruskin and Euphemia Chalmers (known as Effie) Gray married in 1848. When they had first met, seven years earlier, Gray had been a child of twelve and Ruskin a recent Oxford graduate, published writer and talented draughtsman and watercolourist. With the publication of the first two volumes of *Modern Painters* in 1843 and 1846, Ruskin was on his way to becoming Victorian Britain's most authoritative voice on art. His next big projects, two books on Venetian Gothic architecture, involved extended stays in Venice in 1849–52. Ruskin studied and drew 'every fragment' of medieval Venice 'stone by stone', leaving Effie to enjoy the social scene. They seem, at least separately, to have been happy. But the marriage remained unconsummated, and there were tensions to do with Ruskin's fixation on work and his closeness to his controlling parents.

Back in England, Ruskin became an advocate for a group of young painters who called themselves the Pre-Raphaelite Brotherhood. After Effie posed for a history painting by one of them, John Everett Millais, Ruskin invited Millais to join him and Effie on a holiday in Scotland. In early July 1853 they arrived at Brig O'Turk in Glenfinlas, where they rented a cottage. Ruskin was finishing his next book, *The Stones of Venice*, while Millais made drawings of Effie in preparation for a portrait. Ruskin's letter to an unknown correspondent, full of vague but sympathetic health tips for a traveller with chest problems, gives no hint of the love affair that was dawning behind his back, though it looks as if Effie supplied him with his frilly-edged writing paper. Within a year their marriage was over: Effie divorced Ruskin on grounds of 'incurable impotency' (a fact he later offered to disprove) on 15 July 1854. In July 1855 she married Millais.

Bridge of Turk

My dear Sir

I cannot give a satisfactory answer to your letter, as it depends entirely on the particular form of affection of throat or chest by which you are affected whether Italy will be good or bad for you. Of Australia I know nothing, but as in all probability, the accommodations and medical advice are inferior there, and assuredly you would find no architecture to interest you, I think the disadvantages would counterbalance the probable gain: The great thing is to keep your mind agreeably employed and not to expose yourself rashly. With precautions – you may obtain almost any climate in Italy you choose, provided you do not allow yourself to be led away by temptation into the shady side of a street, when you know you ought to keep to the sunny one. – I think Italy – take it all in all – is essential country for an Invalid [...] I think the French air exquisite. When you find it getting too cold for you, run to Paris by the railroad and thence to Nice [...]

7 July 57

REFLETS DE LA COTE BASQUE
SAINT-JEAN-DE-LUZ
14 - La Plage et la Rhune

Dear Miz & Hans -
It isn't this crowded nor
this sunny here at the moment
but we love it; have a large
place and lots of room to
paint — which is exactly what
we're doing! The town is simple
& comfortable ... really, a french
Provincetown. Hope you're both
well and having a good summer.
Write us, we hope: What's new?
 Villa Ste - Barbe
 rue Ste - Barbe
 St. Jean-de-Luz (B. Pyr.)
 France .
Love Helen + Bob

AVION

Mr. & Mrs. Hans Hofmann
Provincetown
Mass. .
U . S . A .

PAR AVION

MEXICHROME
couleurs naturelles

Helen Frankenthaler (1928–2011) and Robert Motherwell (1915–91) to Maria and Hans Hofmann
7 July 1958

Helen Frankenthaler and Robert Motherwell married in the spring of 1958, then spent several months of their summer honeymoon in the seaside town of Saint-Jean-de-Luz, on the French side of the border with Spain. As Frankenthaler explains in this postcard to her former teacher, Hans Hofmann, and his wife Maria ('Miz'), she and Motherwell have 'lots of room to paint' in their rented villa above the town's main beach and are making productive use of the space.

Twelve years older than his third wife, Motherwell had been one of the original abstract expressionist painters and, like Jackson Pollock (see page 121), had been promoted by the New York gallerist Peggy Guggenheim in the 1940s. In the Villa Sainte-Barbe he continued working on a series he had begun ten years earlier, titled 'Elegy to the Spanish Republic'. Characterized by a sombre dance of shadowy uprights and ovals, these would eventually number more than 170 paintings.

Frankenthaler belonged to a younger cohort of American abstract painters. She recalled being first excited by the possibilities of gestural abstraction on seeing Pollock's poured paintings in 1950 and wanting 'to live in this land … and master the language'. During a five-year relationship with the influential critic Clement Greenberg, which she described as 'a painting bath', she saw every possible exhibition, met leading artists and developed her own 'soak-stain' method of using very thin washes of colour that soaked straight into the raw canvas. Painted in Saint-Jean-de-Luz, *Silver Coast* (Bennington College, Vermont) is a hothouse fusion of cloudy blue-grey staining and explosive brushed or spattered red, black and ochre paint.

Frankenthaler and Motherwell both came from wealthy families and enjoyed a privileged lifestyle of travel and entertaining. Their upbeat message to the Hofmanns would have reached them shortly after Hans retired, at the age of seventy-eight, from teaching at his school at Provincetown. This was the last of a series of schools in Germany and the United States where Hofmann had been a much-respected and (judging by the roll-call of well-known artists who had studied with him) highly effective mentor.

..

Dear Miz & Hans,

It isn't this crowded or this sunny here at the moment, but we love it; have a large place & lots of room to paint – which is exactly what we're doing! The town is simple & comfortable ... really, a french Provincetown. Hope you're both well and having a good summer. Write us, we hope: what's new?
Villa Ste-Barbe
rue Ste-Barbe
St-Jean-de-Luz (B. Pyr.)
France.

Love Helen & Bob

Albrecht Dürer (1471–1528) to Willibald Pirckheimer
7 February 1506

Towards the end of 1505 Albrecht Dürer set off from Nuremberg on his second trip to Venice. The previous time, in autumn 1494, he had been a young artist whose only contact with Italian Renaissance art had come through the medium of prints. He was self-confident, curious, original. The watercolour scenes he painted on his journey across the Alps mark the first appearance of landscape as a subject in its own right in art.

Dürer returned to Venice a famous artist, master of a thriving workshop. But he was still driven by a desire – first fired by a Venetian painter who had worked in Nuremberg, Jacopo de' Barbari ('Master Jacob') – to perfect his knowledge of perspective and classical proportion. Writing to his best friend, the humanist scholar Willibald Pirckheimer, a few weeks after his arrival, he sounds eager to challenge Italian artists on their own ground. Commissioned by some German merchants for their church in Venice, *Feast of the Rose Garlands* (National Gallery, Prague) was intended to do just this.

. .

First my willing service to you, dear Master! If things are going well with you I am as glad with my whole heart for you as I should be for myself. I recently wrote to you and hope that the letter reached you. In the meantime my mother has written to me, scolding me for not writing to you [...] She said I must duly excuse myself to you, and she takes it very much to heart, as her way is [...].

How I wish you were here in Venice! There are so many nice men among the Italians who seek my company more and more every day – which is very pleasing to one – men of sense and knowledge, good lute-players and pipers, judges of painting, men of much noble sentiment and honest virtue [...]

Amongst the Italians I have many good friends who warn me not to eat and drink with their painters. Many of them are my enemies and they copy my work in the churches and wherever they can find it; and then they revile it and say that the style is not antique and not so good. But Giovanni Bellini has highly praised me before many nobles. He wanted to have something of mine, and he himself came to me and asked me to paint him something and he would pay well for it. And all men tell me what an upright man he is, so that I am really friendly with him. He is very old, but is still the best painter of them all. And that which so well pleased me eleven years ago pleases me no longer [...] You must know too that there are many better painters here than Master Jacob [...]

My friend! I should like to know if any one of your loves is dead – that one close by the water for instance, or the one like [flower] or [brush] of [hound]'s girl, so that you might supply her place by another [...]

APRIL 17 POST CARD air

DEAREST EVA

KYOTO BEYOND ALL
DREAMS
SOUND OF BROOK EVA HESSE DOYLE
UNDER MY WINDOW EWING PAVILLION
CHERRY PETALS 68TH ST & FIRST AVE
LIKE SNOW IN AIR · NEW YORK CITY
FEET ON CRUSHED NEW YORK
STONE
WATER REFLECTING USA
LOVE AND BE WELL
CARL

Carl Andre (b.1935) to Eva Hesse
17 April 1970

In Japan for the 10th Tokyo Biennale in the spring of 1970, Carl Andre sent Eva Hesse (see page 117) a postcard he knew she would enjoy, showing a Japanese print or painting based on the garden at Ryōan-ji, a Zen temple and imperial mausoleum in north-west Kyoto. Consisting of irregularly shaped rocks surrounded by white gravel, which the monks carefully rake every day into patterns resembling spreading ripples, the garden is a famous example of *kare-sansui* or 'dry landscape', conceived as a focus for meditation. In its combination of natural forms and rhythmic patterns, it shares something with Hesse's sculpture and, more distantly, with Andre's own minimalist idiom, which is based on regular arrangements of standard, industrially produced units, such as bricks and metal plates. Andre's core idea of 'axial symmetry' related to his years working on American railways, surrounded by 'horizontal lines of steel and rust and great masses of coal and material'.

In Japan after the Second World War, artists had been engaged in a parallel extension of the boundaries of art, using raw industrial and natural materials, and exploring alternative media like performance and installation. Under the title 'Between Man and Matter', the 1970 Tokyo Biennale would be the first large-scale gathering of radical American, European and Japanese artists. Travelling with Andre in Japan and also showing at the Biennale was Hesse's close friend and creative collaborator Sol Lewitt, who sent his own postcard from the Ryōan-ji rock garden a couple of days later.

Both Andre and Lewitt were clearly excited by their encounter with this centuries-old form of minimalist installation. Andre was inspired to write his card in the form of a Japanese poem, loosely modelled on the seventeen-syllable haiku. It is a parody, for sure, but also a serious message of consolation for 'Dearest Eva'. In April the previous year, Hesse had undergone surgery for a brain tumour. The prognosis was not good, but she continued working and exhibiting until, on 22 May 1970, a month after Andre posted his card from Japan, she fell into a coma. She died on 29 May.

..

APRIL 17

DEAREST EVA
 KYOTO BEYOND ALL
DREAMS
 SOUND OF BROOK
UNDER MY WINDOW
 CHERRY PETALS
LIKE SNOW IN AIR
 FEET ON CRUSHED
STONE
 WATER REFLECTING
LOVE AND BE WELL
 CARL

C/o Thos. Cook Salisbury S. Rhodesia.

22/2/51 — Dearest Erica I got here about a week ago & stayed at Zimbabwe and the country from there to here is too marvellous / it is like a continual Renova landscape and Zimbabwe itself is incredible. Robert Hale - Perry has left and will be back in London soon. There started to work at ... Thulking here and I met a dear old ... he's a farm near Zimbabwe and am going back there now that I've got my car Robert has made his particular family well from me to try and do a get on 3 quickly — could the gallery possibly advance me £50 as now that I have left Robert I'm practically no money. I have the return ticket again which I'm changing and trying to get a boat from Beira off the east coast they call in at all the ports and then I want to get off at Port Sudan and go to Thebes and rejoin the boat again at Alexandria to Marseille. I'm trying to get a passage on a boat that leaves Beira on the 18th of March and I should be here about the end of April. I would be terribly grateful if you could do this for me ever so & terribly mine here I don't like sponging on them all the time and paint

Francis Bacon (1909–1992) to Erica Brausen
22 February 1951

In November 1950, Francis Bacon sailed for South Africa in the company of Robert Heber-Percy. Known as 'the Mad Boy', Heber-Percy had been the lover and companion of Lord Berners, until Berners' dath in April 1950. Bacon was intending to visit his mother, who had moved to Rhodesia (now Zimbabwe), and to travel back to England via Egypt. Two years earlier Erica Brausen had given him his first exhibition at her recently established Hanover Gallery, where her other young protégés included Lucian Freud (see page 19). The widely read but poorly educated Bacon writes with a characteristically unpunctuated blend of gossipy banter and requests for money. Brausen seems not to have responded quickly enough, since five days later he is writing, 'I am sorry to ask again but could you wire me the £50 [about £1500 today] immediately.'

c/o Thos Cook Salisbury, S. Rhodesia

Dearest Erica I got here about a week ago I stayed at Zimbabwe and the country from there to here is to[o] marvellous it is like a contin[ual?] Renoir landscape and Zimbabwe itself is incredible Robert Heber-Percy has left and will be back in London soon I have started to work it is so thrilling here and I met someone who has a farm near Zimbabwe and I am going back there now I have got shot[?] of Robert to try and do a set of 3 quickly – could the gallery possibly advance me £50 as now that I have left Robert I have practically no money I have the return ticket again which I am changing and trying to get a boat from Beira at the east coast they call in at all the ports and then I want to get off at Port Sudan and go to Thebes and rejoin the boat again at Alexandria to Marseilles I am trying to get a passage on a boat that leaves Beira on the 18th of March and I should be home about the end of April I should be terribly grateful if you could do this for me everyone is so terribly nice here I don't like sponging on them all the time and paints and canvas are very expensive you can send it from Thos Cooks office in Berkeley Street to their Branch in Salisbury and send to me by cable I shall be in and out of Salisbury for the next 3 weeks – the men are to marvel on darling lazy over fed – and rich – champagne starts at 11 o'clock in the mornings – Tell Arthur – the Rhodesian police are completely him too sexy for words starched shorts and highly polished leggings – I feel 20 years again yes we are mad to stay in England I am certain you would adore this country. All my love to you all. Francis

Dear Judy:

Here I am in Cuban soil working. It really is a great experience to be working in my homeland. I am in la cárdenas area in a mountain region in the province of Havana. Will show the work in New York in November. Have a good summer and more to New Haven. All the best, Love, Ana

Cueva de Bellamar, Matanzas
Bellamar Cave, Matanzas
Grotte de Bellamar, Matanzas

TARJETA POSTAL

CUBA correos 1972 13
TORNEO BOXEO
GIRALDO CORDOVA
CARDIN

Judith Wilson
517. East 13th Street
Apt 2B
New York, New York
10009
USA

Ana Mendieta (1948–85) to Judith Wilson
20 August 1980

'Here I am on Cuban soil working,' Ana Mendieta writes to her art historian friend Judith Wilson. 'It really is a great experience.' This trip in August 1980 was the first time Mendieta had returned to Cuba since the age of twelve, when her father had sent her and her older sister to supposed safety in the United States. He was arrested soon afterwards for opposition to President Fidel Castro and spent the next eighteen years in prison. Separated from her sister, Mendieta was consigned to a brutal reform school in Iowa, followed by a series of foster homes.

In her twenties, after studying on the University of Iowa's postgraduate Intermedia Program, Menieta developed her 'earth-body sculptures', in which her body, natural environment and elemental materials like blood, soil and fire became the focus for performances, photographs and videos. A visit to Mexico in 1971 – 'like going back to the source, being able to get some magic just by being there' – initiated her *Silhueta* (*Silhouette*) series, in which she traced her body's outline on the ground by various means – stones, leaves, even by lighting gunpowder. In 1981 she would return a second time to Cuba, where she carved her *Rupestrian Sculptures* in rocks at Escalares de Jaruco. 'My art is grounded on the belief in one universal energy that runs through everything,' she wrote, 'from insect to man, from man to spectre, from spectre to plant, from plant to galaxy.'

Moving to New York in 1978, Mendieta became involved in the feminist movement, exhibiting *Silhueta* at the all-women A.I.R. Gallery in 1979. Through A.I.R. co-founder Nancy Spero, she met the minimalist artist Carl Andre (see pages 105 and 205). Like their work, their personalities seemed incompatible – Mendieta was excitable and outspoken, Andre reserved and methodical – but they eventually married in January 1985. On the night of 8 September, Andre called the emergency services to say that his wife had 'somehow gone out the window' of their thirty-fourth-floor Manhattan apartment. He was charged with her murder. It seemed that, after heavy drinking, they had had a violent quarrel, but the events leading up to Mendieta's death were never firmly established, and Andre was acquitted. Friends could not believe, however, that Mendieta had committed suicide. 'She told me that she was making new work,' recalled one, 'and that she was going to give up drinking and smoking because women artists did not get recognition until they were old. She said she wanted to live long enough to savour it.'

Dear Judy;

Here I am in Cuban soil working. It really is a great experience to be working in my homeland. I am in a cavernous area in a mountain region in the province of Havana.

Will show the work in New York in November. Have a good summer and move to New Haven.

All the best,
Love, Ana

Dear Jackson - Sat -

I'm staying at the Hôtel Quai Voltaire, Quai Voltaire
Paris, until Sat the 28 then going to the South of
France to visit with the Gimpel's + I hope to get
to Venice about the ~~and~~ early part of august - It
all seems like a dream - The Jenkins, Paul + Esther
were very kind. in fact I don't think I'd have
had a chance without them - Thursday nite
ended up in a Latin quarter dive, with Betty
Parsons, David who works at Sidney's, Helen Franken-
thaler, The Jenkins, Sidney Gist + I don't remember
who else, all dancing like mad - Went to the flea
market with John Graham yesterday - saw all the
left-bank galleries, met Druin and several other
dealers (Tapie, Stadler etc). am going to do the
right bank galleries next week - + entered the
Louvre which is just ~~and~~ across the Seine outside
my balcony which opens on it - About the Louvre
I can ~~say anything~~ - It is overwhelming - ~~fab~~
beyond belief - I miss you + wish you were ~~doing~~
~~shar~~ this with me - The roses were the most beaut.
deep red - kiss Gyp + ahab for me - It would be
wonderful to get a note from you. Love Lee -
The painting here is unbelievably bad (How are you)
Jackson?

Lee Krasner (1908–84) to Jackson Pollock
21 July 1956

Writing from Paris on her first visit to Europe in summer 1956, Lee Krasner enthuses to her husband Jackson Pollock, 'It all seems like a dream.' Despite the background to her trip – a trial separation after eleven years of marriage, giving her a break from Pollock's alcoholism and depression – he has sent red roses to her hotel. In their role as Krasner's Parisian hosts, Paul and Esther Jenkins have made sure she has plenty of New York company. She mentions the sculptor Sidney Geist, painter Helen Frankenthaler (see page 201) and Pollock's former dealer Betty Parsons. John D. Graham, her companion on the mandatory foray to a flea market, is a Russian-American artist and collector who in 1941 organised the exhibition that brought Krasner and Pollock together. Of the splash-and-drip paintings that subsequently made Pollock's international reputation, he regarded Graham as 'the only man who really knows what it's about'.

Krasner also mentions Michel Tapié, who helped to arrange the exhibition in Paris in 1952 that introduced Pollock to the French art world. She reassures him that he has no competition from contemporary French painting, which is 'unbelievably bad'. Her summer itinerary includes staying with the London dealers Charles and Peter Gimpel at their country house in Ménerbes, then going on to Venice for the Biennale. She sends kisses to the dogs, Gyp and Ahab. What she does not know is that Pollock's new girlfriend, the young artist Ruth Klingman, has moved into their home in Springs while she is away. Three weeks later, on 11 August, Pollock is killed, drunk at the wheel, when the car in which he is driving with Klingman hits a tree. Instead of travelling on to Venice, Krasner returns to arrange his funeral (see page 63).

Sat –

Dear Jackson –

I'm staying at the Hôtel Quai Voltaire, Quai Voltaire Paris, until Sat the 28 then going to the South of France to visit with the Gimpel's & I hope to get to Venice about the early part of August – It all seems like a dream – The Jenkins, Paul & Esther were very kind; in fact I don't think I'd have had a chance without them. Thursday nite ended up in a Latin quater dive, with Betty Parsons, David, who works at Sidney's Helen Frankenthaler, The Jenkins, Sidney Giest & I don't remember who else, all dancing like mad – Went to the flea market with John Graham yesterday – saw all the left-bank galleries, met Druin [Drouin] and several other dealers (Tapie, Stadler etc). I am going to do the right bank galleries next week – & entered the Louvre which is just across the Seine outside my balcony which opens on it – About the 'Louvre' I can say anything – It is over whelming – beyond belief – I miss you & wish you were sharing this with me – The roses were the most beautiful deep red – kiss Gyp & Ahab for me – It would be wonderful to get a note from you. Love Lee –

The painting hear is unbelievably bad
(How are you Jackson?)

Chapter 8

'I see better'

Signing Off

Dear Sir,

Your very obliging Letter inclosing a Norwich Bank Bill, Value Seventy three Pounds, on Mess.rs Kerr & Williams, I acknowledge (when R.d) to be in full for the Landscape with Cows & all demands.

I am glad Sir that the Picture got no damage, if ever you should find anything of a Chill come upon the Varnish of my Picture, owing to its being a Spirit of Wine Varnish, Take a rag, or little bit of Spunge with Nut oil, and rub it till the mist clears away, and then wipe as much of it off as softer Strokes with a clean Cloth —; this done once or twice a year when damp weather you will find convenient — — My Smoaked Neck is got very painful indeed, but I hope it the near coming to a Cure — How happy should I be to set out for yourselves

and after recruiting my poor cragg Frame, enjoy the Country along till I reach'd Norwich and give you a call — God only knows what is for one, but hope is the better of Colors we all paint with in Sickness —

To add how all the Childish passions hang about one in Sickness, I feel such a fondness for my first imitations of little Dutch Landskips that I can't keep from working an hour or two of a Day, though with a great mixture of bodily Pain — I am so childish that I could make a Kite, catch Gold Finches, or build little Ships —

Believe me Dear Sir
with the greatest sincerity
Your ever Obliged Sthudious
Serv.t

Tho.s Gainsborough

Pall Mall
May 22.d 1788 —

P.S. I have recollected that a Stamp Rec.t may be proper.

Thomas Harvey Esq.r
at Catton near
Norwich

Thomas Gainsborough (1727–88) to Thomas Harvey
22 May 1788

Growing up in rural Suffolk, the precociously gifted Thomas Gainsborough was about nine when he painted his first self-portrait. He went on to become one of eighteenth-century Britain's most eminent artists, in high demand for his graceful portraits of the landed gentry and society figures like the actors Sarah Siddons and David Garrick. By the 1780s Gainsborough was living in a grand townhouse in central London and receiving regular royal commissions. Yet part of him loathed what he called 'the Face Business' and longed to return to his first – though far less profitable – love of landscape painting.

Early in 1788, Gainsborough was increasingly troubled by a swelling in his neck, which he had noticed three years earlier but had now become painful. He was prescribed a harmless 'seawater poultice' yet feared the worst, telling a friend, 'if this be a cancer I am a dead man'. He went on selling work from his showroom at home, including a landscape that was bought by a collector from Norwich, Thomas Harvey. In one of his last letters (he died just two months later), Gainsborough gives Harvey detailed technical advice about how to care for the painting, and – in a wistful echo of the madcap humour for which he was known – a frank picture of his state of health and mind.

Dear Sir,

Your very obliging Letter inclosing a Norwich Bank Bill, Value Seventy three Pounds, on Messrs. Vere & Williams, I acknowledge (when pd.) to be in full for the Landscape with Cows & all demands.

I am glad Sir, that the picture got no damage; if ever you should find anything of a Chill come upon the Varnish of my Pictures, owing to its being a spirit of wine Varnish, take a rag, or little bit of sponge with a Nut oil, and rub it 'til the mist clears away, and then wipe as much of it off as a few strokes with a clean Cloth will effect. This done once or twice a year after damp weather you will find convenient.

My swelled neck is got very painful indeed, but my hope is the near coming to a Cure – How happy should I be to set out for Yarmouth and after recruiting my poor Crazy Frame, enjoy the coasting along til I reach'd Norwich and give you a call – God only knows what is for me, but hope is the Pallat of Colors we all paint with in sickness.

'tis odd how all the Childish passions hang about one in sickness, I feel such a fondness for my first imitations of little Dutch Landskips that I can't keep from working an hour or two of a Day, though with a great mixture of bodily Pain. I am so childish that I could make a kite, catch Gold Finches, or build little ships –

Believe me Dear Sir
with the greatest sincerity
Your ever Obliged & Obedient
servant
Thos Gainsborough
Pall Mall

Aix, 21 septembre 1906,

Mon cher Bernard —

Je me trouve en un tel
état de trouble cérébrale,
dans un trouble si grand,
que j'ai craint à un
moment que ma frêle
raison n'y passât. Après les
terribles chaleurs que nous
venons de subir, une
température plus clémente a
ramené dans nos esprits
un peu de calme, et ce
n'était pas trop tôt, mainten-
ant il me semble que je
vois mieux et que je pense
plus juste dans l'orientation
de mes études. Arriverai-je
au but tant cherché, et si longtemps
poursuivi.

Paul Cézanne (1839–1906) to Émile Bernard
21 September 1906

This is the last of a series of letters the elderly Paul Cézanne wrote to the younger painter and writer Émile Bernard, who had first visited him in 1904. As Bernard must have hoped (he had already published letters he had received from Van Gogh), their correspondence elicited some of Cézanne's most deeply felt reflections on his art: 'treat nature by means of the cylinder, the sphere, the cone'; 'we must render the image of what we see, forgetting everything that existed before us'. 'Will I ever attain the end for which I have striven so much and so long?' he asks Bernard here. A few weeks later, on 17 October, he wrote to an artists' supplier, complaining that the paints he had ordered had not arrived. Then, on 22 October, after collapsing while painting in his garden at Aix-en-Provence and very nearly fulfilling his promise to himself, he died.

My dear Bernard,

I am in such a state of mental disturbance, I fear at moments that my frail reason may give way. After the terrible heatwave that we have just had, a milder temperature has brought some calm to our minds, and it was not too soon; now it seems to me that I see better and that I think more correctly about the direction of my studies. Will I ever attain the end for which I have striven so much and so long? I hope so, but as long as it is not attained a vague sense of uneasiness persists which will not disappear until I have reached port, that is until I have realized something which develops better than in the past, and thereby can prove the theories – which in themselves are always easy; it is only giving proof of what one thinks that raises serious obstacles. So I continue to study.

But I have just re-read your letter and I see that I always answer off the mark. Be good enough to forgive me; it is, as I told you, this constant preoccupation with the aim I want to reach, which is the cause of it.

I am always studying after nature and it seems to me that I make slow progress. I should have liked you near me, for solitude always weighs me down a bit. But I am old, ill, and I have sworn to myself to die painting, rather than go under in the debasing paralysis which threatens old men who allow themselves to be dominated by passions which coarsen their senses.

If I have the pleasure of being with you one day, we shall be better able to discuss this in person. You must forgive me for continually coming back to the same thing; but I believe in the logical development of everything we see and feel through the study of nature and turn my attention to technical questions later; for technical questions are for us only the simple means of making the public feel what we feel ourselves and of making ourselves understood. The great masters whom we admire must have done just that.

A warm greeting from the obstinate macrobite who sends you a cordial handshake.

Paul Cézanne

Timeline

c.1482	Leonardo da Vinci to Ludovico Sforza 122
7 Februrary 1506	Albrecht Dürer to Willibald Pirckheimer 202
29 December 1519	Sebastiano del Piombo to Michelangelo Buonarroti 54
20 December 1550	Michelangelo Buonarroti to Lionardo di Buonarroto Simoni 22
14 March 1559	Benvenuto Cellini to Michelangelo Buonarroti 78
Early 17th century	Wang Zhideng to a friend 90
1636	Guercino and Paolo Antonio Barbieri to unknown recipient 102
Mid-February 1639	Rembrandt van Rijn to Constantijn Huygens 178
April/May 1640	Peter Paul Rubens to Balthasar Gerbier 110
c.1650	Nicolas Poussin to Paul Scarron 164
c.1688–1705	Zhu Da to Fang Shiguan 40
21 October 1746	William Hogarth to T.H. 126
16 October 1773	Joshua Reynolds to Philip Yorke 172
22 May 1788	Thomas Gainsborough to Thomas Harvey 214
July 1794	Francisco Lucientes y Goya to Martín Zapater 16
January–March 1797	John Constable to John Thomas Smith 80
12 March 1804	William Blake to William Hayley 36
18 October 1806	Jean-Auguste-Dominique Ingres to Marie-Anne-Julie Forestier 140
29 September 1823	Henry Fuseli to unknown recipient 166
26 July 1853	John Ruskin to unknown recipient 198
April 1866	Gustave Courbet to Philippe de Chennevières 180
16 July 1873	John Linnell to James Muirhead 186
15 October c.1875–7	Pierre-Auguste Renoir to Georges Charpentier 106
2 August 1880	Édouard Manet to Eugène Maus 64
8 September 1885	Edward Lear to Hallam Tennyson 192
c.1886	Auguste Rodin to Camille Claudel 154
May 1888	Claude Monet to Berthe Morisot 72
1 October 1888	Paul Gauguin to Vincent van Gogh 50
17 October 1888	Vincent van Gogh to Paul Gauguin 52
Summer 1890 or 1891	Camille Claudel to Auguste Rodin 156
c.1893	Aubrey Beardsley to Frederick Evans 182
6 June 1893	James McNeill Whistler to Frederick H. Allen 170
19 May 1894	Gustav Klimt to Josef Lewinsky 30
8 March 1895	Beatrix Potter to Noel Moore 26
25 October 1896	Camille Pissarro to Julie Pissarro 42
c.1897–8	Edward Burne-Jones to Daphne Gaskell 34
4 January 1901	Winslow Homer to Thomas B. Clarke 114
5 September 1905	Mary Cassatt to John Wesley Beatty 118
21 September 1906	Paul Cézanne to Émile Bernard 216
September 1911	Egon Schiele to Hermann Engel 124
25 June 1913	Paul Nash to Margaret Odeh 142
Mid-January 1916	Marcel Duchamp to Suzanne Duchamp 44
c.September 1916	Vanessa Bell to Duncan Grant 20
16–19 November 1916	Pablo Picasso to Jean Cocteau 60
9 June 1917	Alfred Stieglitz to Georgia O'Keeffe 150
Summer 1918	Georgia O'Keeffe to Alfred Stieglitz 152
17 August 1918	Georges and Marcelle Braque to Paul Dermée and Carolina Goldstein 196
21 July 1920	Paul Signac to Claude Monet 56

8 November 1920	Francis Picabia to Alfred Stieglitz 68
19 July 1921	Berenice Abbott to John Henry Bradley Storrs 194
November 1921	Kazimir Malevich to Anatoly Lunacharsky 184
Summer 1928	Eileen Agar to Joseph Bard 160
December 1928	Jean Cocteau to unknown recipient 148
Autumn 1931	Ben Nicholson to Barbara Hepworth 158
6 June 1936	Alexander Calder to Agnes Rindge Claflin 38
December 1936	David Alfaro Siqueiros to Jackson Pollock, Sande Pollock and Harold Lehman 58
17 April 1938	Naum Gabo to Marcel Breuer 176
September 1939	Salvador Dalí to Paul Eluard 14
1940	Lucian Freud to Stephen Spender 18
1940	Frida Kahlo to Diego Rivera 136
Early 1940s	Piet Mondrian to Kurt Seligmann 28
9 November 1941	Henry Moore to John Rothenstein 168
July 1945	George Grosz to Erich S. Herrmann 94
2 June 1946	Jackson Pollock to Louis Bunce 120
1948	Leonora Carrington to Kurt Seligmann 88
3 March 1948	Dorothea Tanning to Joseph Cornell 46
1949	Andy Warhol to Russell Lynes 188
22 February 1951	Francis Bacon to Erica Brausen 206
Summer 1951	Joan Mitchell to Michael Goldberg 138
15 March 1954	Anni Albers to Gloria Finn 174
1955–68	Joseph Cornell to Marcel Duchamp 86
c.18 February 1955	Ad Reinhardt to Selina Trieff 144
21 July 1956	Lee Krasner to Jackson Pollock 210
16 August 1956	Mark Rothko to Lee Krasner 62
7 July 1958	Helen Frankenthaler and Robert Motherwell to Maria and Hans Hofmann 200
6 April 1959	Eva Hesse to Helene Papanek 116
c.1963	Cy Twombly to Leo Castelli 112
5 April 1963	Roy Lichtenstein to Ellen H. Johnson 108
26 August 1963	Joan Miró to Marcel Breuer 98
17 August 1964	Philip Guston to Elise Asher 24
16 November 1966	Joseph Beuys to Otto Mauer 128
1967–8	Agnes Martin to Samuel J. Wagstaff 130
1 January 1970	Jasper Johns to Rosamund Felsen 32
17 April 1970	Carl Andre to Eva Hesse 204
6 September 1971	Robert Smithson to Enno Develing 70
23 December 1971	Yoko Ono and John Lennon to Joseph Cornell 96
Summer 1973	Judy Chicago to Lucy Lippard 132
26 June 1974	Yayoi Kusama to Donald Judd 92
February 1976	Nancy Spero to Lucy Lippard 104
June 1978	Marina Abramović and Ulay to Mike Parr 74
24 July 1978	Mike Parr to Marina Abramović and Ulay 76
20 August 1980	Ana Mendieta to Judith Wilson 208
c.1981–2004	Jules Olitski to Joan Olitski 146
14 September 1988	David Hockney to Kenneth E. Tyler 66
8 March 1995	Cindy Sherman to Arthur C. Danto 84

Index

Page numbers of letters are given in **bold**

Abbott, Berenice **195**
Abramović, Marina 9, **75**, 77
abstract expressionism 25, 71, 145, 201
Académie Française 173
Agar, Eileen **161**
Albers, Anni **175**
Albers, Josef 175
Allen, Frederick H. 171
American Abstract Artists group 29
American Civil War 115
Amsterdam 51, 75, 97, 179
Andre, Carl **205**
Antwerp 111
architecture 55, 97, 123, 177, 199
Arnauld, Céline 197
art dealers 43, 109, 115, 119, 139, 187, 211
Asher, Elise 25
Atget, Eugène 195

Bacon, Francis 9, 10, **207**
Barbieri, Paolo Antonio **103**
Bard, Joseph 161
Bauhaus 175, 177
Bayeu, Francisco 17
Beardsley, Aubrey **183**
Beatty, John Wesley 119
Bell, Vanessa 10, **21**
Benton, Thomas Hart 121
Berlin 95, 177, 195
Bernard, Émile 11, 51, 217
Beuret, Rose 155, 157
Beuys, Joseph 9, **128**
Blake, William **37**, 187
Bloomsbury Group 21
Boguslavsky, Mikhail 185
Bonnard, Pierre 57
Bourdelle, Antoine 195
Braque, Georges 61, **197**
Braque, Marcelle **197**
Brausen, Erica 9, 207
Breton, André 161
Breuer, Marcel 97, 177
Brumswell, Marcus and René
Bunce, Louis 121
Burne-Jones, Edward **35**, 183

Cage, John 33
Calder, Alexander **39**
Caravaggio 85
Carrington, Leonora **89**
Cassatt, Mary **119**
Castelli, Leo 9, 33, 109, 113, 139
Castro, Fidel 209
Cellini, Benvenuto **79**
Cézanne, Paul 10, 11, 43, 109, **217**
Chagall, Marc 29, 185
Chanel, Coco 15, 149
Charles I (King of England) 111
Charles IV (King of Spain) 17
Charpentier, Georges 9, 107
Chéret, Jules 109
Chicago, Judy **133**
cinema 69, 85
Claflin, Agnes Rindge 39
Clark, Kenneth 169
Clarke, Thomas B. 115
Claudel, Camille 8, 10, 155, **157**
Cocteau, Jean 61, 69, **149**, 195
collage 47, 93, 95, 97, 105, 197
Colonna, Vittoria (Marchesa di Pescara) 23
conceptual art 45, 71, 113, 129, 133
Constable, John 10, **81**, 187
Cornell, Joseph 9, 47, **87**, 97
Courbet, Gustave **181**
Cowper, William 37
cubism 45, 57, 61, 197
Cunningham, Merce 33

Dada 69, 95, 197
Dale, William 175
Dalí, Gala 15
Dalí, Salvador **15**, 87, 89
dance 33, 61, 195, 211
Danto, Arthur C. 7, 85
David, Jacques-Louis 141
De Chennevières, Philippe 181
de Kooning, Willem 139, 145
Degas, Edgar 119
Demikovsky, Jevel 147

Dermée, Paul 197
Desbordes, Jean 149
Develing, Enno 71
Dewald, Joseph Frederick 151
Diaghilev, Sergei 61, 177
Dormer, Alexander 177
Duchamp, Marcel 10, 39, **45**, 69, 87, 195
Duchamp, Suzanne 10, 45
Durand-Ruel, Paul 73, 119
Dürer, Albrecht 6, 10, **203**

Éluard, Paul 15
Engel, Hermann 125
engraving 37, 167
Ernst, Max 29, 47, 87, 89
Eugénie de Montijo 181
Evans, Frederick 183

Fang Shiguan 41
Felsen, Rosamund 33
feminism 105, 133, 209
Fini, Leonor 15
Finn, Gloria 175
First World War 21, 45, 57, 61, 69, 95, 143, 195, 197
Flaubert, Gustave 107
Florence 23, 55, 79, 123
Ford, Sheridan 171
Forestier, Marie-Anne-Julie 141
Fouquet, Jean 85
Franco-Prussian War 43
Frankenthaler, Helen 67, **201**, 211
Franklin, Miriam 177
Fréart de Chantelou, Paul 165
Freud, Lucian **19**, 207
Friedman, Lawrence 117
Fry, Roger 21
Fuseli, Henry (Johann Heinrich Füssli) **167**

Gabo, Naum **177**
Gainsborough, Thomas, 11, **215**
Garnett, Edward 21
Garrick, David 215
Gaskell, Daphne 35
Gaskell, Helen Mary (May) 35
Gauguin, Paul 9, **51**, 53
Geist, Sidney 211
Gerbier, Balthasar 111

Gili, Joaquim 97
Gimpel, Charles and Peter
Giovanni da Udine 79
Godoy, Manuel (Duke of Alcudia) 17
Goethe, Johann Wolfgang 31
Goldberg, Michael 139
Goldstein, Caroline (Céline Arnauld) 197
Gorky, Arshile 121, 139
Gouel, Eva 197
Goya, Francisco Lucientes y 10, **17**
Graham, John D. 211
Grant, Duncan 21
Gray, Euhpemia ('Effie') Chalmers 199
Greenberg, Clement 201
Gropius, Walter 177
Grosz, George 10, **95**
Guercino (Giovanni Francesco Barbieri) **103**
Guggenheim, Peggy 121, 201
Guston, Philip **25**, 59, 139

Harvey, Thomas 11, 215
Hayley, William 37
Hepworth, Barbara 7, 159, 177
Herrmann, Erich S. 95
Hesketh, Lady Harriett 37
Hesse, Eva 10, 105, **117**, 205
Hitchcock, Henry-Russell 177
Hitler, Adolf 95
Hockney, David 10, **67**
Hofmann, Maria and Hans 201
Holtzman, Harry 29
Homer, Winslow **115**
Hugo, Victor 51
Huygens, Constantijn 9, 179

Impressionism 43, 45, 51, 65, 73, 107, 119
Ingres, Jean-Auguste-Dominique 109, **141**

James I (King of England) 111
Jenkins, Paul and Esther 211

Johns, Jasper **33**, 67, 131
Johnson, Ellen H. 109
Joyce, James 195
Judd, Donald 93

Kahlo, Frida **137**
Kennedy, John F. 113
Keynes, John Maynard
 21, 169
Klimt, Gustav **31**
Kline, Franz 139
Klingman, Ruth, 211
Krasner, Lee 7, 63, 121,
 211
Kunitz, Stanley 25
Kusama, Yayoi **93**

Laffitte, Paul 69
Lear, Edward 10, **193**
Leduc, Renato 89
Léger, Fernand 29
Lehman, Harold 59
Lennon, John **97**
Leonardo da Vinci 6, 85,
 123
Lepel-Cointet, Eric 181
Lett-Haines, Arthur 19
Levy, Julien 15, 47, 87, 177
Lewinsky, Josef 31
Lewitt, Sol 117, 205
Licht, Jennifer 71
Lichtenstein, Roy 67,
 109, 131
Linnell, John **187**
Lionardo di Buonaroto
 Simoni 23
Lippard, Lucy 9, 105, 133
London 15, 21, 27, 29, 35,
 43, 89, 95, 97, 143,
 167, 215
Los Angeles 33, 59, 67
Louis XIII (King of
 France) 165
Lunacharsky, Anatoly
 9, 185
Lynes, Russell 189

Madrid 17, 111
Malevich, Kazimir **185**
Malory, Thomas 183
Manet, Èdouard **65**
Manet, Eugène 73
Martin, Agnes 9, **131**
Massine, Léonide 61
Matisse, Henri 151
Matsch, Franz 31
Mauer, Otto 9, 129
Maus, Eugène 65
McKim, Musa 25
Medici, Cosimo de' 79
Medici, Giulio de' 55
Mendieta, Ana **209**
Mexico 59, 75, 77, 89,
 137, 209
Michelangelo Buonarroti
 6, 9, 10, **23**, 55, 79
Milan 123, 193
Millais, John Everett 199

minimalism 71, 93, 113,
 117, 131, 205, 209
Miró, Joan **99**
Mitchell, Joan **139**
Mondrian, Piet 10, **29**, 39,
 77, 139
Monet, Claude 10, 43, **73**,
 57, 107
Moore, Henry 9, 159,
 169, 177
Moore, Irina 159
Moore, Noel 27
Morgan, John Pierpont 115
Morisot, Berthe 73
Morris, Cedric 19
Motherwell, Robert **201**
Muirhead, James 187

Nanchang 41
Napoleon Bonaparte 141
Napoléon III 181
Nash, Paul **143**, 159
New York 25, 29, 33, 45,
 47, 69, 71, 73, 85, 87,
 89, 93, 95, 97, 105, 109,
 113, 115, 117, 121, 137,
 139, 147, 151, 153, 171,
 177, 189, 195, 201, 209
Newman, Barnett 93
Nicholson, Ben 7, **159**, 177
Nijinsky, Vaslav 61

O'Keeffe, Georgia 151,
 153
Odeh, Margaret 143
Olitski, Joan (Kristina
 Gorby) 147
Olitski, Jules 10, **147**
Ono, Yoko **97**

Page, Patti 139
Palmer, Samuel 187
Papanek, Helene 117
Paris 43, 45, 61, 63, 65, 69,
 73, 89, 97, 107, 109,
 119, 147, 161, 165, 171,
 177, 195, 197, 211
Parr, Mike 10, 75, **77**
Pars, William 173
Parsons, Betty 211
Petit, Georges 73
Philip IV (King of Spain)
 111
photomontage 95, 197
Picabia, Francis **69**, 197
Picasso, Pablo **61**, 109,
 149, 151, 197
Pirckheimer, Willibald
 6, 203
Pissarro, Camille 10, **43**,
 57, 73, 107
Pissaro, Julie 43
poetry 37, 41, 91
pointillism 57, 109
Pollock, Jackson 7, 59, 63,
 115, **121**, 145, 201, 211
Pollock, Sanford (Sande)
 59

Pop art 33, 93, 109, 113,
 189
Porter, Endymion 111
Potter, Beatrix 10, **27**
Poussin, Nicolas **165**
Pre-Raphaelite
 Brotherhood 35, 199
Radiguet, Raymond 149
Raphael 55, 85
Rauschenberg, Robert 67
Ray, Man 69, 195
Readymades 45
Realism 181
Reinhardt, Ad 131, **145**
Rembrandt van Rijn 9, **179**
Renoir, Pierre-Auguste
 73, **107**
Reynolds, Joshua 167, **173**
Rhode Island School of
 Design 177
Rivera, Diego 137
Roberts, Winifred 159
Rodin, Auguste 151, **155**,
 157, 195
Roessler, Arthur 125
Romanticism 31, 45, 141,
 167
Rome 23, 55, 79, 113, 141,
 165, 193
Romney, George 37
Rothenstein, John 169
Rothko, Mark **63**, 93, 145
Roussel, Raymond 149
Rubens, Peter Paul **111**
Ruskin, John 171, **199**
Russian Revolution 177,
 185

San Francisco 137
Sao Paulo 67, 85
Satie, Erik 61
Scarron, Paul 165
Schiele, Egon **125**
sculpture 33, 39, 45, 71,
 79, 93, 117, 123, 129,
 131, 151, 155, 157, 159,
 177, 195, 205, 209
Sebastiano del Piombo **55**
Second World War 15, 25,
 29, 89, 147, 169
Seligmann, Kurt 29, 89
Seurat, Georges 53, 57,
 109
Sforza, Ludovico 123
Shakespeare, William
 31, 193
Shapiro, Miriam 133
Sherman, Cindy **85**
Siddons, Sarah 215
Signac, Paul 57
Siqueiros, David Alfaro **59**
Sisley, Alfred 73
Slade School of Art,
 London 161
Smith, John Thomas 81
Smithson, Robert **71**
Sonnabend, Ileana 109
Spanish Civil War 59

Spender, Stephen 19
Spero, Nancy **105**
Steichen, Edward 151
Stein, Gertrude 149
Stieglitz, Alfred 69, **151**
Storrs, John Henry Bradley
 195
Strachey, Lytton 21
surrealism 47, 87, 89,
 143, 161
Suzhou 91

Tanning, Dorothea **47**, 87
Tapié, Michel 211
Tennyson, Alfred 193
Tennyson, Hallam 193
theatre 31, 61, 127, 165
Thompson, Dorothy 161
Tokyo 93, 205
trains 21, 27, 53, 77, 121,
 195
Trieff, Selina 145
Twombly, Cy (Edwin
 Parker) **113**, 131
Tyler, Kenneth E. 67
Tzara, Tristan 69, 197

Ulay (Frank Uwe
 Laysiepen) **75**, 77

Van Gogh, Theo 51, 73
Van Gogh, Vincent 51, **53**,
 57, 73, 217
Van Volbergen, Thyman
 179
Velázquez, Diego 111
Venice 85, 199, 203, 211
Verhulst, Pieter 111
Vienna 31, 75, 125
Vietnam War 93, 97
Von Freytag Loringhoven,
 Elsa 195
Vreeland, Diana 189

Wagstaff, Samuel J. 9, 131
Wang Zhideng 10, **91**
Warhol, Andy 131, **189**
Washington 85, 175
watercolours 57, 61, 65,
 143, 199
Weisz, Csizi 89
Whistler, James McNeill
 171
Wilson, Judith 209
Wtenbogaert, Johannes
 179

Yorke, Philip (2nd Earl of
 Hardwicke) 173

Zadkine, Ossip 147
Zapater, Martín 10, 17
Zhu Da (Bada Shanren)
 10, 41
Zijlstra, Sjouke 71
Zola, Émile 107

Picture Credits

The publishers thank the following for permission to reproduce the letters in this book. Every effort has been made to provide correct attributions. Any inadvertent errors or omissions will be corrected in subsequent editions.

14 Private Collection / © Salvador Dali, Fundació Gala-Salvador Dalí, DACS 2019, translation by Michael Bird; **16** Casa Torres Collection, Madrid; Marquesa Vda collection of Casa Riera, Madrid; Prado Museum, 1976, translation by Philip Troutman in Sarah Symmons, ed., *Goya: A Life in Letters* (Pimlico: London, 2004); **18** Private Collection / © The Lucian Freud Archive / Bridgeman Images; **20** © Tate, London 2019 / © Estate of Vanessa Bell, courtesy Henrietta Garnett; **22** British Library, London, UK / © British Library Board. All Rights Reserved / Bridgeman Images; **24** Philip Guston letter to Elise Asher, 1964 August 17. Elise Asher papers, 1923–1994. Archives of American Art, Smithsonian Institution / © The Estate of Philip Guston; **26** © The Morgan Library & Museum; **28** Private Collection; **30** Image courtesy of Wienbibliothek, Estate Josef Lewinsky; **32** Jasper Johns, New York, New York letter to Rosamund Felsen, Los Angeles, California, 1970 January 1. Rosamund Felsen letters, 1968–1977. Archives of American Art, Smithsonian Institution / © Jasper Johns / VAGA at ARS, NY and DACS, London 2019; **34** © Ashmolean Museum, University of Oxford; **36** © The Morgan Library & Museum; **38** Alexander Calder to Agnes Rindge Claflin, 1936 June 6. Agnes Rindge Claflin papers concerning Alexander Calder, 1936–*c.*1970s. Archives of American Art, Smithsonian Institution / © 2019 Calder Foundation, New York / DACS London 2019; **40** © 2019. Image copyright The Metropolitan Museum of Art / Art Resource / Scala, Florence; **42** Courtesy of Sotheby's London, translation by Michael Bird; **44** Marcel Duchamp letter to Suzanne Duchamp, 1916 Jan. 15. Jean Crotti papers, 1913–1973, bulk 1913–1961. Archives of American Art, Smithsonian Institution / Letter reproduced by kind permission of Association Marcel Duchamp, translation by Francis M. Naumann, in 'Affectueusement, Marcel: Ten Letters from Marcel Duchamp to Suzanne Duchamp and Jean Crotti', *Archives of American Art Journal*, vol.22, no.4 (1982); **46** Dorothea Tanning to Joseph Cornell, 1948 March 3. Joseph Cornell papers, 1804–1986, bulk 1939–1972. Archives of American Art, Smithsonian Institution / © ADAGP, Paris and DACS, London 2019; **50** Van Gogh Museum, Amsterdam (Vincent van Gogh Foundation); **52** © The Morgan Library & Museum; **54** British Library, London, UK / © British Library Board. All Rights Reserved / Bridgeman Images; **56** Autograph letter to Claude Monet, 21 July 1920 (w/c, pencil & ink on folded paper), Signac, Paul (1863–1935) / Private Collection / Photo © Christie's Images / Bridgeman Images; **58** David Alfaro Siqueiros letter to Jackson Pollock, Sandy Pollock, and Harold Lehman, 1936 Dec. Jackson Pollock and Lee Krasner papers, *c.*1905–1984. Archives of American Art, Smithsonian Institution / © DACS 2019; **60** © 2019. Image copyright The Metropolitan Museum of Art / Art Resource / Scala, Florence / © Succession Picasso / DACS, London 2019, translation by Michael Bird; **62** Mark Rothko letter to Lee Krasner, 1956 Aug. 16. Jackson Pollock and Lee Krasner papers, *c.*1905–1984. Archives of American Art, Smithsonian Institution / © 1998 Kate Rothko Prizel & Christopher Rothko ARS, NY and DACS, London; **64** Metropolitan Museum of Art, Purchase, Guy Wildenstein Gift, 2003 – Public Domain, translation by Michael Bird; **66** David Hockney fax (hand-written letter) 1988, hand written letter faxed via a fax machine on one sheet of white, machine made, fax paper, 26.8 × 21.6 cm, National Gallery of Australia, Canberra, Gift of Kenneth Tyler 2002 / Reproduced by kind permission of David Hockney; **68** Yale Collection of American Literature, Beinecke Rare Book and Manuscript Library, Yale University / © ADAGP, Paris and DACS, London 2019, translation by Michael Bird; **70** Robert Smithson letter to Enno, 1971 September. Robert Smithson and Nancy Holt papers, 1905–1987, bulk 1952–1987. Archives of American Art, Smithsonian Institution / © Holt-Smithson Foundation / VAGA at ARS, NY and DACS, London 2019; **72** Musée Marmottan Monet, Paris, France / Bridgeman Images, translation by Michael Bird; **74** Handwritten letter from Marina Abramović and Ulay to Mike Parr, page 1. Mexico, June 1978, National Gallery of Australia, Canberra, Gift of Mike Parr 2012 / Letter reproduced by kind permission of Marina Abramović and Ulay; **76** Letter from Mike Parr to Marina Abramović and Ulay. Newtown, 27 July 1978, National Gallery of Australia, Canberra, Gift of Mike Parr 2012 / Letter reproduced by kind permission of Mike Parr; **78** British Library, London, UK / © British Library Board. All Rights Reserved / Bridgeman Images; **80** Yale Center for British Art, Paul Mellon Collection; **84** Cindy Sherman postcard to Arthur Danto, 1995 March 8. Arthur Coleman Danto papers, 1979–1998. Archives of American Art, Smithsonian Institution / Reproduced with kind permission by the artist; **86** Joseph Cornell, New York, N.Y. letter to Marcel Duchamp, Flushing, N.Y., between 1955 and 1968. Joseph Cornell papers, 1804–1986, bulk 1939–1972. Archives of American Art, Smithsonian Institution / © The Joseph and Robert Cornell Memorial Foundation / VAGA at ARS, NY and DACS, London 2019; **88** Yale Collection of American Literature, Beinecke Rare Book and Manuscript Library, Yale University / © Estate of Leonora Carrington / ARS, NY and DACS, London 2019; **90** Metropolitan Museum of Art, bequest of John M. Crawford Jr., 1988 – Public Domain; **92** Letter from Yayoi Kusama to Donald Judd, March 21, 1978. Image © Judd Foundation / Judd Foundation Archives / Letter reproduced by kind permission of Yayoi Kusama / extract from Donald Judd's review in *Donald Judd: Complete Writings: 1959–1975* (Distributed Art Publishers: New York, 2016), quotations from Yayoi Kusama in *Infinity Net: The Autobiography of Yayoi Kusama* (Tate Publishing: London, 2013); **94** George Grosz letter to Erich S. Herrmann, 1945. Erich

Herrmann papers relating to George Grosz, 1935–1947. Archives of American Art, Smithsonian Institution / Reproduced with kind permission of the Estate of George Grosz, Princeton, N.J / © Estate of George Grosz, Princeton, N.J. / DACS 2019; **96** John Lennon and Yoko Ono Christmas card to Joseph Cornell, 1971 Dec. 23. Joseph Cornell papers, 1804–1986, bulk 1939–1972. Archives of American Art, Smithsonian Institution / © Yoko Ono, Courtesy Galerie Lelong & Co., New York; **98** Joan Miró to Marcel Breuer, 1963 Aug. 26. Marcel Breuer papers, 1920–1986. Archives of American Art, Smithsonian Institution / © Successió Miró / ADAGP, Paris and DACS London 2019; **102** © The Samuel Courtauld Trust, The Courtauld Gallery, London, translation by Danielle Carrabino in *Immediations*, no.4 (2007); **104** Nancy Spero letter to Lucy R. Lippard, 1976 February. Lucy R. Lippard papers, 1930s–2010, bulk 1960s–1990. Archives of American Art, Smithsonian Institution / © The Nancy Spero and Leon Golub Foundation for the Arts / VAGA at ARS, NY and DACS, London 2019; **106** © RMN-Grand Palais (Musée d'Orsay) / RMN-GP; **108** Roy Lichtenstein letter to Ellen H. Johnson, 1963 Apr. 5. Ellen Hulda Johnson papers, 1872–1994, bulk 1921–1992. Archives of American Art, Smithsonian Institution / © Estate of Roy Lichtenstein / DACS 2019; **110** © The Samuel Courtauld Trust, The Courtauld Gallery, London; **112** Cy Twombly letter to Leo Castelli, 1963?. Leo Castelli Gallery records, *c.*1880–2000, bulk 1957–1999. Archives of American Art, Smithsonian Institution / © Cy Twombly Foundation; **114** Winslow Homer letter to Thomas B. (Thomas Benedict) Clarke, 1901 Jan. 4. Winslow Homer collection, 1863–1945. Archives of American Art, Smithsonian Institution; **116** Allen Memorial Art Museum, Oberlin College, Ohio, USA / Gift of Helen Hesse Charash / Bridgeman Images; **118** Mary Cassatt letter to John Wesley Beatty, 1905 Sept. 5. Carnegie Institute, Museum of Art records, 1883–1962, bulk 1885–1940. Archives of American Art, Smithsonian Institution; **120** Jackson Pollock letter to Louis Bunce, 1946 June 2. Louis Bunce papers, 1890s–1983. Archives of American Art, Smithsonian Institution / © The Pollock-Krasner Foundation ARS, NY and DACS, London 2019; **122** Veneranda Biblioteca Ambrosiana, Milan, Italy / © Veneranda Biblioteca Ambrosiana / Metis e Mida Informatica / Mondadori Portfolio / Bridgeman; **124** © Leopold Museum, Vienna, translation by Jeff Tapia; **126** Royal Collection Trust / © Her Majesty Queen Elizabeth II 2014; **128** Courtesy of the photographer and Ketterer Kunst / © DACS 2019, translation by Daniela Winter; **130** Agnes Martin letter to Samuel J. Wagstaff, 19–. Samuel Wagstaff papers, 1932–1985. Archives of American Art, Smithsonian Institution / © Agnes Martin / DACS 2019; **132** Judy Chicago letter to Lucy Lippard, 1973. Lucy R. Lippard papers, 1930s–2010, bulk 1960s–1990. Archives of American Art, Smithsonian Institution / © Judy Chicago. ARS, NY and DACS, London 2019; **136** Frida Kahlo letter to Diego Rivera, 1940. Emmy Lou Packard papers, 1900–1990. Archives of American Art, Smithsonian Institution / © Banco de México Diego Rivera Frida Kahlo Museums Trust, Mexico, D.F. / DACS 2019; **138** Joan Mitchell letter to Michael Goldberg, *c.*1950. Michael Goldberg papers, 1942–1981. Archives of American Art, Smithsonian Institution / © Estate of Joan Mitchell; **140** © The Morgan Library & Museum; **142** © Tate, London 2019; **144** Ad Reinhardt Valentine to Selina Trieff, 1955 Feb. 18. Selina Trieff papers, 1951–1981. Archives of American Art, Smithsonian Institution / © ARS, NY and DACS, London 2019; **146** Jules Olitski note to Joan C. Olitski, 1981. Jules Olitski notes to Joan Olitski, 1981–2004. Archives of American Art, Smithsonian Institution. Jules Olitski note to Joan C. Olitski, 1981. Jules Olitski notes to Joan Olitski, 1981–2004. Archives of American Art, Smithsonian Institution / © Estate of Jules Olitski / VAGA at ARS, NY and DACS, London 2019; **148** Courtesy of Sotheby's, Inc. © 2017 / © Adagp / Comité Cocteau, Paris 2019; **150** Yale Collection of American Literature, Beinecke Rare Book and Manuscript Library, Yale University; **152** Yale Collection of American Literature, Beinecke Rare Book and Manuscript Library, Yale University / © Georgia O'Keeffe Museum / DACS 2019; **154** © Musée Rodin, translation by Michael Bird; **156** © Musée Rodin; **158** © Tate, London 2019 / © Bowness, Hepworth Estate; **160** © Tate, London 2019 / © The estate of Eileen Agar; **164** © The Trustees of the British Museum, translation by Michael Bird; **166** Heritage Image Partnership Ltd / Alamy Stock Photo; **168** © Tate, London 2019 / Reproduced by permission of The Henry Moore Foundation; **170** James McNeill Whistler to Frederick H. Allen, 1892 or 1893 June 6. James McNeill Whistler collection, 1863–1906, *c.*1940. Archives of American Art, Smithsonian Institution; **172** Lebrecht Authors / Bridgeman Images; **174** Anni Albers to Gloria Finn, 1954 Mar. 15. Gloria Dale papers, 1952–1970. Archives of American Art, Smithsonian Institution / © The Josef and Anni Albers Foundation / Artists Rights Society (ARS), New York and DACS, London 2019; **176** Naum Gabo to Marcel Breuer, 1938 Apr. 17. Marcel Breuer papers, 1920–1986. Archives of American Art, Smithsonian Institution / © Tate, London 2019; **178** British Library, London, UK / © British Library Board. All Rights Reserved / Bridgeman Images, translation by Walter L. Strauss and Marjon van der Meulen in *The Rembrandt Documents* (Abaris Books, New York, 1979); **180** Image courtesy of Jürg Blaser, translation by Michael Bird; **182** Private Collection / Prismatic Pictures / Bridgeman Images; **184** Bonhams; **186** Fitzwilliam Museum, University of Cambridge, UK / Bridgeman Images; **188** Andy Warhol letter to Russell Lynes, 1949. Managing editor Russell Lynes correspondence with artists, 1946–1965. Archives of American Art, Smithsonian Institution / © 2019 The Andy Warhol Foundation for the Visual Arts, Inc. / Licensed by DACS, London. 2019; **192** Tennyson Research Centre, Lincolnshire Archives; **194** Berenice Abbott letter to John Henry Bradley Storrs, 1921 July 19. John Henry Bradley Storrs papers, 1790–2007, bulk 1900–1956. Archives of American Art, Smithsonian Institution / © Berenice Abbott / Commerce Graphics; **196** Courtesy of Sotheby's London / © ADAGP, Paris and DACS, London 2019, translation by Michael Bird; **198** Bonhams; **200** [Frankenthaler and Motherwell to Hans Hofmann.] Hans Hofmann papers, [*c.*1904]–2011, bulk 1945–2000. Archives of American Art, Smithsonian Institution / © Helen Frankenthaler Foundation, Inc. / ARS, NY and DACS, London 2019; **202** Private Collection, translation from William Martin Conway, *The Writings of Albrecht Dürer* (Peter Owen: London, 1958); **204** Allen Memorial Art Museum, Oberlin College, Ohio, USA / Gift of Helen Hesse Charash / Bridgeman Images / © Carl Andre / VAGA at ARS, NY and DACS, London 2019; **206** © Tate, London 2019 / © The Estate of Francis Bacon. All rights reserved. DACS 2019; **208** Ana Mendieta postcard to Judith Wilson, 1980 August 20. Judith Wilson papers, 1966–2010. Archives of American Art, Smithsonian Institution / © The Estate of Ana Mendieta Collection, LLC, Courtesy Galerie Lelong & Co.; **210** Lee Krasner letter to Jackson Pollock, 1956 July 22. Jackson Pollock and Lee Krasner papers, *c.*1905–1984. Archives of American Art, Smithsonian Institution / © The Pollock-Krasner Foundation ARS, NY and DACS, London 2019; **214** © The Samuel Courtauld Trust, The Courtauld Gallery, London; **216** © The Samuel Courtauld Trust, The Courtauld Gallery, London, translation by Marguerite Kay in John Rewald, ed., *Paul Cézanne: Letters* (Bruno Cassirer: Oxford, 1941, 4th edn 1976).

Acknowledgments

For their generous help with contextual information, translations and locating digital images of letters, I thank Catherine Angerson and Andrea Clarke at the British Library, Okkyun Choi, Ketty Gottardo at the Courtauld Gallery, Alice Howard at the Ashmolean Museum, Jessica Lin, Alice Mahoney, Gesine Mahoney, Ian Massey, Sheila McTighe at the Courtauld Institute of Art, Darragh O'Donoghue at Tate, and Gemma Rhodes. Thanks are also due to my patient and wonderfully efficient editors at White Lion, Nicki Davis and Michael Brunström, and to Alison Stevens for her brilliant picture research.

Brimming with creative inspiration, how-to projects and useful information to enrich your everyday life, Quarto Knows is a favourite destination for those pursuing their interests and passions. Visit our site and dig deeper with our books into your area of interest: Quarto Creates, Quarto Cooks, Quarto Homes, Quarto Lives, Quarto Drives, Quarto Explores, Quarto Gifts, or Quarto Kids.

First published in 2019 by White Lion Publishing,
an imprint of The Quarto Group.
The Old Brewery, 6 Blundell Street
London, N7 9BH,
United Kingdom
T (0)20 7700 6700 F (0)20 7700 8066
www.QuartoKnows.com

Introduction and commentaries © 2019 Michael Bird
Illustrations and translations © as listed on pages 222–3

A catalogue record for this book is available from the British Library.

ISBN 978-0-7112-4128-2

10 9 8 7 6 5 4 3 2 1

Typeset in New Caledonia and Akkurat
Design by Paileen Currie

Printed in China